ADVANCED PRAISE

Epstein succeeds in her goal of bringing attentio
ically underrepresented form of abuse, marking
project.

Kirkus Reviews

Empowering memoir of sibling sexual abuse that offers hope for healing.

Booklife by Publisher's Weekly

Jane Epstein makes the case for overcoming the wretched experiences of family sexual abuse in an honest and brave memoir. For all of us who have endured family sexual abuse and are looking for paths forward, reading *I Feel Real Guilty* will provide a roadmap to recovery.

Jackie Speier, Former U.S. Congresswoman, a fighter for equality, our troops, and the working poor and author of *Undaunted*

This powerfully moving memoir sheds light on the silent epidemic of sibling sexual abuse. Jane shares her personal battles, giving a voice to survivors and their families who have struggled in silence. This essential read offers hope to all and is crucial for those aiming to end this hidden form of abuse. *I Feel Real Guilty* is an important step toward eradicating this insidious trauma that affects countless children and families globally.

Brad Watts, author of *Sibling Sexual Abuse: A Guide for Confronting America's Silent Epidemic*, Licensed Professional Counselor (LPC) and Certified Sex Offender Treatment Provider (CSOTP) specializing in working with families where sibling sexual abuse has occurred.

Jane's storytelling is extraordinary. Her use of description and imagery pull us into the settings, sights, sounds, personalities and characters spanning several decades. I can easily visualize her experiences and feel her deepest, darkest moments as well as her victories—both minute and monumental.

Holli Kenley, MA, Licensed Marriage & Family Therapist, Author, TEDx Speaker

Jane's insightful exploration of sibling sexual abuse provides crucial psycho-educational tools for educators and practitioners, offering guidance on assessing trauma, understanding family dynamics, and fostering recovery.

Dr. Jeyda Ibrahim, Consultant Clinical Psychologist and Author of *Harmful Sexual Behaviour between Siblings (HSB-S) Practice Guidance: Considerations for assessment and intervention and supporting families to heal and move on from this crisis through a shared narrative*

Jane Epstein's powerful memoir invites you into the depths of her painful past, revealing the long-hidden secrets of sibling sexual abuse and her journey to reclaim control over her life through stripping. With raw honesty, Jane shares the heartbreaking loss of her first husband and the struggles in her second marriage that led her to confront her traumatic memories. Through faith, therapy, and vulnerability, Jane's story offers a safe space for others to understand, heal, and know they are far from alone.

Dr. Margaret Rutherford, TEDx Speaker, Host of *The SelfWork Podcast, Author of Perfectly Hidden Depression*

Jane Epstein boldly confronts the harsh realities of sibling sexual abuse and its lasting impact. Her raw and honest narrative offers survivors realistic hope and empowerment, illuminating a path to healing.

Alice Perle, author of *Resolve: A Story of Courage, Healthy Inquiry and Recovery from Sibling Sexual Abuse*

Pure bravery. Through her unflinching honesty and masterful storytelling, Epstein highlights the rarely discussed issue of sibling sexual abuse. Her memoir is not just a personal account, but a critical resource that provides clarity for understanding the profound impact of such trauma and the path to healing. This book is a must-read for parents, professionals, and advocates committed to protecting children and supporting survivors.

Kimberly King, Sexual Abuse Prevention Educator, Advocates, and Author of *I Said No! a kid-to-kid guide to keeping private parts private* and *Body Safety for Young Children: Empowering Caring Adults*

A powerful reminder of our inner strength and capacity to heal even after the most unimaginable circumstances. With a firm yet gentle hand, Jane Epstein skillfully empowers readers to courageously face their deepest fears and begin their journey towards healing. *I Feel Real Guilty* is a must-read for anyone who is navigating the complexities of trauma.

Shari Alyse, TV Host, 2x TEDx Speaker, Bestselling Author of *Love Yourself Happy*

Jane deftly guides us through a range of complex emotions, sharing her experiences of confusion, fear, joy, grief, love, and guilt. For those unfamiliar with childhood trauma, this memoir offers an intimate look at its physical and mental impacts. For those who have endured similar experiences, it provides validation and a deeply personal view of our varied responses to trauma, rarely discussed with such raw honesty.

Tessa Stevenson, Mental Health Therapist and CSA survivor

An eye-opening tale of navigating life amidst shame and grief - interwoven with Jane Epstein's heartbreaking reflections and inspiring journey towards healing! This book is impossible to put down! As a Grief Coach, I resonated deeply with Jane's experiences; recognizing her silent struggles and resilience. Yet, on a personal level, I felt a strong desire to just hug Jane through each phase - from her childhood innocence to every layer of her complex adult life.

Kari Driskell, Mother of Two, Remarried Widow, Recovering Extrovert, Grief & Widow Coach at KariDriskell.com

A powerful and gripping account of how her past trauma of sibling sexual abuse had a profound impact on the trajectory of life. This is a must-read that demonstrates how she bravely persevered in order to heal.

Maria Socolof, Author of *The Invisible Key: Unlocking the Mystery of My Chronic Pain;* Sibling Sexual Trauma Survivor; President & Cofounder of 5WAVES, Inc.

A courageous story about surviving trauma and its unseen implications. This book offers an intimate understanding of the emotional toll trauma takes on the mind and body. Jane bravely shares her lived experiences, helping readers grasp the impact of unprocessed pain on her coping skills and self-beliefs. Through dedication and finding one's truth, healing and transformation are possible. Overall, a powerful, emotional journey of a survivor who fearlessly shares her life story.

Janet Philbin, LCSW, CHt, Bestselling Author of *Show Up For Yourself: A Guide to Inner Awareness and Growth*

As a survivor of sibling sexual abuse myself, I am profoundly grateful to Jane Epstein for bravely addressing this relatively unknown topic in her memoir, *I Feel Real Guilty.* This book is so much more than just an SSA memoir. Epstein's beautifully crafted narrative takes us through various seasons of her life—her time as a stripper, becoming a young widow, navigating marital tensions, and ultimately confronting her sibling sexual abuse experience. Whether these experiences feel exotic, familiar, or a mix of both, Jane's story is bound to resonate deeply with readers. A powerful testament to resilience and self-discovery, that has left a lasting impression on me.

Diane Tarantini, author of *Everyone Was Silent: A memoir*

I
FEEL
REAL
GUILTY

A MEMOIR OF
SIBLING SEXUAL ABUSE

JANE EPSTEIN

LIFE TO PAPER
PUBLISHING

Library of Congress Control Number: 2024904775

Paperback ISBN: 978-1-990700-68-2
KDP Paperback ISBN: 978-1-990700-68-2
eBook ISBN: 978-1-990700-31-6

Printed in the U.S.A.
1 2 3 4 5 6 7 8 9 10

Life to Paper Publishing Inc.
Toronto | Miami

www.lifetopaper.com

LIFE TO PAPER
PUBLISHING

This book is dedicated to all those affected by sibling sexual abuse and trauma, especially survivors who cannot come forward due to legal reasons or family dynamics, survivors raising awareness, and survivors who have yet to articulate their experiences. Because sibling sexual abuse and trauma is a whole-family trauma, I also want to dedicate this book to parents who have discovered such abuse or trauma within their homes.

As a co-founding member of 5WAVES.org, I have insights into the grief and trauma process families go through. I hope that one day, we can normalize the discussion around sibling sexual abuse and trauma so no family is blindsided. It is a devastating blow.

While I am not a coach or therapist, I have heard from thousands of survivors, each with different triggers. This book is written in a very real way—though I don't divulge explicit details, I also don't leave you guessing. Please take care when reading and take breaks as needed.

C O N T E N T S

Part Four

Part Five

Part Six

PROLOGUE

"Jane, someone wants to see you outside—a woman."

I went to the exit and found the woman. Her face was etched with tears. The expression of gratitude in her eyes was unmistakable. "Thank you for talking about this. My husband is here with me, and I almost left because I thought it might trigger me. I'm so glad I stayed. When does the hurt go away? When will I stop crying?"

I hugged her and asked her to contact me after the event, and we said goodbye. I had reached a survivor, and that is why I had come to Florida. I headed towards my family who were in line for hot chocolate when I was intercepted.

A gentleman asked, "Jane? Are you Jane?"

"Yes."

"Thank you for your talk. It was powerful. The person next to me left right after you finished. They said they had to get home and tell their spouse that this had happened to them."

I felt honored and grateful for his affirmation and told the gentleman how to contact me and to please tell this person to reach out. They did, by email, the next day.

I continued to make my way to the hot chocolate line, where Steve and our friends were standing, when a husband and wife approached me. She said, "Thank you for sharing your talk. I feel so naïve and feel we are living in a society that does not know this is such a problem. You have enlightened us. You are very brave."

I finally made it to my family—Steve and the kids—along with five friends who had traveled from four states to support me. Overwhelming emotions spilled over. Hugs were exchanged, tears flowed freely, and photographs captured the profound moment.

I heard a squeal and "There she is!" coming from my right. I glanced over and saw my mom running toward me with outstretched arms, and we hugged, symbolizing a lifetime of support and love.

INVENTORY
AND PUZZLES

SPRING OF 2017, SAN FRANCISCO, CALIFORNIA

I couldn't shake the feeling that I needed to write my story, and write it from the very beginning. It would help me find that little girl. I made a mental inventory of the items I would need. I glanced at the dining room table, a perfect place to spread out my photo albums—all of them—and my baby book—anything that detailed my childhood and early adult years. I was ready.

I pulled the retractable attic stairway down from the ceiling of our upper hallway—and I climbed.

A storm of microscopic particles danced in the air with each step as if to say, "Leave the past alone. It's messy and dirty." I turned on the light and listened for the scurrying of tiny feet, hoping not to run into any critters. I sorted through the boxes of photo albums and trinkets, remembering when I brought them up here, believing I would never touch them again. But I carried them back down the ladder and into the dining room..

The once-spotless table was now cluttered with boxes and albums. It was 10:00 a.m. That gave me almost five hours before kiddo pickup. I felt a sense of urgency to sit and sort through the buried memories.

I placed my cup of coffee on a napkin on the table and nestled into a dining room chair. Ready to begin my excavation, I started with my parents and rummaged through the long forgotten pictures as if I were sorting through the recollections of someone else's life story.

A picture of a handsome, tall man wearing a black leather bomber jacket with his hair slicked back. He had a soft grin: Keith, my father. A woman. She was young. She looked at him with adoration. She was a beautiful brunette

with wavy hair: Andrea, my mother. They were married in 1959—a simple church wedding with a small reception in the church basement.

Baby James was born two years into the marriage. My dad secured a job with the Denver schools as a social worker and later as a school psychologist. My parents settled into a house in Wheatridge, Colorado. My mom was pregnant again, with Joey. There were photos of family camping trips and the family's first dog, Max. The albums helped me understand the importance of certain people and events in my ancestry.

I flipped through the pages of the album. Almost like a journal entry, a letter in my mother's handwriting was attached to a photo. It stated, "We loaded up the car and made a trip to North Dakota to visit Keith's mom and sisters. Keith's youngest sister, Esther, had a new baby girl, June. I held the baby girl, wrapped in a pink blanket. As I held her, I knew I wanted a third child, and I wanted a girl."

I had to know more. I put my coffee down and called my mom, who still lived in Colorado.

"Mom, this seems impulsive and rushed, but can you share my birth story with me?"

"What?"

"I know that sounds weird. I'm going through the family albums, and I feel like there's something there I need to understand. I just came across a photo of you holding baby June with the words, 'As I held her, I knew I wanted a third child, and I wanted a girl.'"

It was quiet on the other end of the phone.

"Mom?"

"Janie, I wanted you. I desperately desired a little girl when I held that baby girl. But in your father's mind, two children, both boys, were enough. We were done having children."

She paused.

"Mom, I can't explain it, but I have this nagging sensation there is more."

Silence.

"Well, there was an evening with unprotected intercourse, and I secretly hoped and prayed to become pregnant. With a little girl. God answered my prayers. I became pregnant with you. I sensed you were a girl. Five months into my pregnancy, I stood beside your father. He motioned at my belly, barely protruding from the yellow flowery dress, a dress you would one day play in for dress-up, and he had told a friend that he had decided we would not have a third child, but here he was, gesturing towards my small bump."

I felt like someone had hit me with a dagger in my heart. This revelation stung because it suggested that my father didn't initially embrace or plan my birth—and maybe not ever. I felt unwanted, and a sense of hurt, disappointment, and shock flooded my body upon hearing my mother's words.

"Janie, your father did his best with what he had."

"I know," I said, and I believed it.

"He was content with two children, boys. I don't think he had a clue what to do with a girl."

That wasn't true. What about all the girls he "saved" at his schools?

"Thanks, Mom. This helps."

She continued, "We moved to a nearby neighborhood just before you were born, and it was the kind of place where kids ran and explored safely. Your father struggled with the idea of having a daughter."

While she spoke, I focused on the baptismal photos. My father was standing near my mother, but not close. He had a calling to save the world, and his instrument was the school system. It often preoccupied him with helping at-risk boys and girls, which led to his limited availability or presence in my life during my upbringing. I nodded as my mother finished her story, the phone call ending. "Thanks for sharing, Mom," I said. "Understanding our family's history and Dad's choices means a lot."

With gratitude in her voice, she replied, "You're welcome. Knowing our roots shapes us. Your father loved you deeply."

After a few more words of love and reassurance, we said our goodbyes and hung up, leaving me to reflect on the legacy of my parents' choices and the path they'd set for me.

As I flipped through the photo album, there were images of a little girl—me—as my two older brothers stood on either side of me like protective bookends. As the years passed, I stood further and further apart from them in photos of us. Despite the happy memories captured in these images, I couldn't shake the notion that something was amiss in our family.

I stared at a photo of us at the Royal Fork Buffet, a special occasion because we had guests, and my grandmother attended. I was a little living doll with white-blonde hair pulled up into a pile on my head and affixed with a red bow. Curls framing my face, I studied that little girl in the photo. I was a typical little girl. Sometimes silly, I loved playing in the yard with my dog, Freckles, an Australian Shepherd. I enjoyed entertaining myself with dolls and my dollhouse, where I imagined being married to a prince and raising children together.

Looking at these photos, I felt lost and confused, as if something had been omitted from my childhood memories.

As I held the album in my hand, I recalled a family dinner scene in the fall of 1974. The kitchen's dining area featured a table with faux-wood linoleum. A picture window was positioned at one end, its handmade white eyelet curtains lending a touch of charm. Encircling the table were six chairs, each covered with an avocado-green cushion. The aroma of steamed vegetables and roasted pork permeated the kitchen, adding a savory allure.

At the head of the table, my father sat, pushing his food around with a fork. A pristine white napkin lay atop his lap, untouched. He refrained from unfolding it. He could save it for tomorrow's breakfast if he only used a portion of his napkin during the meal. Such was the nature of a man who valued thriftiness above all else.

Seated opposite my mom and me were my brothers, James and Joey. James occupied the seat closest to my father. Now twelve, he stood tall, his frame hinting at the onset of puberty. His gaze remained fixed on our father, absorbing every word with unwavering attention. Dark hair was carefully combed over his forehead, perhaps to conceal the blemishes of emerging acne. Joey was ten and had sandy blonde hair. He was less awkward and smiled as he watched me, his goofy little sister, age six, flatten my rice with my fork. My father didn't ask questions. He just talked. My mom seemed distant and distracted as she stared out the window. As I made my rice pancake and sprinkled sugar on top, I sensed the tense atmosphere in my family.

My dad peered at James. "Perhaps we can take some time in the shop this weekend and make more display boxes for your bugs. What do you say?"

James changed his expression in anticipation of some time with his father, his hero.

I looked up, "My hamsters! They're scared when the saw goes, and it's loud!"

My mom said, "Oh, don't worry, honey. We can put your hamsters in their plastic hamster balls, and they can race around the basement while your brother and dad are building. Just make sure you close the lid tightly. We don't want them getting out again."

I sensed an opportunity. "I want a kitten."

"Jane, you know I hate cats! And your brother is allergic to them. No." My dad was tired of talking about kittens. I couldn't understand my father's obsession with assisting troubled children but not rescuing one kitten.

My mom stood up and began clearing the dishes. My brothers glanced at my parents as if to ask if they could leave, but my dad cleared his throat and broached the subject of Gianna. Gianna was a student at my father's school, where he was the school psychologist. She was his latest project, the next child he wanted to rescue.

"Did I tell you the elderly woman who has been watching Gianna was killed in a car accident?"

My mom immediately shook her head in dismissal. She knew where this was going.

"A single man like her father can't raise her. That's not appropriate."

She stood up abruptly, nearly dropping her spoon, and admonished him, "Keith, not at the table."

"Gianna has moved back in with her alcoholic mother. She's not safe there."

Over my mother's objections, he asked if they could house Gianna until he found a stable arrangement for her. My mom firmly pressed him to spend more time with me, his own daughter, instead of bringing in a new project. He persisted. "God guided me into the field of school social work and psychology. I want to help kids with their education, stand on their own two feet, and be self-sufficient and productive citizens. Unfortunately, Gianna is being raised by alcoholics. Based on her behavior, she will be a prime candidate for Crittendon Home, a home for unwed mothers. Or worse, she may become a sex worker."

"Keith, the kids!" my mother implored. "Kids, you can go watch TV."

We raced down the hall into my bedroom and crowded into my double canopy bed to watch our favorite TV show, *Happy Days*, on a small black and white television set. The bedroom had bright lime green shag carpet, but the rest was decorated in various shades of pink. It was light, fluffy, and pink all over, like being in a cotton candy machine. My mother had adorned the bed with a quilt handmade in a pink fabric with bows forming squares like that of a hot waffle. I was sandwiched between my two brothers and several pillows. We sprawled on the bed, legs loosely intertwined.

I heard bits of the argument between my parents in the kitchen. It was nothing new. James noticed and turned the TV louder to drown my parents out. "How far did you get?" blared from the TV. Richie Cunningham's dreams

seemed about to come true when he was invited to babysit with Mary Lou Milligan, a pretty girl with a racy reputation.

"I'm your best friend. You can tell me. *How far did you get?*" asked the character Potsie.

"All I'm saying is Mary Lou's a nice girl," retorted Richie.

"You didn't get very far."

"Lay off, Potsie, will you?"

Finally, my mother called out, "Hey, kids, it's time to get ready for bed!"

I repeated the words in my head, *How far did you get?* I didn't understand the conversation on the TV. Where were they going? I thought they were talking about babysitting.

With the swift agility of a jackrabbit I bounded out of bed, eager to slip into the comfort of my beloved nightgown. The material was light green with white flowers, making me feel weightless. As I slipped on the sheer garment, which revealed glimpses of my skin, it evoked a feeling akin to a little princess in her ethereal attire. Then, I spun around, twirling towards the bathroom to brush my teeth, unaware that my oldest brother was staring at me.

PART ONE

C A L L M E
C H E L S E A

WHEATRIDGE, COLORADO 1988

Steffanie had recently celebrated her twenty-first birthday, so we could legally imbibe the real stuff. Since she was two years older than me, we had wine coolers to calm our nerves and make the evening more fun while driving on Colfax. My head swiveled from side to side, scanning for a car overflowing with boys, but Steffanie's light touch on the gas pedal momentarily distracted me. The vehicle throbbed as she expertly navigated the streets. Hot-pink hoop earrings dangled from her ears, matching the bright polish on her nails. I couldn't resist playing with my hoop earrings. We wore identical denim mini-skirts. Steffanie's tube top was crisp and white, so tight it held her together like a bandage. Her cleavage was on full display, and I couldn't help but look down at my flat chest with disappointment. I yearned for the padded bra I left at home, the one with the underwire that would have lifted my A cups into something more impressive. My self-pity vanished as we picked up speed.

"Woo-hoo! Yeah, baby!" Four guys in a white Ford Mustang hollered at us, their attentiveness fueling the butterflies swirling in my stomach. In those moments, I craved the thrill of being acknowledged, yearning for a connection that would sweep me off my feet. They sped through the intersection, abandoning us as Steffanie wisely applied the brakes when the light turned yellow. Dismayed, we watched them vanish into the distance. Remaining hopeful, we pulled up next to a cherry red Chevy Camaro. As Steffanie let the car inch forward, we slyly looked over, but we were greeted by judgmental stares from two women wearing more makeup than we were.

The late night rolled into early-morning hours—time to wrap up our unsuccessful night. Our efforts to connect with guys and secure phone numbers had come up empty. The Village Inn Pancake House sign, still illuminated, drew us in, our favorite way to end a night. Chatter and clinking dishes penetrated the air, and the lighting was warm. We always ordered the same thing: hash browns, extra crispy with melted cheese on top, and iced tea. Brushing past the signage telling us to "Seat yourselves," we found our preferred booth.

We declined the menus. The waitress asked, "The usual?"

We both stared out the window of the restaurant. The avenue was now deserted.

Although Steffanie and I had not known each other long, we'd bonded quickly, sensing a sisterhood. One day, I attended a picnic at my apartment complex and was relaxing by the pool. Steffanie sat alone on the side of a chair, sipping from a bottle of Bartles and James. I was unsure how she would react to me because of my reputation for being promiscuous. Women were not slow to judge me.

"Hey there," I said, sounding casual as I approached Steffanie.

She turned to me with a shy smile. "Hey!"

"Thought I'd relax for a bit," I replied, fidgeting with my towel.

Steffanie patted the empty spot next to her. "Well, you've come to the right place."

As we chatted, it felt like we had known each other forever. Our shared experiences and struggles instantly created a strong bond. We connected on a level beyond any judgments or categories society might stick us in.

"So, you live around here?" Steffanie asked, swirling the wine cooler in her hands.

"Yeah, just a couple of buildings down," I said, feeling more at ease.

Steffanie nodded. "Nice. I'm visiting some friends here, but don't live far away."

I popped the lid off a bottle of alcohol, and she asked, "So, do you work?"

"I'm a student at a local business college for court reporting. I have one more year to go."

I chuckled as I recounted the story of my mom kicking me out. I spoke in a high pitch, imitating my mom: "My house, my rules. If you are going to live here, you need to be honest about your whereabouts and be home before midnight. I can't sleep if I don't know where you are, if you will be home, or if you're alive or dead."

"Wow! Our stories are so similar! My mom kicked me out, too! I'm working at an auto parts store. Great place to meet men, ya know?"

"My mom agreed to give me the child support payment she receives from my father each month so I can pay rent while I'm in school. It's mostly women in the court reporting field, not men. Maybe I'll come to work with you!"

We soon discovered common interests that brought us closer. And even though I wore a tough girl exterior, I had longed for a friend like Steffanie—a female I could relate to. She dressed like me; she was boy-crazy, and we each had a partner in crime when we hit the bars. Steffanie was exactly the no-judgment, no-nonsense friend I needed in my life. She understood my savage spirit, craving male attention just as much as I did. We were no strangers to one-night stands and risky encounters. With Steffanie by my side, there was no need to hide or pretend.

Our fearlessness and desire for male recognition led us to cruise up and down Colfax Avenue every Friday and Saturday night.

"I can't believe we're at it again," I laughed as we hopped into the car one evening. Steffanie's eyes narrowed, and she smiled mischievously. "Why not? Searching for eye candy is always entertaining."

"And there's never a shortage of that here," I added, motioning towards the street.

We enjoyed the chase, hoping for glances and whistles from the guys in the muscle cars. No matter how fleeting, every little validation fed our

starved souls and made us feel better about ourselves. Men became a routine topic of discussion between us, and we cultivated a reciprocal understanding instead of judging each other. We shared our triumphs and regrets, offering encouragement without shame or disapproval. In Steffanie, I had finally found someone who saw past the surface and embraced me for who I was, allowing us to be our authentic selves without fear. Through good and bad times, we unconditionally supported and accepted each other.

At the diner that evening, the waitress passed a check across the table as if to say, "Don't bother me unless you need anything else."

I rummaged through my black faux leather purse, looking for its mate, a black wallet.

"Crap!"

I snagged my fingernail on one of the metal studs coming loose, swearing and muttering. "One day, I want to afford a designer handbag that doesn't turn into a nail-ravaging trap!" I put a twenty-dollar bill on the table and noticed Steffanie staring at her lap, obviously collecting her thoughts.

"What's up?" I asked. There was very little she could have said to make me think any less of her.

In a low tone, Steffanie said, "I'm behind on bills, in over my head. I'm tired of being constantly broke."

I waited, intuiting there was more.

"Please don't judge me, but I'm considering becoming a stripper."

Her words resonated briefly before I got a rush of empathy, surprise, and excitement.

I leaned close to her, leaning my chest over the table. She sat straight up and pushed herself into the back of the booth as though I'd intruded on her bubble.

My voice was soft, and I said, "I'm in. Let's do it! If you knew how often I've gone through the help wanted section of the paper and circled stripping ... I've just been too chicken!"

I remembered all the instances I danced in front of a mirror, desiring to be on stage. It excited me to think about performing as a stripper. But I also felt nervous and apprehensive about what the stripper life entailed.

She leaned in, resting her breasts on the table, and met me halfway, and like two kids whispering in a classroom, looking around, not wanting to be caught, we began a secret chat. We paused several times to assess if anyone was listening, making the exchange feel clandestine and exciting. We hatched a plan to contact the Bustop, a club in Boulder, Colorado's college town.

The next day, we called the Bustop to find out if they were hiring and what the requirements were. They told us, "You must be eighteen or older, and we will employ no one without an audition. No exceptions. Ask for Big Mike."

On the audition day, we tossed our highest heels and shortest skirts into a pink duffle bag which we threw into Steffanie's trunk. Although we'd sprayed our hair with enough Aquanet hairspray to last a week, the T-top remained closed to keep our hair and makeup intact. We flew down the highway accompanied with a Def Leppard cassette pounding from the radio—always Def Leppard, just a different track.

As we pulled into the club's parking lot, we drank shots of Peppermint Schnapps for courage. As the alcohol slid down my throat, a burning sensation warmed my insides, and I considered my surroundings. The Bustop was a nondescript brick building with a red awning over the main doors. No windows. Were we going to do this? We exchanged a reassuring thumbs-up and entered through the glass doors with the words "Bustop On Broadway, Topless" written on them. The lobby had a payphone on the wall to our right, and we made our way through another set of double-glass doors, plunging headfirst into the world of stripping.

It was dark, and the loud music drummed against my ears. A glass sign greeted us with the white outline of a woman wearing a bikini. She reminded

me of Marilyn Monroe as she sexily smiled at us, not knowing we weren't her target audience. She looked like an ice sculpture, spotlighted in a purplish-red light in the back of the glass. An enormous shadow of a man emerged. He must have been over six feet tall and weighed at least 250 pounds. Steffanie said, in a meek voice, "Big Mike?"

He was not warm and fuzzy, and his face was like a mask, showing no emotion, adding an air of mystery. He was there to keep the patrons and the dancers in line. A pale woman with bony legs, hollow eyes, and faded tattoos swayed on the stage—was that an indicator of what we would become? We sat at the end of the bar and filled out our applications.

Big Mike's gigantic frame loomed over us, and he placed his empty can of Diet Coke on the bar. He bent forward, his arms crossed over his massive torso, and his stern gaze pierced through us, magnified by the glasses perched on his nose. "Which one of you is Jane?" he demanded.

He explained that since I stated I was not yet twenty-one, I could strip down naked and dance in front of a room full of strangers, but I couldn't serve drinks. So between sets, I would clear ashtrays. Steffanie would be a cocktail server.

The barstool squeaked as though it felt relief when Big Mike stood. He tilted his head towards the end of the stage, much like a mob boss—that was our cue to follow him to the tiny DJ booth to choose our songs for the audition. Cassette tapes lined the shelves. The DJ's belt was cinched to the last hole to keep his jeans up. His long hair hung near the tip of a lit cigarette suspended from his mouth. The cigarette released a wisp of smoke that slowly swirled up to the dim ceiling light and floated above our heads. The nicotine made my eyes burn.

Steffanie went right for Def Leppard songs, always her favorite. I felt the DJ scan me from head to toe, and he pointed to a Debbie Gibson cassette, but I ignored him as I studied the Metallica and White Snake section. He'd misread me for my music preferences. Sensing fresh blood, he stood on his toes

and retrieved a cassette tape. He held the plastic box with both hands and as though offering a sacred gift held it out for me to see. "You can earn tips just by dancing to great tunes!"

He read song titles I wasn't familiar with. "The patrons, bikers, love this shit. "Hair of the Dog" by Nazareth? Ozzy Osborn, "Crazy Train"?

I slowly shook my head. Never heard of them. Big Mike was waiting impatiently outside of the DJ booth. His body language suggested he would rather be behind the bar, a man of few words, using his mass to direct and intimidate. When he glanced into the booth, I knew we'd run out of time.

As I stepped out of the tiny room, I turned and said. "Just play whatever you want."

The DJ grinned so wide his cigarette almost fell out of his mouth. I'd made a new friend. "Wait!" He waved his arms. "I need your stage name to introduce you!"

Flipping my hair over my shoulder, I called out, "Chelsea. Call me Chelsea."

S T A G E S

Big Mike led us past the bar and toward the head of the stage, where we saw three steps and a door. He motioned as if to say, "After you, ladies." But he would not be following us. "Kathy will show you the ropes."

No more time or opportunity to back out. Did he sense our angst?

I was nervous and excited as I entered the private area where the dancers prepared for their performances. It was like stepping into a different world, and I found myself captivated and slightly jealous of the balls of the women as they hit the stage in only a G-string.

On one side were plain white lockers, functional; on the other, a row of mirrors reflecting the images of a group of half-naked women. Among them stood Kathy, whose age seemed to be etched in the lines of her face, adding a rugged charm to her presence. Her body was covered in old-school style tattoos featuring roses and hearts in vivid colors that told stories of her journey. Though her exterior might have been unpolished, a sense of wisdom emanated. She had infectious laughter and a husky voice hinting at her many nightlife adventures.

As we studied Kathy, she was more than just a performer—she was a mentor, a mother hen to the younger dancers, guiding them with a protective yet encouraging hand.

As she applied more lipstick, she glanced at us. "You girls have G-strings?" We nodded. *Thank God we had our G-strings.* Something tells me she would've let us borrow her G-string if we'd asked. The matching lingerie from Victoria's Secret made us braver and ready for the new escapade.

Kathy showed us the lockers and introduced us to the other dancers, making us feel at home. While chatting with the other girls, Kathy willingly

shared her experiences and insights. Her openness made me comfortable enough to dig deeper into my motivations for being here—beyond the thrill of trying something unfamiliar was an underlying desire to explore my sensuality on my terms.

The mic blasted out our introduction. "Well, gentlemen, you're in luck this evening. We have a tryout! Welcome, Chelsea!"

And like a cattle auctioneer, the DJ rolled the words off his tongue as he slurred, "Chelsea, come on out!"

Shit. Too late to turn back now. The music for my set began. Nazareth's heavy metal song came alive with relentless drumming and guitar solos. I stepped forward onto the stage. It was long and thin, like a runway for models, with an oval circle at the end and a shiny bronze stripper pole to my left. *Oh, God! What do I do with a pole? Should I try it? I mean, what could go wrong?*

Did I consume enough booze to get through this?

What if I trip in these high heels and land flat on my face?

The world around me changed as I continued to shuffle on the stage. The adrenaline rush was palpable. As I undressed, a potent swell of passion flowed through me. I was strong and free.

Hot lights struck down on my skin, causing beads of sweat to form and trickle down my spine. I smelled a mix of cigarette smoke and beer from the men at the front. My eyes locked in their hungry gaze. As the dollar bills slid into my G-string, I felt validated and proud of my body and appearance. The worry of rejection faded away and I was consumed by the moment. A hypnotic beat coaxed me on. I was the celebrity, the focus of attention. I reveled in it.

I ran my fingers through my hair and threw my head back, feeling anger rise inside me along with a wild resolve to take control. With my eyes closed, I moved with the music, letting it guide me. My heart pounded in my chest.

The combination of anxiety and excitement churned within me, a storm of emotions that threatened to engulf me.

The cool metal pole against my palm reassured me amid the chaos. The screeching of the electric guitar carried me, and I let it lead my movements, my body reacting instinctively to the intoxicating rhythm. With each step I took from the pole, I was liberated, leaving behind the shy adolescent hiding inside me for too long.

My skin tingled as the cheers and whistles of the audience urged me to push my boundaries further. The stage and the patrons blended, the noise of the crowd overcome by the pulse of my heartbeat, pushing me on. Everything around me faded, and I embraced the paradox of vulnerability and empowerment as each twist and turn became a dance step of self-discovery.

I was hooked. I relished the high, like a line of cocaine. And I craved more—I needed the constant tingly energy circulating in my body and the intensity of cold goosebumps on my skin. The panic that had gripped me had transformed into a fierce sense of ownership, an acceptance of the potential I held at this moment.

I realized this audition was more than just a chance to impress; it was a passage into the depths of my desires and the liberation of my identity. I found my place in this unpredictable world as Chelsea, a woman who defies conventions and owns her truth. As I strode off the stage, my heart raced with the realization I had exposed myself in a way I never had before, both physically and emotionally.

Afterward, we were thrilled to learn we were hired and put on the schedule for the next day. I had entered the club cloaked with fear I wasn't attractive enough, but I walked out that night feeling like a sex symbol. The stage drew me in like a drug. I was invincible. Three songs, rowdy clientele with cash to burn, and one audition. That's all it took.

After several months of working at the Bustop, I had my act worked out. I looked virtuous for the first song, then transitioned and became as naughty as I wanted. There was no secret as to how to earn tips.

Arrogance came over me as I evolved from prey to predator. My authority had been solidified, drawing men in, manipulating them with my body, and getting them to hand over dollar bills. I had been a stripper in the making for years, using my body to gain a man's admiration, but now I was making money doing it.

Over the next few months, I had more confidence and learned how to make small talk with the guys who rode in on Harley-Davidsons wearing leather vests, and I tamed the rowdy college students with the sway of my hips.

I found my superpower.

But it wasn't enough. As the months passed, I was tired of performing for the broke college students and the hour-long commute. The clientele kept telling Steffanie and me we should try Shotgun Willies. One told me, "You have the business executives, and you can earn extra money from lap dances."

"What are lap dances?"

Billy, a club regular, gaped at me like I had two heads and withheld the dollar bill he was about to give me for cleaning out his ashtray for the tenth time that night. He tapped the ashes off the end of his cigar. "Girl! Maybe you are too damn innocent for that place. A lap dance is where you go into a dark corner, and the dude pays you additional for one-on-one time."

"Wait. What? I'm not into that." I thought he was talking about sex with guys for money.

"Good Lord, girl! It's just a private dance. No funny business, or those bouncers will be all over his ass."

Spending almost every hour together over the last six months, Steffanie and I had become best friends—and roommates. We moved to the other side

of town, Aurora, near all the bars. Stripping had taken priority over school. I'd dropped out. Not a big deal. Court reporting, the idea I had for a career, could wait.

Our new two-bedroom, two-story apartment had only one bathroom, where we set the tone for our shenanigans, smearing our faces with makeup. Steffanie bent towards the mirror to have a closer inspection of her lashes. I slithered into a skin-tight black miniskirt jumper with a hot-pink tank top that matched my nails.

As I dug in my closet looking for my patent leather thigh-high boots, Steffanie turned around and asked, "What do you think?"

"You are stunning, Steffanie," I said, grinning at her. "That outfit suits you perfectly."

Steffanie picked up her purse and rechecked her reflection, saying, "By the way, I bought that new lipstick shade I told you about. Try it! It'll match your nails!"

"Ooh, yes! Let's see it."

Steffanie had an above-suspicion air about her, reminiscent of Daisy Duke. Her tanned skin glowed against the white lace blouse she wore. Her muscular, toned legs resembled the stems of a beautiful flower as they gracefully slipped into her white pumps—the result of hours spent dancing in heels. I couldn't help but purse my lips together and blow her a kiss in approval.

Shotgun Willies was the big league of stripping in a trendier area of Denver on Colorado Boulevard. The structure was massive and seemed to dwarf everything around it. Red spotlights were shining onto the building—blazing red. We were intrigued and intimidated as we approached the grand mahogany doors. A sense of unease crept over me. Compared to the Bustop, this was a foreign world. Steffanie didn't pick up on my jitters, her excitement bubbling over as she raised her arm to high-five me, exclaiming, "We're killin' it! We've arrived!" She was enthusiastic, but I was still uncertain.

Two male bouncers doused in cheap cologne and dressed in black tuxedos adorned with red bowties and suspenders greeted us with leering smiles. My hands trembled as we lied and said we were there to talk to the manager about an audition. They were delighted to let two women enter the club, fresh meat, into the slippery slope of darkness.

"No problem. Go to the bar and ask for Barry."

The floor vibrated underneath my feet from the bass pounding as Tone Loc rapped Wild Thing. Laughter and squeals rose above the music. I scanned the bar, distracted by flashy neon lights advertising drinks and the busy scene of men in fancy suits exchanging business cards with women hovering nearby. As the song faded, the DJ announced, "Lookin' good! Don't stop. Let's keep it goin' again, and then we'll transition to the night crew."

Steffanie and I went to the bar without intending to look for Barry. Men parted like the Red Sea, creating a path for us, and two bar stools opened up. Women in the audience always created a buzz. Were they lesbians or dancers? Were they looking to hook up? These men were primed and ready to mingle like they were in a singles bar—drink in one hand, cheeks flushed, and sly grins.

"Hey ladies," one of them called out, raising his glass in a half-hearted toast. "Can we buy you a cocktail?"

Steffanie, always the outgoing one, flashed them a smile. "Yeah, it's our first time here. We thought we'd check out the scene."

Another man, wearing a sleek suit and mischievous smirk, said, "You two dancers?"

I hesitated, not entirely comfortable with the attentiveness, but Steffanie responded, "You could say that. We're here to figure out what this place has to offer."

A guy in his late fifties intercepted me before I could follow Steffanie to the bar. His skin was tanned and gray chest hairs sprang from his open-neck white dress shirt. Thick gold chains were looped around his neck. His

black hair was dyed. He squinted and tilted his head. "I'm Barry. I understand you're here for an audition". He was speaking to me and ignoring Steffanie, my wingwoman.

I took a step back. "Umm, yeah. We wanted to check the place out."

"What kind of experience do you have? You've got the looks and the bod ..." He scanned me from head to toe as though he were making a high-priced investment in a sports car. I felt desirable and attractive, but a familiar suspicion of objectification washed over me. It was a sensation I had grown accustomed to. Steffanie spun her barstool around and began a discussion with two guys standing nearby. Both were wearing wedding bands.

"Come back tomorrow morning at ten-thirty sharp. Give the day shift a shot. But for now, hang out for a bit. Feel the vibe."

Barry snapped his fingers, and the bartender stared in our direction as though he was on call. "Joe, take care of these two. The first drink is on the house."

Did he say the "day shift"? As if! I'd been working the night shift at the Bustop. I wasn't interested in being downgraded to the day shift! But I quickly grasped the reality of Shotgun Willies when the late-shift dancers entered the club. Everyone turned to inspect the merchandise.

The women brushed past me with their gigantic makeup bags, expensive clothes, and heels in hand. They stole the attention of the day shift girl on stage (the one with tired feet and multiple layers of hairspray and wilting makeup from her eight-hour day). The moneymakers had appeared. Leaning against the bar, I felt like the warmup band at a concert where no one knows your name or cares. You were just there to fill the time until the real enter-tainment came.

Something shifted in my body. Standing near them, I felt their power. That's who I wanted to be! *What is it they have that I don't?*

I watched the DJ introduce Barbie, and she sashayed across the stage. Her silicone breasts were perky, exploding from the white halter bra that

complemented her gleaming thigh-high white boots. She had an orangey fake tan and long flowing blonde hair with the perfect waves that glowed in the blue light. She looked like a living Barbie doll as she strutted along the edge of the stage, cheering, waving her arms to excite the crowd, to lead them. Salt-N-Pepa's "Push It" played in the background. Dollar bills, and five- and ten-dollar bills, rained down on her like confetti, and a pang of envy and inadequacy shot through me. This was like being on a stripper movie set.

As I kept watching Barbie, I heard the familiar voice: *I'm not worthy. I can never measure up. I wish I could be like Barbie.* The allure of stardom and glamor that had drawn me to the club disappeared, and I felt small and insecure.

S L O W L Y
D Y I N G I N S I D E

When Steffanie and I showed up to apply for the job at Shotgun Willies the next day, we didn't have to audition because of prior "dance" experience. Barry told Steffanie she was not a good fit for the club right now but to come back another time. While disappointing for both of us, the club had a particular atmosphere that may have yet to match Steffanie's unique style. That left me to navigate the club alone, and I questioned my ability and worth. *Would I be able to cut it?*

As I settled into my new routine, I learned many day staff were single moms or young, married women who preferred to be home in the evenings. They were approachable even though they required more maintenance than the Bustop girls (prettier and slimmer). They were nice enough but distant. They half-smiled and kept eye contact to a minimum. We'd all built protective walls around ourselves and kept one another at a distance.

But I missed Steffanie, my sidekick. At the Bustop, while some days were more challenging than others, we found commiseration in each other's company when the tips were not pouring in as expected. On one particular day, when neither of us was making much in tips, we shared a knowing look that reassured me it wasn't just me facing the challenge.

Laughter and inside jokes helped Steffanie and me stay positive during tough days at work. Beyond the glitz and glamor, Steffanie was someone I confided in. We talked about our dreams, aspirations, and even the patrons— discussing the charming ones who left generous tips and the ones to look out for. She had an uncanny ability to uplift my spirits when I was down or

overwhelmed by the demands of our job. We were like a dynamic duo supporting each other through the highs and lows of our profession.

I missed the more innocent days at the Bustop and longed for Kathy, the mother hen. She always wore bright red lipstick, thick eyeliner, and red rhinestone pasties with tassels to match. She had those tassels swinging in circles like hula hoops. In her mid-thirties, I considered her old for stripping. You'd think fresh, youthful faces coming into her territory would have threatened her, but she just smiled when Steffanie and I had staggered in six months ago.

I remember Kathy putting it into perspective to help us relax on that first day. "This is not a big deal. You get naked every day, don't you? If you don't forget to take your top off and smile, you will make tips and land the job. But your audition doesn't count if you don't take your top off." She laughed because we were nervous.

But in this unfamiliar territory, my initial nervousness had turned into a disturbing numbness. While the earnings at Willies might have been more promising, I soon discovered a simple smile and baring my chest carried little weight. The patrons wanted your crotch in their face, envisioning what they would do to you. They demanded more, wanting to objectify and demean us further. It wasn't just about the tips anymore; we degraded ourselves for their gratification. The essence of our humanity was stripped away and replaced by a transactional exchange. The sense of being misunderstood and reduced to my physical appearance weighed on my psyche, smothered me. No one cared about who I was or what I aspired to be.

As I earned each dollar, I became increasingly detached. Mentally checking out was my coping mechanism, helping me navigate through the frustration and disillusionment I was feeling. The men I danced for always demanded more, as if it were a game to see how far they could push me. "Is that all I get?" they would ask or pull the money away until I worked harder. I perceived them as power-hungry individuals who enjoyed exerting control

over a desperate dancer. Perhaps they were inadequate in their own lives or were powerless at work and saw themselves as inferior to their bosses, so they took out their insecurities on the dancers. They dressed impeccably in custom-made suits, which they used to lure you over, but you were never sure what you were getting into. Some were generous tippers, while others believed they were "the shit," ensured you knew it, and refused to tip. They would regularly sit at the stage, picking a front-row seat and gawking at us, occasionally tossing a twenty-dollar bill to keep us on our toes. Just business to them. I sensed their eyes on me, judging and evaluating but showing no appreciation for the effort we put into our performances. These experiences planted seeds of hatred and bitterness within me.

It pissed me off, and I stared them down with a steely gaze, daring them to challenge me. As I continued working at the club, I despised most of the men who came in. Their entitlement and lack of respect for the dancers only fueled my anger and resentment, but I had power over them.

At Willies, for several months I'd been perfecting my bumping and grinding, all to measure my self-worth by the amount of money I brought in. But as I stepped onto the stage for my final set of the day, something shifted inside me. A veil had been lifted, and I discovered what the club was.

It was no accident whoever designed the club had filled it with sexual cues. Each item was invented to titillate and arouse, from the red lighting to the suggestive artwork. But as I looked around, everything was sucked out of me, drained away in a vortex of greed and lust.

The color red, which had once been alluring and sexy, now resembled the war being waged in my core, a bloody battle I was losing. The power and confidence I used to feel on stage were slipping away, substituted by a sense of sadness and despair, and I struggled to hold back tears.

Red velvet tufted sofas were tucked into dark corners. The buttons on the furniture created soft, geometric patterns that took after a woman's curves. The armrests scrolled tighter and tighter into delicate loops that once

reminded me of lollipops when stripping was fun. But now, after months in the club, they looked like vipers coiled and ready to strike.

As the music started, I felt nothing—completely emotionless. I was too deadened to be angry. Who was there to direct my rage towards anyway? Myself? The clients? I vaguely recalled experiencing a surge of anger in the past, but I had suppressed it so deeply I couldn't recognize it anymore. That was precisely the plan: to avoid feeling weak or sad and maintain mastery.

I removed my last item of protective clothing, leaving me with only a tiny G-string. I tossed my turquoise and black satin blanket onto the stage as I prepared for my finale, an erotic floor show. A businessman took a seat in front of me. His body language told me he was one of the cool kids. He leaned back, crossed his legs, and cupped his chin into his hand, elbow resting on the arm of the sofa. He stretched his other arm across the back of the couch. I might have appeared naïve to a bystander, but when I was on the stage above the men, peering down at them, I soaked up every nuanced look. I could read the patrons like a book.

This client looked like the typical unhappily married guy who was looking for a brief escape from whatever had made him not want to go home. *What I do harms no one. There's no contact. The only exchange is a smile, a naughty bump, and a grind six inches apart—a real six inches—and I get a few dollar bills.* He returned to his drink, swished the ice cubes, and downed his last swig before he headed home to his wife and kids. *If he hustles, he'll be home for the kids' bedtime stories and his wife won't notice he's a little late. He gets a thrill, and I make a couple of bucks.*

My limbs felt heavy, like I was taking up too much space. Boundaries became blurry, and I was no longer a girl on the stage. I blended into the backdrop, not knowing where I began or ended. But I kept moving my body seductively. The music and my body were connected, but the rest of me was lost. I pushed aside the nagging discontent and frustration, convincing myself I could rise above it.

The silvery-haired guy hanging near the stage during my entire set dragged out a five-dollar bill. Finally, but he kept two fingers on its corners, signaling my work was not done. I ground my pelvis as though I were fucking an invisible dick. My mind disappeared again, traveling as if I were in a vacuum, devoid of sensations or emotions—a place that was easy to reach— I'd had years of experience doing it. I clutched my silky floor show blanket by its tips, pulled it between my legs, tilted my head from side to side, and leaned back. I raised my hips and brought my hands to my thigh, persuading him to take his fingers off the five-dollar bill. He paused as though it were a hundred-dollar bill. I slunk away as fluidly as a cat sneaking up on its prey while pushing the burning sensation of humiliation past my throat and into my heart.

I scanned the stage, but no new customers had been seated, so I settled in to finish my set. I turned my head and tossed my hair back, trying to look confident and seductive as I slowly undulated. I clenched my teeth, holding back tears. I closed my eyes and tried to escape somewhere else.

As the loud beat of the music pulsated through the club, the DJ's voice sliced through the haze, momentarily jerking me back to reality. "Give the ladies a hand, gentlemen. And remember, if you have a favorite dancer, grab a private lap dance from her."

I hurriedly picked up my clothes and cash, attempting to hide I was naked in a room full of strangers. As I moved down from the stage, the applause faded, no longer drowning out the patrons' usual spate of comments. "Ah, she's alright, but not my type. Nice boobs, but I like 'em a little bigger."

As my eyes adjusted to the stage lights, I made out the shadowy figure in front of me. The man's glasses reflected the light, revealing his identity: Biz, one of my regular customers. I was relieved to see him since I knew he would tip me generously, but it came at a price. Biz was my biggest spender, but only if I played by his rules: spending all my time with him as he taunted me with twenty- and fifty-dollar bills. He needed to assert his power in this

male-dominated space. I cringed. He was massive, and how he licked his lips after a sip of beer made him more repulsive.

Never quite knowing what to say, we limited our communications. *What does a twenty-year-old ask a forty-something married man she is not interested in? He is in command and possessive. If another client tries to gain my attention, he slowly withdraws the twenty-dollar bill sitting on the corner of the table, signaling to me I better stay by his side. I suppose he thinks he is in command if I linger and chat with him. When I talk to other patrons or give them lap dances, he throws me a look as if to say, "If you don't want to lose me as your biggest tipper, you had best end your conversation with him and start your way over here."*

I had turned my will over to him easily. He was one of my first regulars early on. But after all these months, he still demanded so much of my time. *Did he sense my inability to say no?* I would avoid eye contact with other patrons when he was around. Wasn't that little insecure girl just being careful, not wanting to hurt his feelings? He stared at me, commanding me to head downstairs and freshen up before I returned promptly to him.

Ours was a puzzling relationship. He protected me in his way, as large and imposing as he was. His jealousy made it easy for me to avoid interacting with other men. At least with Biz, I could predict what I was dealing with, even if it wasn't always pleasant. Despite his flaws, there were moments when Biz showed genuine concern. One evening, as I finished my performance, Biz called me to his table. "Hey, sweetheart," he said in his deep voice. "You were amazing up there."

I managed a small smile. "Thanks, Biz. I'm glad you enjoyed it."

He reached into his pocket and pulled out a wad of cash. "I want you to have this," he said, pressing the money into my hand. "It's not just for the great show you put on tonight. I was hoping you could use it to go back to school. You're too innocent to be stuck here for a lifetime."

His sincerity took me aback. "Biz, I ... I don't know what to say."

"Say you'll consider it," he replied, his intense gaze softening slightly. "I know this scene isn't where you want to be forever. You deserve better, and education can open doors for you. Just think about it, okay?"

I nodded, feeling a blend of gratitude and surprise. Biz seemed to genuinely care about my future. There may have been more to him than met the eye. But I couldn't deny his possessiveness sometimes bordered on overbearing, making it hard for me to breathe. *How the hell did I end up in this place?*

I continued to grip my clothing and dollar bills in a tight ball, thinking about how I would spend the next hour in Biz's clutches, and I headed down to the basement, a dirty vault lined with lockers and dingy carpet. I stashed my earnings into my locker, careful not to let others see my lock's combination. Jewelry and twenty-dollar bills had gone missing in the past. I studied myself in the dressing room mirror, freshened up my makeup, and climbed the stairs for my obligatory kiss-ass session with Biz, my stomach in a knot.

As I approached our "usual table," the standard twenty-dollar bill, folded in a teepee position, was on the edge of his side, so he kept jurisdiction over it. We began discussions where we left off last week.

"So, I will have a car pick you up on Friday afternoon at five sharp."

I nodded, knowing this was not a good idea. But I owed him. He had given me so much money over the preceding few months. Besides, we had set the parameters. It would be just a lap dance in the nude at a hotel. Not sex. What could go wrong? I told him I would be there and got up, trying to act like nothing mattered.

CHAPTER 4

R E V O L V I N G
D O O R S

Regardless of wanting to deny what was in store for me, Friday evening arrived. The commitment had been made—no easy way to say no or cancel the date with Biz. I didn't know how to call it off or say no, and I still felt obligated. Standing on the curb, I smoothed my skirt and ran my fingers through my hair again as I watched the limousine enter the cramped parking lot. Biz hadn't asked for my address, only the cross streets. It was better that way—no one would spot me heading out on a "date" with him. Hiding behind dark designer sunglasses, I glanced around and hesitated as he beckoned me into the limousine. Time slowed as I paused, torn between the comfort of familiarity and the allure of those tinted windows.

Biz was wearing a black tuxedo. The fabric appeared more expensive than what the DJs and bouncers wore at the club. His white shirt was pressed flat against his bulging torso. It had been thickly starched. The driver peered in the rearview mirror, checking me out. Biz handed me a glass of champagne, and the clink of glasses filled the air as they touched in a toast. Sipping the fizzy bubbles, they tickled the inside of my mouth, and the overpowering scent of Biz's cologne almost made me sick.

Biz leaned towards me. The seat made a crunching noise under his weight, and his double chin wobbled. "How about another glass of bubbly?"

The hotel was only five minutes from my apartment. Convenient. I wondered if the limo was a perk of his profession. I didn't know. I didn't know what Biz did for a living. I didn't care. I didn't care what his wife was doing either. It could be Biz wasn't married, yet a conspicuous wedding band encircled his ring finger.

The limousine pulled into the entrance of the hotel. Men in uniforms with gold buttons down the front raced to greet us—they reminded me of the theatrically dressed royal guards I had seen in movies.

As I stretched my leg out onto the shiny tiles, one of the uniformed door-men took hold of my right hand to assist me. As I inspected the hotel, the massive bronze revolving doors looked ready to capture their victims, spin them around, disorient them, and toss them out the other side—a different world.

It was abrupt, a punch in my gut, like trying to catch my breath after the wind had been knocked out of me. The cool night air against my skin as I exited the limousine contrasted with the warmth and stuffiness inside the car. My fingertips tingled. Pins and needles crawled up my arms like they were being eaten. As I stepped out, I knew I would not leave the hotel as the same woman I went in.

As Biz slid his credit card across the counter, he was reticent. I couldn't help but notice a subtle shift in his demeanor, a hint of unease. I wondered what was on his mind.

We each carried a small overnight duffle bag. I'd carefully selected my lap dance outfit, a change of clothes, and my favorite light pink boom box with the cassette player cued up and ready to go. The bellboy grabbed our duffle bags and we followed him through the corridor to the room. *What if he tries something more than a nude performance? Jane, seriously? Now you're considering all the ways you could bite the dust?* The image of Biz on top of me made me gag, and a fiery sensation of bile rose in my throat.

We had discussed this situation. Biz said firmly, his voice tinged with longing. "You and me, all to ourselves. No other patrons threatening to divert you, no bouncers watching my every move."

Being exclusively his appealed to a part of me that craved a sense of belonging. But he smothered me with his possessiveness. As I forced the

bile down, Biz turned to thank the bellman. As we entered the suite, Biz hung back, glancing around as if checking for any prying eyes. There was something different about him. My heart pounded, my feet itching to escape down the hall, but the sound of the door lock clicking shut stopped me dead in my tracks. At that instant, I realized I was not just a dancer to Biz; I was something more he wanted to possess entirely.

He avoided my gaze, focusing on anything but me. Attempting to lighten the mood, I asked, "Is everything okay, Biz?"

He looked up for a second. "Yeah, it's just ... complicated."

I understood our connection was far from conventional, and I had come to terms with my choices. But seeing Biz grapple with the consequences of our encounter made me realize that he was in this tangled web too.

"I never wanted to hurt anyone," he confessed. "Especially not my wife. But I can't seem to stay away from you."

I didn't know what to say. I saw the man behind the plump, repulsive visage for a moment. Beyond the desire and demands, I caught sight of a man who was conflicted, a man who, despite his flaws, had a conscience that tugged at him. And in some inexplicable way, his struggle with guilt and remorse made him feel more human, more relatable.

We spoke briefly, nervously, about where to move the chair. Draperies open or closed? Now he did not take his eyes off me, so I examined the floor around the small room until he motioned toward the bathroom. Why did it matter where I changed clothes? I would be undressed in front of him in a few minutes. But it mattered. It allowed me a moment to put on my uniform, to disengage mentally if not emotionally. I switched into my outfit in the bathroom—a hot-pink Spandex dress—one he had not seen, but I knew he would appreciate it based on his former criticisms of previous attire. I always had to satisfy the client.

My new dress had a thick black zipper running down the center, an appropriate accent for manipulation. Like a kitten at play, men fixed on the

zipper and prepared to pounce just as the zipper eased upward. I had learned to entertain with zippers, unzip one notch, down half an inch, back up two inches. It was like my life: two steps forward, one step back.

I stuffed my breasts into a black lacy Victoria's Secret push-up bra, producing what cleavage I could, and glided into thigh-high lace stockings and leather high-heel pumps. After I brushed my teeth and reapplied a red-colored lipstick, I performed one last adjustment; I pressed my skirt down and pulled my small breasts up from the bra—much like a bodybuilder priming a muscle before a show.

When I re-entered the room, the king-size bed to my right was insignificant compared to the large and gross shadow of Biz. The draperies were drawn, and the lamplight was excessive, brighter than the club lights. I was more exposed, like he might see into my eyes and detect the disgust. I wished for another glass of champagne or a shot of Tequila. Biz had moved a chair to be front and center. He sat in anticipation, practically licking his lips, as though expecting to be presented with a Thanksgiving feast, missing only a napkin tucked under his chin. His legs oozed through the armholes of the armchair, and his belly fat lay atop the handles. He was nastier than I recalled. Or possibly it was the light and odor that made him more obscene.

My surroundings collapsed in on me. I was a caged animal with Biz eyeballing me, fooling with me. At least in the club, I could read him better as he would pull out the twenty-dollar bills. But there was no cash in this hotel room, not until the dance was done. I envisioned him devouring me but couldn't predict when he would leap. Having already suited up like Robert Downey Jr. in *Iron Man*, I vacated my body, cloaking myself in an invisible metal cocoon. But I was no superhero. Superheroes save the world. I needed to be saved from myself.

On lockdown, I started my ritual lap dance—business as usual. The tension in my neck spread into my chest, and I couldn't breathe. Wishing I had a jetpack to take me to the sky, my head abandoned my shoulders and

journeyed to the clouds. I glazed over, feigning to peer into his eyes but staring through him, another skill I had mastered. He tried to penetrate my eyes; I averted his ogle by rocking and fluttering my hips and thrusting my breasts into his face, cutting his eyes out, scanning the horizon instead of acknowledging his presence. I moved to the music of the boom box.

He touched my waist to shift my body away from him enough that he could reach his hands to his crotch and rub himself. I barely reacted. I had escaped my frame. His erection came to life and surged against the zipper. He unzipped his pants and yanked his penis out. My mind froze, but my body gyrated. I shifted to face the opposite angle, a plain white wall with cheap art. I hadn't considered he would do that. Silly little girl. He inhaled deeply, and I sensed a familiar movement of his palms on his erect penis. He instructed me to turn around. I obeyed. He was a paying customer. But an air of resentment was developing in me. I couldn't watch what he was doing but recognized his icy stare.

"Take it off."

I removed my G-string.

"Now bend over."

I became light-headed, my mouth was dry, and my vision was blurry. I was nauseous—what if he jumped from his chair, bent me over, and thrust himself inside me? With my rear to him, I arched over, and the sliver of material fell down my thighs and bared my naked body to him.

Where did I take the wrong turn? Ever since I was a little girl, I had longed to be on stage, dancing, and captivating an audience. I loved playing records in the family room and twirling my baton. I never imagined my audience would be reduced to a single man with his pants down to his knees.

Slapping and moaning sounds jilted me off my childhood stage.

I stared just above his head. Although my exterior continued to move to the rhythm of the music, my insides stopped dead. He sighed as he concluded. I lingered, hips rolling and pulsating as the music died away, uncertain

of what else to do. Uncomfortable, like missing the cue at the club when the emcee announces the set is over. I wanted to retreat. He broke the silence.

"Pass me a towel."

I walked to the bathroom and snatched a white washcloth. Not wanting to make eye contact, I kept my eyes down. His ankles were casually crossed like he was at an ordinary business meeting. He threw his hands up, forcing me to look up and meet his furrowed brow. "A bath towel. This is not sufficient."

I shuffled back to the bathroom and grabbed the oversized towel. A picture flashed before my eyes. Transported as though I were observing a movie, not in my body, I visualized two children on the other side of the revolving door in my mind. I despised them. If only they would leave me alone. A little girl and a young boy. The young boy masturbated. The little girl was lying on the floor, looking up. She floated to the ceiling.

Biz was louder this time. "Are you bringing me a towel or do I have to get it myself?"

Gone were the champagne and limousine. Now I was retrieving a towel for him to wipe up his cum. I had turned into the hunted, not the hunter, the one in control.

Biz paraded me through the main entryway. My heart palpitated as my body spit through the revolving door. As I suspected, I was not the same person I was when I came in. I knew going through those doors something would not be right, something would happen, but I didn't consider the mind fuck. As he opened the door to the limo, he said, "See you at the club." He then headed back into the hotel. I climbed into the limo and quietly rode back to my apartment. What just happened in that hotel room?

As I stared at the back of the driver's neck, I thought back to a few months ago when the little boy in my recurring snapshot—my oldest brother, now a grown man—had returned home from a stint in the army accompanied

by his wife and newborn child. While his wife attended to the child in another room, I sat on a couch and waited. The grown man squatted on the floor in awkward stillness. He scrutinized me. "I'm sorry for what I did to you when you were younger."

I stopped breathing. *What did he do to me when I was younger?* But suddenly, I remembered, and I slumped, trying to shrink as if to be unseen. With interlocked hands, I responded, "No, it's okay. I participated."

His wife came back to the room and brought me the tiny bundle. As I cradled the baby in my arms, I accepted the information he had delivered and crammed it into a box in my soul, sealing it up for good. It's better in there, neither seen nor heard. I mean, it's not like he hurt me. And I love my brother. He apologized.

I can't be that fucked up from it, can I? It wasn't a big deal, was it?

I popped out of the limo. There I was, back on the curb. As I went into the apartment, Steffanie greeted me. "How'd it go?"

I pursed my lips together, and a thin line of displeasure appeared. "Easy money!" I lied.

Something inside me was not right, and someone deep in my inner parts wanted out. I felt dirty and ashamed. *Why did I do this to myself?* I hated how he looked at me like I was just an object for his pleasure. But wasn't that what I had offered? Was I worth anything more than that? I told myself I still had a handle on things, and what had happened would pass, as all things do.

T O U G H G I R L

Steffanie parked the car in the short-term parking lot, and we walked towards the glass doors, where red letters flashed Emergency Room. My heart sank. Revolving doors—again. I dreaded going through revolving doors since that fateful day with Biz a month ago. The experience profoundly changed me. I wanted to get in and out of there as quickly as possible.

"How can we help you?" asked the nurse at the desk without looking up.

I giggled and showed her my bloody right pointer finger. "Um, I was in a bar fight and some bitch bit my finger."

Peering over her reading glasses, she said, "It's not funny. Human bites are extremely infectious, and you could lose your finger."

"Oh." The bouncer was legit. He had told me to go directly to the ER.

She shoved a pen and clipboard in my direction. "Take a seat. Fill out this paperwork. We have a gunshot wound ahead of you. It may be a while." You could almost hear her roll her eyes.

Steffanie and I sat together in the corner of the busy ER, the harsh fluorescent lights overhead casting a clinical glow across the room. Feeling guilty and trembling, I couldn't meet Steffanie's gaze as I recounted the night's events. Since Biz, I had been simmering with frustration. Frustration at slow drivers, at slow service, at everything and anything that didn't go my way. But the slightest provocation sent me spiraling into a rage. My heart pounded in my chest, my pulse racing as red-hot anger burned through my veins. I had not been this out of control since I was a child. My mom used to tell me I must have inherited my temper from my father's side of the family. It had been building for years, like a volcano ready to erupt. And now it was boiling over inside me, the anger too intense to keep a sweet exterior.

But why did I feel this overwhelming sense of rage threatening to consume me from the inside out?

These days, I was looking for an excuse to slap anyone, even a patron. It had been two weeks since the arm of a stranger reached out and snapped my G-string. I spun around and slapped him, experiencing pleasure as my hand contacted his cheek.

Exhilarating.

Unfortunately, that move put me on probation at the club—no shifts for a month. But Steffanie and I were working on a better plan: Iowa. While I was stripping at Shotgun Willies, Steffanie served drinks at a local bar. She met some older strippers who did roadshows. We were both restless, and I was on probation, so when she heard about an opportunity to hit the road and get some bookings by the week in Iowa, we thought, *Why not?*

Steffanie told me the details as we waited in the hospital waiting room. She explained. "You send the bar a picture, they book you for a week, and they pay you one thousand a week, plus tips!"

It sounded perfect. Of course, we had to pay for our hotel and food for the week, but it was still an enticing deal.

Steffanie continued, "The girls said the farmers are super horny because they have little to look at and they have money to throw around."

I was looking for freedom from being tied down to the typical schedule and the regular clients. And I missed having Steffanie by my side, so we decided to head off to Iowa—assuming I didn't have to have my finger amputated.

The hospital smelled like Lysol and alcohol. "Come with me," said the nurse as she peeked at her notes. Painful pins and needles rushed into my hand as I rose, now swollen like a baseball glove. Steffanie gave me a sympathetic glance. She wasn't allowed to come with me.

"Have a seat. The doc will be with you as soon as he can. In the meantime, I'm going to start this I.V."

Crunchy white paper cracked under my skin and attached to my bare legs when I hopped onto the bed. I yawned, proof my alcohol buzz had long since worn off. I just wanted to go home and call it a day, but I didn't want my finger to fall off.

"I will be back to check on you," she said matter-of-factly. She swiped the light curtain behind her. The metal hooks scraped the track, the acoustics of an emergency room at midnight.

Oh, yay, Miss Bright and Cheery will return. Can't wait.

Settling onto the pillow, I closed my eyes. "Beep, beep. Dr. Hawkins, please report to the front desk. Beep, beep." I just wanted to sleep, people. Maybe if I chilled out, I wouldn't find myself in the ER, but it seemed like trouble stuck to me. This evening's trouble started when we went to Thirsty's, our back-up bar. A girl began insulting me and causing a scene by calling me names when she caught her dude checking me out. She didn't like it when I threw a pitcher of beer at her. It was a split-second decision. But in that pivotal moment, the beer-drenched woman lunged towards me with an unhinged fury, sinking her teeth into my finger. The throbbing was unbearable, shocking my senses to their core. *Who does that?!* I grabbed a handful of her hair and held on until we were pulled off one another. I lay there on the gurney, giggling at the absurdity of it all.

I heard the nurse assistant speaking as he wheeled a hospital bed next to me, interrupting my thoughts. "Nurse Reese will set you up with a catheter." *Was Miss Bright and Cheery's name Nurse Reese?* But she was so stoic, unlike the average cheerful and bubbly nurse.

He continued, "Then we will take you down the hall for a CT scan. After that, the doc will be in to see you soon." Another patient had arrived. Crap, did this mean this new patient was ahead of me? I considered stepping down and asking if I needed to take a number. *What does it take to get me out of*

here? But off the stage, I was still apprehensive, afraid to make my needs known, so instead, I stayed put. *Be a good patient. Be a good girl.*

I followed the trail of incidents that led to the fiery girl in the emergency room, like the breadcrumbs left by Hansel and Gretel. But the birds had eaten those breadcrumbs, leaving me with a hazy memory of how I got here. What had happened to the gentle, pure little girl who cared about people?

That Jane had since slowly died inside. Somewhere along the way, I encased myself in a cloak of anger. Why was I filled with such anger?

I curled into the blanket, and the nurse returned to check my injured hand. "The swelling is going down. That's a promising sign. How does it feel?" She smiled slightly.

"The tingling is gone, so better, I guess."

As she left, she drew the curtain behind her, quiet this time. She seemed to be less cranky. I rubbed my eyes. I wanted to go home, but not wanting to suffer the loss of a finger kept me there.

A handsome man in a white jacket appeared behind the curtain, jarring me awake. "Jane? I understand you're feisty. Got into a bar fight, did you?"

My lips parted as I tried to respond, but I couldn't take my eyes off the gorgeous man before me. He reached out and gently cradled my hand. As he observed the bite mark, he smiled at me with perfect white teeth. "Let me check this out. Yikes! She got you pretty good, didn't she? This one may leave a scar, but we have the infection under control. Reese here will go over the daily care with you. It will require some antibiotics. You stay put. She will be right back with the instructions and the prescription. Do you have questions for me?"

"No." Picking my jaw up from the floor, I wanted to ask, are you single, but he left the room just as swiftly as he'd entered. He was kind, a professional. Would I ever find a guy like that in the actual world who would love me and accept me?

Nurse Reese reviewed the routine I had to adhere to in order to avoid an infection. Although, an infection may lead to another ER visit to catch sight of Mr. Handsome-and-possibly-single. She bandaged me up and said I could remove the bandages in a week, just in time for my Iowa debut next week. New city, new club, a new stage. Maybe I'll meet a new guy? I exited the hospital through the revolving doors filled with new hope and confidence and a bandage around my middle and pointer finger.

K N I G H T S

Steffanie and I hit the road for our first three-week stretch a week after the bar fight and ER visit. I booked us into small clubs throughout Iowa. After packing the car with stripper outfits and snacks, we took a trip like the movie *Thelma and Louise*. We never drove off a cliff or had the thrill of meeting a young Brad Pitt, but we had fun.

The highways through Eastern Colorado and Nebraska seemed never-ending as we took turns driving. The scenery was monotonous, with wheat fields on both sides, occasionally broken by billboards advertising ice cream at the next gasoline station, forty miles away. Amongst this endless expanse, we encountered countless tractor-trailers operated by weary men. The drivers would ogle at us from their cabs and wave, giving us a little entertainment to make time pass.

I switched out the cassette tape for George Michael's "I Want Your Sex". Steffanie was driving when I noticed the car slowing down. We were behind another big rig. Feeling mischievous, I unhooked my bra. "Ready?" Steffanie asked as I rolled down my window. Steffanie sped up and steered into the far-left lane. I leaned out the window, the wind whipped through my hair, and I squinted my eyes to shield them from stray bugs. Then, pulling up my shirt, I hung my breasts out the window, with a joyful squeal.

Through my wind-whipped hair, I glimpsed a bearded man in the truck, his attention shifting from the road to my display. He put his eyes back on the road, glanced back at me, and then back on the road again. With a grin, he reached for his CB radio handset, mouthing a warning to fellow truckers ahead, "Shirtless babe on the move!" As he placed his CB handset down, the driver began honking his horn, alternating his gaze between the road and me.

I ducked back into the car, and we laughed uncontrollably. The antics contin-
ued as we repeated the same routine with the next truck we came upon. The
driver greeted us with honks and peeks in the side-view mirror each time,
eagerly awaiting my show. It was a blast.

Our Midwest tour was successful and packed with quirky moments. It
became a repetitive pattern for over a year, with our bookings reserved and
the drive route memorized from Colorado to Nebraska and Iowa. Des Moines,
in particular, proved to be a cash cow as we performed for businessmen and
hardworking farmers. The farmers, dressed in plaid shirts, jeans, cowboy
boots, and baseball caps, would come to the club after a long day's work,
ready to let loose and have a good time.

We would enter the strip clubs with our locking briefcases to safeguard
our hard-earned profits. After each set, we unfolded the wadded-up dollar
bills, smoothing them out and counting the piles. I would organize them in
stacks of 25 to keep track of the evening's earnings. Customers sometimes
wrote cute notes on napkins and placed them into dollar bills, which I cher-
ished as reminders of my worth.

Yet, within the laughter, there was always a hint of anxiety. We couldn't
help but wonder what we would do if someone dared to walk away with our
precious briefcases. It was a comical thought, imagining a hapless thief run-
ning off with our currency-stuffed cases only to discover they had unknow-
ingly acquired the burden of keeping track of meticulously organized heaps
of bills that had been in our G-strings hours before.

Steffanie and I had come a long way since our first audition. Reunited, we
made navigating hurdles and maximizing earnings from certain customers
easier. Iowa was a new start, turning us into entrepreneurial women who
knew how to capitalize in each venue. These men put us on pedestals.

The male patrons were as diverse as the shapes and sizes of a woman's
breasts, and we could swiftly categorize them. There were the "unhappily
married guys," the "social outcasts/nerds," the "controllers" who enjoyed

making you work for a dollar, the "entitled" who assumed they could touch you whenever and wherever, and the rowdy "testosterone on steroids" bachelor parties. We faced the "slick dicks and sideliners" as well as the ones exhibiting "not-so-regular behavior." Each category required a unique approach to extract the max amount from their wallets.

Iowa had fewer restrictions and fewer bouncers, allowing Steffanie and me to devise strategies to boost our yield. Despite our different body builds, we presented ourselves as sisters, as the customers wanted to believe it. Embracing this illusion, Steffanie and I took the stage together as the formidable double trouble. We secured our favorite gig every three weeks at BJ's in Des Moines, as it attracted more extensive crowds and offered more lucrative opportunities.

A farmer, one of the regulars, fixed his eyes on Steffanie and tried to charm his way into her favor. "The night is young and we're just getting started. How about a double dance?" he suggested with a raise of his eyebrows.

Steffanie giggled. "Hmm. That's up to Blake, the boss."

Undeterred, another man slipped a few bills into her hand. He winked and said, "Consider it an advance payment for your performance. You're gonna knock 'em dead. I can tell."

Steffanie smirked, tucking the bills into her G-string. "Well, I never say no to a generous tip. You boys enjoy the show."

As we approached Blake, the men at the bar swapped glances, intrigued. Their attempts to lure her were met with playful banter, and Steffanie left them hanging. I couldn't help but admire her ability to navigate this world effortlessly. At that moment, I sensed my timidity, while Steffanie was a force to be reckoned with.

Always wanting to be the cool dude and avoid drama, Blake, the proprietor of BJ's, muttered as he wiped down the counter. "You can both be out there together, but only for one song, or the other girls will complain."

We jumped at the opportunity. Dollar bills came more easily when there were two of us. We analyzed each patron. Which category are they? *Pour Some Sugar on Me* by Def Leppard pounded through the speaker system, raw, animal, and sexy. I twisted and swayed my hips. I cocked my head to the side and slowly slid my hands down my breasts before moving them towards my abdomen. I moved my body in a sensual undulation, subtly urging the men to tip me by directing my fingertips toward my G-string. We were persuasive. We held the attentiveness of these men by sensually moving our bodies, and we owned them. They were brainless noodles, unable to think.

The audience devoured it, reveling in their fantasy. We seamlessly portrayed sisters, each taking a side, delving into the art of deception. As I honed my skills of trickery, I detached from myself, skilled at maneuvering through my surroundings. Living this dual life would prove a valuable skill. Like flipping a switch, I had become proficient at accessing that power at will. Stepping through the revolving door meant shedding one identity to assume another, wearing a mask.

I knew that even as a young woman, I was becoming adept at existing in multiple worlds simultaneously, skillfully camouflaging. A tool, a way to hide pain, genuine feelings, and my true self. I pretended to be strong and composed to survive, succeed, and not reveal my truth as an imposter. However, this constant need to conceal and mask made it challenging to be at ease and express myself authentically.

Yet wasn't I in command of everything?

I spun and twirled, immersed in the rhythm and movement of my body, shutting out the second world, the world of shame I refused to acknowledge. The music was loud, the drinks were flowing, and the dollars were piling up in front of me. I wore a broad smile, yet beneath it, I yearned for something more profound, a need to be recognized and loved for who I truly was.

As we ventured into our second year of traveling through Iowa, the air began to warm and winter gave way to spring, the season of renewal. I'd booked us for a week at BJ's. It had been a quiet evening so far, just a few patrons. I was trying to get through another weeknight until Thursday, Friday, and Saturday arrived, with it, the real money and lively crowds. The swirling red and blue lights bounced off the stained and smudged walls that desperately needed a coat of paint, matching the cheap worn carpet and frayed cloth chairs. I gritted my teeth and pressed on, my body moving to the thumping beat of tunes. The room was almost empty, but I grooved and swung gently. I was laid bare under the heat of the spotlights. I pushed through, determined to finish the set.

As I shimmied my way across the room to the main stage, I was acutely aware of the bartender, the owner, and the DJ, all non-paying "customers," watching for free. With the beginning of the second track, they grew restless, hoping for more regulars to arrive. Just then, the bouncer at the front door welcomed a customer enthusiastically, "Hey! How ya doin'? Where ya been?"

I heard the sound of the two men exchanging high-fives and peered in the direction of the door. A man I'd wanted to get to know better walked in. I stood up straight, present in the moment, captivated by him. Leaning on the bar, he ordered his usual gin and tonic. I did not take my eyes off him.

I saw my knight in shining armor. He had beautiful sun-kissed hair, light green eyes, and tan skin. He was handsome in his suits, which made him stand out from the ranchers in their cowboy shirts and jeans. He often came in for a drink, tipped me without a word, and then disappeared. I would come dashing out to find him, but he was always gone when I finished my set. After receiving his drink order, he walked right up to the stage with a tip in his hand. No arrogance about him, almost a slight shyness. He tucked his money tip into the side of my G-string as he said, "What are you doing here? You look like someone I would take home and introduce to my mother."

A spark of hope ignited within me. Here is my opening. Instantly, I responded, "You always leave after you tip me. I can never find you after my set."

He looked toward the bar and said, "Hey, I'll stay for one drink as long as you come right out."

I nodded in agreement. I couldn't let this lucky chance slip away.

I still had one more dance to perform. He nestled at the end of the bar, sipping his drink. The butterflies in my stomach rose to my chest, and my cheeks felt warm and flush. I couldn't wait to talk to him. As the music ended, I rushed off stage to freshen up quickly so he didn't leave. I selected my outfit for my next set, cleaned up, touched up my makeup, applied more perfume, and shoved a breath mint in my mouth. After all, I had to preserve that Barbie doll image for their fantasies.

As I approached him, he rose and said, "I'm Mark." His presence filled the room.

I shook his hand and gave a nervous smile. "I'm Jane."

He chuckled and motioned for me to sit. I climbed onto the barstool next to him in awe.

"Oh, so your stage name, Chelsea, isn't your real name." And with that simple exchange our story began. We started talking and I was drawn to him like a magnet. He was smart, older, wiser, funny, charming, intelligent, and gorgeous. I couldn't help but stare into his eyes, which popped against his olive skin. His mustache was perfectly manicured, and he had a shy half-smile. He made me feel noteworthy, like I was the only person in the room. I was twenty-one, he was the first *man* I had come in contact with. To me, he seemed perfect. Right there, I fell in love. Deep in my heart, I knew somehow I would marry him.

"So you said I look like someone you would take home and introduce to your mother. You look innocent yourself. What are *you* doing here?"

Tilting his head as if wondering if he could trust me, he said, "Recent breakup. I just need to get my head back. This place is an escape for me."

"I'm sorry," I said when, in reality, I was eager to jump at being his rebound.

"Oh, no, it's not like that. I ended the relationship months ago. It's just I hate hurting people, letting them down."

Not wanting to remain somber for long, he altered the pace of the discussion by asking me questions. "You don't appear like you're from Iowa. You must be one of the women they ship in from somewhere else."

"Well, I am originally from Colorado, and that is where I live with my roommate, Steffanie." She was now on stage and I pointed to her.

He continued to study me. "Why are you here? You seem too classy and innocent."

He thought I was too classy? He was sitting next to me with a monogrammed, starched shirt. That was classy! Not having an answer, I changed the subject. "Your monogram says MSR. What does that stand for?" The scrolled monogram on the cuffs told me these were tailored clothes. He was clearly a man who took care of himself.

He took a drag of his cigarette, exhaling the smoke away from me as a protective gesture. "Mark Steven Ropar."

I put my head down and giggled. "You mean 'Ropar' like from the TV series *Three's Company?*"

He shook his head in embarrassment and disbelief.

As the conversation flowed, we shared stories and laughter. Time stood still, and neither of us wanted it to end. Mark's green eyes enchanted me, and his smile, though still shy, had become more frequent. I couldn't deny the strong connection that had formed between us. Mark leaned in closer, his voice softer. "You know, Jane, I wasn't expecting you to be so down to earth, funny and sweet. You've taken me by surprise."

I blushed and stared at my hands, fiddling with a cocktail napkin. He reached out and touched my hand. "I'm glad you convinced me to stay."

Before I responded, Steffanie completed her performance and joined us, breaking the spell momentarily. Mark and I glanced at each other acknowledging this was only our story's beginning. We had stumbled upon something remarkable.

The night had taken an unexpected turn, and I knew my life would change in ways I couldn't imagine. But in the back of my mind, doubts circled in my head. How many men were there before him? Over thirty? Fifty? Closer to seventy? They were dispersed about somewhere in my inner being, but they were now barely faces without names. *Why was he really interested in me? What were the odds of a professional businessman falling in love with a broken dancer, a woman who had given herself to so many men before him she had lost count?*

PART TWO

PART TWO

CHAPTER 7

IT'S ALL IN THE DETAILS

I began journaling at every opportunity, my pen hitting the paper with intensity. I clenched my teeth as I spewed out my relationship fears, the words flowing so fast and furious the ink barely had time to dry, leaving dark smudges in its wake. Doubts resurfaced, making me question if I deserved love from someone like Mark.

Steffanie and I were spending more and more time in Iowa. My desire to be with Mark consumed every spare minute while Steffanie had formed a bond with Gary, a local farmer, and she dedicated her Sundays to him.

"Gary wants to introduce me to his family, parents and sisters. They are having a barbecue next Sunday. He told me to dress conservatively."

We both smiled. We had curated an entire wardrobe based on our "profession." Not dressing like a stripper would be a challenge.

"He still hasn't told them what you do?"

"No way! They'll kill him! But I think his sisters are suspicious."

"Well, Mark is out of town. Want me to come along?"

"Would you?"

"Of course, but I can't promise I won't dress like a stripper."

Steffanie giggled, knowing I wouldn't throw her under the bus intentionally.

On the day of the family barbeque, Gary was welcoming and demonstrated how to shuck and boil corn. He was apologetic when he realized he had not gotten all the corn silk, but Steffanie quickly showed him a few tricks, like removing the corn silk using a dry paper towel. I could visualize her as a farmer's wife.

Watching Steffanie's budding connection with Gary, I couldn't help but feel Mark's absence. I wished he could be here with us. But things were, well, complicated.

Mark was a sales representative for Hewlett-Packard hospital equipment, and he crisscrossed Iowa to visit hospitals. Our meetings were frequent, yet sporadic, given his job. Whenever I found myself in Des Moines, his hometown, it made a rendezvous seamless. But Mark wasn't just your conventional, determined guy. He'd drive for hours to hang out when I was in other parts of the state, risking his job by taking time off. I could always count on him, even if it meant playing the waiting game at the bar, sipping his gin and tonic, and stealing glances at the clock.

"Hey, babe," he would say, in his smoky tone. "I'm heading back to the room. I can't keep my eyes open any longer."

"Alright," I'd reply. "I'll slip in quietly so you can rest."

With a devilish grin, he wrapped his arm around my waist and said, "Give me your word that you'll wake me up when you come in!"

Well past midnight, I returned to the hotel room, calculating every step to avoid disturbing him. The soft rustling of sheets was the only sound in the room as I slid under them.

He rolled over and spooned me with his warm chest on my back. In the pitch dark, he said, "Sometimes when I hold you, there's no physical way to get close enough to you. I can honestly say this is a feeling I have never had before. The need for that closeness is always in contrast to you and I having to be separate, not knowing for sure when we might see each other again, and the possibility when we do see each other, it may be to steal a few hours from two schedules that are like night and day."

As I pressed my body tightly against his, I couldn't help but confess, "I hate being away from you. I become insecure and wonder if you still love me. I guess that's why I take a while to get to know you all over again."

Mark inhaled, his breath grazing my neck. I gazed at the ceiling, still energized from the night, unable to sleep. "I can't believe I have to say goodbye to you again tomorrow morning," I sighed.

He stirred, half-asleep, and whispered, "It will be a long week without you."

"But I will see you next week in Carroll at our favorite hotel," I murmured, my voice trailing off. Mark's breathing grew heavier as he slipped into a deep slumber.

The next morning we followed our usual routine of waking up, having breakfast with Steffanie and Gary, and saying goodbye. Again. Steffanie and I spent the next week in Ames, Iowa, but we focused on the following week when we would be back in Carroll, Iowa, with Mark and Gary.

This was the late eighties. Email was not a thing; no Facebook or text messaging. We wrote letters and cards back and forth. Old-school style. Mark would often send letters to the hotel in Carroll, timed to be nearby when Steffanie and I arrived. What a treat to arrive on a Sunday evening and have a love letter waiting for me that assured me of his love and teased me about what would happen when we met again, things like "I think it would be nice to have you slide into bed with me and give me a big hug!!!" They'd be in envelopes addressed to me in his trademark modus operandi: "Butt Head ... Butt Face ... Girl of My Dreams ... Love of my Life ... Jane ..."

With the blue envelope against my nose, I breathed in his familiar scent, a dash of Grey Flannel cologne—his signature fragrance. Delicately, I unfolded the envelope, handling it carefully to preserve its precious contents, just like the others I cherished. As I broke the seal, the magic of his words came alive, bridging the distance between us. "Jane Munster [another nickname], I felt incredibly lonely for you today... If only we had more hours to spend together. I love you. Mark."

Those letters got me through to Friday when he would drive to meet us. I was young and hungry for love. His love notes on napkins, cards, and letters filled me with the belief I had ultimately found love and was worthy.

It was finally Friday night in Carroll. Steffanie and I raced out of Ossy's Bar, fueled by expectation, knowing Mark and Gary were waiting for us at the hotel. By this time, the owners of the hotel, an elderly couple who weren't so friendly at first, now found us almost endearing. So much so they would let our men into our rooms as long as we paid for the extra person rate.

Steffanie parked the car, and as soon as the engine shut off, I flung open the door, catching my shirt on the window crank. I steadied myself, heart pounding, my palms moist with sweat, and my cheeks flushed. I couldn't wait to see Mark, hoping he had not discovered the surprise I had in store for him. We were going to celebrate his birthday.

As I grabbed my briefcase from the trunk, door no. 6 opened, and he poked his head out, "Hi, Buttface!"

I ran and tackled him, pushing him onto the bed. Our heads bounced off the cheap, firm pillows on the double bed. As our bodies tangled, I twisted my tongue inside his mouth. It had only been a week since we had seen each other, but it felt like it had been months. I lifted my head and took him in, gazing into his green eyes. "I missed those eyes so much."

He responded, "Wouldn't it be weird if I died and donated my eyes, and you ended up with the guy who received them?"

"What the hell?" I slapped his chest. "Where did that come from? That's not funny!"

I lingered in his embrace.

"So I have another surprise for you, Birthday Boy! Turn around and close your eyes."

"Should I be scared?" he asked as he turned towards the wall.

I soundlessly went to the door where Steffanie and Gary were waiting with cans of silly string in their hands, the bright-colored concoction known as a party in a can.

"Okay, you can turn around."

As Mark turned, we started attacking him with plastic string sprayed from aerosol cans. He raised his arms in self-defense with his mouth wide open in shock. The colored strands flew everywhere; before he knew it, he was entangled in a web of silly string. He lunged at the dresser where I had put three more cans of the stuff, grabbed a can, and began spraying all of us. Thank God I had put the cake in a drawer or it would have been covered in the silly string.

But it wasn't all fun and games. Sometimes we clashed.

Later that evening, he said, "It is hard for me to admit to feelings of insecurity. I have always been confident and have always felt in control, safe, and strong, but for whatever reason, in our situation, I feel vulnerable, unprotected, and, in some ways, out of control."

I was silent. Where was this conversation headed?

"I believe it is a combination of all these things that makes me feel the way I do about your dancing. I have a real problem understanding your attraction to it. I always have the sense it is about more than money. Perhaps it's the control it gives you over men. I don't know."

As Mark expressed his feelings about my dancing, part of me understood his concerns and empathized with his vulnerability. After all, I loved him and didn't want him to feel this way. But I couldn't ignore the fact that dancing had been a part of my life for so long, and it gave me a sense of empowerment and independence that I couldn't easily let go of.

He continued, "I love you and will never come to grips with other men touching you. I'm sorry. I don't like it. It seems disrespectful and violating. When you dance, and I'm present, I feel unmanly and weak. It's like I left my character and strength somewhere else. My instinct is to want to protect and

nurture you, and in that environment, I'm forced to turn you over into the crowd. I hope we can get through this and on to the better things that life offers."

His words hit me hard. I never wanted to emasculate him or make him identify as inadequate. My heart ached as I realized the internal struggle he was going through, torn between his love for me and his discomfort with my profession.

Over the next few weeks, he persistently urged me to give up dancing and move to Iowa to live with him and go back to school. It was a big decision. Dancing had become a part of my identity. Could I surrender it? We were at a crossroads, and I had to weigh my desires, dreams, and identity against his wishes.

I knew I needed time to process all of this. What did I want? Could we find a compromise that would satisfy both our needs? We had some serious conversations ahead of us that would test our relationship. But as Mark had said, I hoped we could navigate this and move forward, embracing the better things life offered together.

In one such conversation, Mark's honesty spilled out. He said, "I love you very much, and I wish we could be together now! We have been seeing each other for almost a year now, and I have said on a few occasions this is so much more to me than dating or infatuation. For me, I believe you and I can have a future together that would be loving and special. I have spent the past several years building walls around me to safeguard myself from getting hurt. Because you are the one to climb over the wall, you have the power to hurt me. This leaves me pensive and unsure."

I, too, had powerful emotions, confessing, "I'm nervous, but you've given me the desire to change. I've never felt this way before."

Despite my doubts, I felt protected by him, making me question my choices. *Was he my reason to leave the bar scene behind?*

Our love was unique, but doubt crept in. *What if he wasn't being genuine? What if he left me one day?*

I battled conflicting feelings and didn't want to tell Mark I was worried I would miss the stage, even though I understood it gave me a false sense of self-esteem. *Would his constant attention be enough? What if I wasn't good at school?* I had such a fear of losing him. One second, I was ready to surrender; the next, I was doubting everything, and I was unsettled, particularly about my father. My parents divorced when I was in sixth grade, and since that time, my father had made a more significant effort to be available for me through my trials. He had seen me make decisions and mistakes that contradicted my upbringing in a religious home. I remembered he was the one I called when I was caught shoplifting at sixteen, and he was the one who went to court with me for the incident.

My father and I were out to dinner on one of our Sunday dinners, and he finally asked me, "So this traveling waitress job makes little sense. You say they pay you to travel to Iowa and be a waitress?"

I had told my parents I was a traveling waitress, a lie to explain why I had dropped out of court reporting school and now was always carrying bundles of one-dollar bills. They bought into it, probably because they didn't want to accept the truth, but now he was asking me questions. Time to come clean.

"Dad, I'm not a traveling waitress." I disassociated and said, "I'm a stripper."

He drew in a breath and looked down at his plate. It was one of the few times in my life when I saw his pain. It was also a time when he did not lecture me and tell me what a poor choice and lifestyle I was leading. Instead, he purchased a travel door alarm for Steffanie and me to put on the doorknob of the hotel rooms. If someone on the outside tried to jiggle the lock or test the door, an alarm would sound. Thankfully, the whistle only went off a handful of times.

When I told my dad I was moving in with Mark, he pointed out I was on the wrong path by living with Mark before marriage. He brought up statistics about unmarried couples and their chances of never marrying or divorcing after marriage. As much as I wished for his permission, he could not provide it to me. But moving forward with Mark was the right decision. So, despite my fears and my father's hope for a more "legitimate" alliance involving marriage, in the summer of 1990, I took a leap of faith. I loaded up my black Ford Escort and a U-Haul trailer filled with clothes and furniture, and I was on my way to Des Moines.

But as I stood by my stuffed U-haul trailer, he handed me a letter, saying, "You will have to admit you are very headstrong in your quiet way. When you told me about your dancing, I had a hard time with that, and I don't know how I got through that, except the Lord helped me. I kept praying you would quit. The sooner, the better—and go back to school. I believe God is using Mark to answer that prayer." He said he was praying for our relationship and preferred to have us get married instead of living in sin and that he'd tried to be a loving father and guide his children.

My mom and I crammed everything into my compact car and the trailer. She shoved two blankets into the trunk. "Mark may be sorry he asked you to move in with him when he catches sight of all this stuff! But at least the cat is declawed and will make a good companion."

I gently placed the carrier containing my cat, Sneakers, into the front seat. He was already howling.

As my mom handed me the small bottle of pills the vet had given me to ease the cat's anxiety, she said, "Well, the medication doesn't seem to work so well. Hopefully, the movement of the car knocks him out."

I stood close to my mom. She smiled. We made eye contact and put our arms around each other. It was as if I was going away to college for the first time, a proud parent moment for her, something my classmates had experienced years ago, and now it was my turn. She released me and said, "We

know you're responsible, and we trust you. Just remember to communicate openly with us, and if you ever need anything, don't hesitate to reach out."

My father added, "And don't forget, family is always here for you, no matter where you are. We love you, kiddo."

I leaned towards my dad and said, "I love you both. Thanks for being so understanding. This isn't goodbye forever, just a new chapter."

When I hugged my dad, he squeezed me so hard it almost hurt. Ever since I was a little girl, he'd hug me hard, as if he couldn't get close enough. Maybe it was his way of expressing emotion—something he couldn't say with words.

"That's right, it's a new adventure. We'll always be your biggest supporters," my mom said, holding back tears.

My father, staying strong, said, "Take care of yourself out there."

"I will. I'll miss you guys so much. I love you both, and I'll call as soon as I arrive."

"We'll await your call—safe travels," they said in unison.

NEW BEGINNINGS

I climbed into my car, courtesy of my earnings from dancing, and headed down the highway for my eight-hour drive. I was looking forward to moving into our home, filled with our own things. As I drove toward my new home, I couldn't help but think about leaving my old life behind. Giving up dancing, control, the ego buzz, and the money was not easy, but I was ready for this new chapter. Steffanie had already moved on, quitting stripping and moving in with Gary. We would only be an hour's drive apart, so we would still stay in touch, but it was odd to be driving alone.

It was mid-July, and I had just a few weeks to settle in before returning to business college to complete my certification in court reporting, as I had promised Mark I would do when I agreed to move in with him. This was now my life. With the window rolled down, I pressed the gas pedal and cranked up the volume on Def Leppard.

Mark had rented an apartment in a newer section of Des Moines, and mailed me the address and directions. He told me the complex was brand new and that he'd be there to greet me when I arrived. As I drew closer to the address, on one side of the road were buildings with balconies and white trim, while on the other side stretched vast fields. The trees and grass were still green since it was late summer.

I searched for the fourth building on the right. One, two, three, four. I spotted his car, and I parked next to it. This was it. Mark was leaning over the balcony rail with a cigarette hanging loosely in his fingers. In our last phone conversation, he'd told me he'd rented an upstairs unit with a small balcony, and there was enough room for a barbecue! He blew out a puff of smoke and

disappeared inside. I grabbed the cat carrier, and Sneakers peeked at me with glazed eyes. Mark came running down the stairs.

"Come in! I can't wait to hear what you think!"

Inside the unit, the kitchen pass-through, a small box, and a card greeted me.

"Read it. It's for you," Mark said as he opened the carrier door and lifted a limp Sneakers out of the carrier.

The envelope read: *Butt-Head ... Butt Face ... Girl of my Dreams ... Love of my Life, Jane.*

I grinned. We had nicknames for each other that I loved. There was a note:

Dear Jane,

Well, I hope you like it! But if you don't, please tell me, and we will pick one you do. I realize this can be a personal choice, and I won't be offended. Now, I chose a watch because now you are going back to school and will then work, so it will be vital you know the correct time. I also want you to know the right time to come home to me. So I'll let you guess which one I think is the most important!

We have a new home! I want you to know how much I look forward to the prospect of the two of us sharing our lives, getting to know each other better, and growing together. I hope you always feel this was a good decision, and I hope I will always deserve your love. I believe time will prove you and me to be the best "us" possible!

I love you very much,

Mark

The box contained a Gucci watch. I definitely had made the right decision to quit dancing and move in with Mark, my knight.

Mark bought a huge armoire, white eyelet sheets, and a flower-covered comforter for our sunny apartment with high ceilings and cream rugs. The crisp sheets had been starched and ironed, and I couldn't help but wonder if he had done it himself. He suggested I take the spacious closet off the master bedroom, knowing I had a ton of clothes and shoes. I brought some furniture and stored the rest at my father's house. We only had a stereo, a TV cabinet, and a Ficus tree in the living room. Money was tight since I was in school, so Mark supported us.

Despite the idyllic setting, our relationship was not without its challenges. I came into the relationship insecure, angry, dependent, and needy, and the new bedspreads and white sheets couldn't change that. I desperately wanted to trust Mark's love as genuine, but didn't know how since I'd never truly felt love or nurturing from a man.

My inner critic often drowned out any affirming messages with overwhelming feelings of shame and guilt. I too often focused on the negatives and ignored the positives. In my eyes, Mark was everything to me, the center of my world, and I placed unrealistic expectations on him to fulfill all my needs.

What that led to was my erupting into fits of yelling and screaming with any perceived failing from him. I could be off the charts with rage and anger. He couldn't grasp why I would become so irate, and would tell me so in a tone that hurt me a lot and triggered intense feelings. My attempts to explain how I felt would only frustrate him even more.

There were times when I'd scream and hurl objects at the floor, finding a strange satisfaction in breaking things, hoping it would heal my pain. Once, I flung a picture frame that held a happy, smiling picture of us at Mark. I wanted it to shatter, to symbolize the brokenness of our relationship, but it pierced the wall and stuck there, like a twisted representation of our love. All Mark said was, "Great. Another thing I have to fix."

Taking up his challenge, I picked up the TV remote and smashed it onto the floor, reveling in the sound of plastic disintegrating into a million pieces.

Mark was bewildered and frightened by my outbursts, not knowing how to handle me. I would storm out of the room, fleeing from my emotions, but later I'd return, consumed by regret and desperate for his love. I was so afraid of losing him I would say or do anything to make him forget my outburst. The hole in my heart was enormous and deep, so deep I felt no one could fill it. Anytime I imagined Mark leaving me, I felt hollow and empty, like a shell of a person, with nothing inside but hurt.

As I grappled with my internal unrest and the fear of losing Mark, our future depended on me keeping my word. I had assured Mark that I would give up stripping and enroll in the court reporting program at the American Institute of Business in Des Moines. It tested me, and I struggled to keep up. Although I could type 180 words per minute, I had to pass a testing speed of 225 words per minute to graduate. I was stalled at 180 for months. My teacher didn't take me seriously. Finally, she asked, "Are you sure you're cut out for this? Perhaps you should consider a different career path."

I was frustrated and wanted to give up. But I couldn't let Mark down. So, I had to beat this, no matter what.

"I am cut out for this," I said, glaring at her. If she only knew how much I'd already conquered. But internally I questioned my abilities. *Would I ever test out of the 180 class?* Even though I was feeling discouraged, I persevered, thanks to Mark's support. With his encouragement and helping me practice typing at home, I eventually surpassed the 180-words-per-minute hurdle and advanced through the classes. I left my doubters behind. My newfound confidence propelled me forward, proving to myself I could achieve my goals.

Court reporting school was not just about shorthand; I had to learn legal and medical terms. Mark suggested I put the words on one side of an index card and the definition on the opposite. I spent hours flipping through those

index cards, placing them into the "pile I know" and the "pile I need more work on." After we finished cleaning our dinner dishes most nights, I often studied at the kitchen table.

"Hey, come over here next to me. Bring your flashcards. Sneakers and I will quiz you," Mark would say as Sneakers nestled under his arm.

I sat across from them in the family room on the floor.

"Which class is this?" he would ask.

"Medical terminology."

As I made my way through the terms, Mark put the ones I wrestled with back into the pack, and they kept reappearing until I had them down.

"See, you can use your mind, not just your body."

He believed in me and told me I was intelligent and could succeed. He was right. I earned straight As for the first time and received the Richard Koch Recognition Award for excellent grades, attendance record, and commitment to pursuing my education. Mark purchased a white three-ring notebook and plastic pocket protectors to preserve my report cards and certificates. After that first year, we put together a memorandum book where I would add multiple report cards and my National Court Reporting certificates.

I couldn't help but recall a discussion in the car with my father in the third grade. I was riding in the front seat next to him. He told me how proud he was of the boys, James and Joey, my two older brothers. They were so intelligent. They'd probably go to college for engineering, he opined.

As for me, he said, "You are more of a social butterfly. You like to flit around and socialize." With those words, I heard, "You are not smart like your brothers."

But there I was, living in sin in Iowa, a straight-A student for two sequential years by then, and heading to Chicago for an internship (a requirement to graduate). I stood in my walk-in closet, trying to pack for my upcoming trip, realizing I had nothing office-like to wear. Mark was right. I needed new clothes.

Mark had an eye for style and detail. He was intuitive when it came to combining colors and designs. One afternoon, there was a pounding at the front door. I ran, wondering what the emergency was. I peered through the peephole to discover Mark loaded down with shopping bags. I opened the door. "What are you doing, and *what* is all of this?"

"You need professional attire for your internship!"

I stared at the red bags as Mark went to his car to grab another load. The packages were from Talbot's, a high-end women's clothing store.

"Mark, this is too much. I can't accept all of these."

"Of course you can. You deserve to look your best and feel confident. And I had fun picking them out for you."

I spent the next few hours trying on the new items, and Mark showed me how to tie everything together. He'd even purchased matching belts and helped me pull several pumps from the bottom of my closet to make five different outfits for the trip.

IT´S
COMPLICATED

As my graduation date approached, and just after my internship in Chicago, a turn of events led to Mark being fired from his job. While he never disclosed the exact circumstances, I suspect our whirlwind romance, which had spanned over a year of chasing each other across the state, missed meetings, and arriving in the office tired and distracted, may have played a role.

When he was let go, we were still determining what our futures held. Our lease was about to end, which led Mark to discuss an opportunity in Pennsylvania with a friend. I sent my resume to several firms in Philadelphia and secured a position as a freelance court reporter. Mark needed to make money while I finished school, so rather ironically he worked as a bouncer at BJ's.

After several weeks of working at the club, Mark started getting home at four, five, and then six in the morning. As I woke up and went to take my morning shower, he would pass me by and crawl into bed. He'd explain his late hours by saying he was playing poker with the other bouncers and bartenders. I wasn't thrilled and couldn't sleep when he wasn't in bed beside me. And soon, I picked up on the pattern. He would be home every night for one week and sometimes two weeks. Then, in the third week, he would not get home until the early hours. Then the following week he'd be home again at a reasonable hour.

I had been a dancer and was familiar with their schedules, so I wondered if he was messing around with one of the girls.

Part of being fired was the requirement to turn in the company car, so Mark purchased a new, small, red pickup he souped up with mud flaps and a

bedcover. He was so fond of the little truck he nicknamed it "Red" and spent hours on the weekends washing and waxing it.

One afternoon, Mark was napping—getting home at six in the morning was taking a toll on him—and I had to have answers, so I rifled through the glovebox. I found a letter from a woman named Kimberly. The letter implied Mark and Kimberly had been spending a lot of time together, and she wanted more. An immense sense of betrayal and hurt overwhelmed me. They'd been chatting and going for breakfast after shifts, and she was falling for him. Hot tears streamed down my cheeks.

Instead of confronting him, I went to bed alone. Mark was at the club, and I prayed he would come home. I rolled over, and the clock read 3:30 a.m. I stared into the darkness—4 a.m. ... 5:15 a.m. ... Still no Mark.

I got up. The display on the clock read 5:30 a.m. I told Sneakers, "Today is different. I need to know what is going on." Getting dressed—no time to rinse off. I studied myself in the mirror and asked if I was ready for the answer. Knowing I couldn't continue like this, I had no alternative. I'd skip the first period, my medical terms class.

I was acquainted with the neighborhood where the dancers in the area would stay, so I drove to a few local motels looking for Red. I began with Motel 6, where Steffanie and I used to stay. I thought, does anything good happen in these motels? Cruising through the parking lot, only encountering potholes, no Red, I gave up and drove towards the Red Roof Inn. I noticed the pool's reflection, smooth like ice—no Red. There was one more motel, but more on the outskirts. I showed up at the third motel, an off-brand, family-owned place, not as vanilla as Motel 6. It had a little more charm with a fresh coat of paint and draperies with a floral design, and was reasonably priced at thirty-nine dollars a night according to the flashing, neon vacancy sign out front. Still no Red. A sense of relief came over me. Perhaps I was wrong, and they were only having breakfast. I made my way through the upcoming alley on the left. Just one more place to investigate, then I would

call it quits. I turned the corner, and Red was on the street to my left. I knew it. He was with her, and this was NOT breakfast!

I parked directly behind Red. At first I didn't shut the engine off. I sat with my hands at ten and two, rehearsing what I would say to the receptionist. Then, angrily, I threw the car into park and cut off the ignition. It was go time.

I strode up to the check-in desk. "Good morning. I am a dancer, and I'm friends with Kimberly. I need to talk to her."

It was close to 7:00 a.m. What if she asked me why I was there so early? What then?

The woman at the front counter nodded. "Oh, yes. Kimberly and her sister. They're nice."

I agreed with a fake smile. "Yes, they are."

She hesitated.

Please, please give me the room number. I thought.

"I appreciate it's an odd hour, but it's kind of an emergency." *Please don't ask any questions!*

"Room 312," she said.

"Thank you!" I exaggerated my gratitude. This was an urgent situation, after all.

As the elevator rose, it creaked, and I detected a damp scent. I glanced down, noticing the patterned carpet under my feet, and muttered a small prayer for strength. With a jarring stop, the doors opened. I followed the numbers down the hall. 306 ... 308 ... 310 ... 312.

I froze before I knocked. *Are you prepared to no longer have the man you love in your life? If you confront him, he may leave you.* I quickly looked at my watch—the Gucci I'd worn daily since he gave it to me. I could still make the second period of speed class if I left immediately. *What the fuck? He's already left me. I have nothing to lose.* I knocked and held my breath.

My body floated up to the sky. I heard footsteps and I sensed an eye peering at me from the peephole. I felt exposed and solitary, just like I felt on-stage for the first time.

A woman's voice said, "It's her." They cracked the door open enough so I could observe "her." She was a blurry image. Was she a blonde? Was she wearing a man's business shirt? Was that his shirt? I didn't have time to notice if his MSR monogram was on the left sleeve. Mark slithered out of the door, leaving me momentarily face-to-face with Kimberly. We walked around the corner to talk.

The reality of what I had seen struck me like a hammer to the head. I felt like an elephant was sitting on my chest. I couldn't breathe. "You need to come home and get your shit out of the house, or I will toss it all on the lawn from the balcony like a bad *Roseanne* sitcom scene. We are done," I said, and I meant it.

He remained expressionless.

"What?" I said. "You don't have anything to say?"

He put his hands to his face and inhaled.

Why wasn't he talking to me? Why wasn't he saying, "It isn't what you think" or "Everything will be okay"?

"What is this? What is going on?" I demanded like a small toddler wanting their way.

"She is a dancer."

"No shit. How do you think I found you? I'm not an idiot."

"She's someone who is going through a tough time."

I glared at him. A tough time? *What about me? What about all the sleepless nights?*

"We have gone to breakfast and just talked."

"But this isn't breakfast. This is a sleazy hotel room. With her wearing YOUR shirt!"

As Mark leaned against the railing, arms crossed, he said, "I was deliberately pushing you away. Moving us both to Pennsylvania is a big commitment, and I got scared."

I kept glaring at him in disbelief.

"I'm so sorry. I don't know what the hell I was thinking. I've never told my parents about you."

The words echoed in the otherwise empty hallway. I had gone to the motel with an ultimatum: me or her. I hovered from above as my world collapsed around me, disassociated. Everything grew dim and misty in my vision.

"Mark, you said you would tell them."

"I know, and I should have. It's just ..."

"Just what?" My body stiffened.

I should've known I wasn't good enough for Mark. Not worthy of his love. Our relationship had always been too good to be true. My hands were trembling, and my face was hot and flushed.

"That's it, then. You're a coward." I stared at him, hoping if he looked me in the eye, he would say something that made it all better. I hoped we would both wake up and discover the whole thing had just been a nightmare.

But he didn't look up. The decision had been made. Now I knew what to do. And so I left, my heart weighing a ton, limbs feeling like lead, a bitter tang in my mouth, and a hollow emptiness in my chest. I expected he would come home, pack his shit and then leave. But he was not mine anymore. What did it matter? I had just kicked him out.

When he arrived home later that morning, I had gathered my belongings. I was not clear about what I had in mind. I just had to pack. We were moving. Somewhere. Together? Apart? I could head back to Colorado or go to Pennsylvania solo. Mark lay on the bed, which was covered in my clothes, making it difficult to sort my clothing. He was struggling to talk to me. Sneakers was aware something was wrong and crept onto Mark's chest.

Mark started crying, petting Sneakers, and said, "I will miss this cat."

"Well, you should have thought about that before you fucked her!" I spat out. I didn't want to suffer the loss of Mark, but what choice did I have? *Keep packing.*

"I don't want to lose you." Mark's voice was frantic.

Inwardly I was screaming, *How could you do this to us?* Outwardly, I continued to fold and load up my entire life.

"I need to tell you something," he said.

I nodded my head, urging him to proceed.

"My parents don't trust my decisions. On the day of my wedding to Cheryl, my brother pulled me aside and said, 'It's not too late to bail. We can be in Vegas in a few hours. Are you sure about this?' When he asked me that question, I actually thought about cutting out. But I was too chicken. The fact I thought about it was my answer. And that marriage was a disaster. They never liked Cheryl, and they have questioned my relationships ever since and have never let me live down the divorce."

I held my breath and thought, *Can we make this work?*

"It's complicated. I didn't know we would move back to Pennsylvania, and it never seemed like the right time to tell them. Kimberly gave me an excuse to push you away and not deal with it. But I don't want to be with Kimberly. I want to be with you."

"You do realize to be with me, you must tell your parents about me. I mean, we will be living in the same state. Kinda hard to hide me."

"Yes, and I am ready. I love you. I can't imagine my life without you. Or this cat," he stroked Sneakers.

"I need some time," I said, placing my toiletry bag into my suitcase.

"I want you to know," he paused to make sure I heard him, "I ended things with Kimberly. Even if you never forgive me and don't give me a second chance, I still don't want to be with her."

I stopped packing for a moment. "Thank you, but I still need some time."

He nodded.

My mother had invited me to Europe as a graduation gift before the Kimberly shit hit the fan, and I required space to reflect, so I left the following day—leaving Mark behind—whatever his solution was about Kimberly, he'd have to work out without me. It was my first European excursion and should have been the adventure of a lifetime. On paper, it was—we planned to visit St. Mark's Basilica in Venice and glide throughout the water city in a gondola, taking in its beauty and vibrant colors. But I discovered I couldn't enjoy it without Mark at my side. Mom and I devoured delicious pasta dinners and took in scenes of sunsets and bridges—too beautiful to describe. With each new experience, I imagined how much Mark would've loved to be there too.

Every day, I called him collect from the phone booths. We had life decisions to make, so radio silence wasn't an option. Plus, I wanted to hear his voice. By the end of the trip, we surrendered to the realization we couldn't live without each other.

When I returned from Europe, I joined Mark, and we began planning our future again—and started paying off the massive long-distance phone bill we'd run up during my vacation. We packed our things into a U-Haul, put his truck on a trailer, and I followed behind him with my loaded-up Ford Escort and a medicated cat and headed to Pennsylvania for a new chance. *A new chance*, I repeated to myself. We had been tested, but moving to Philadelphia was our new beginning, now a thousand miles away from Kimberly and BJ's.

CHAPTER 10

THE BEST IS
YET TO COME

In the fall of 1992, we settled in West Chester, Pennsylvania, a suburb of Philadelphia. I insisted on counseling. We were in love, but obviously, something was flawed with the cheating incident.

"I think we need help to work through this, Mark," I said one afternoon. "I don't want us to keep hurting each other." I believed if we went into counseling, the therapist would "fix" Mark. But it didn't take long for me to realize I needed introspection, too. I didn't give my childhood much thought and attributed my troubles to my emotionally cut-off father. The couples therapy proved to be valuable. We learned a lot about one another and our painful childhoods. Sitting in the therapist's office, Mark finally opened up about his past.

"I never talked about this, but during my parents' marriage, my mom, Janice, had an affair," Mark confessed. "Shortly after, she became pregnant with me. My dad, Chad, would throw the fling into her face and say I wasn't his son. I was an innocent bystander, taking the wrath of his jealousy and embarrassment."

As the counseling sessions continued, I shared more as well. "I am realizing how much I've depended on you," I admitted to Mark. "I made you responsible for all the holes in my heart. I trusted you with everything. I didn't think for myself or speak up for myself. And because of that, I often felt controlled or trapped."

Mark nodded, acknowledging his issues. "I felt accountable for you and your every move, too. But I don't want us to be like this anymore."

The counselor helped us resolve conflicts by addressing my fear of Mark's anger and my desire to avoid discomfort.

"I want you to use your voice," Mark said, looking into my eyes. "Share your feelings with me. I won't leave you. I promise."

My new court reporting position meant taking the train into downtown Philadelphia, which was a fresh experience. As the sun rose on a crisp morning, I stood on the platform, my breath forming small puffs in the chilly air. Dressed in my professional attire, I was grateful for Mark's thoughtful presents. He'd given me a Mont Blanc pen, leather-bound notebook, and satchel to carry everything in as a graduation present. With each item, he provided me with essential tools and instilled in me a sense of confidence.

I observed my new world coming to life. Men in well-tailored suits stood around, some engrossed in their newspapers, others impatiently pacing. The women were equally poised and professional, but what captivated me was the spectacle of Pennsylvania in the fall. The trees were ablaze with brilliant red, orange, and yellow hues, and the leaves drifted from the branches like delicate snowflakes falling in slow motion. It was a breathtaking display of nature, a vivid reminder of the beauty surrounding me.

The train arrived, prompting a sudden flurry of activity as passengers scrambled to board and secure a seat. Finding a spot by the window, I marveled at transitioning from my familiar small-town life to the bustling city. The cityscape unfolded before me, with towering skyscrapers reaching toward the sky. They made me feel grown-up, solidifying my sense of belonging in this energetic world of professionals. I couldn't wait to embrace the challenges and opportunities in this new chapter of my life.

Mark and I spent two more years in Pennsylvania before deciding to tie the knot. During that time, my love for him deepened with each passing day, and I let down the emotional walls I had built around my heart.

We chose October 1996 as the date for our wedding, recognizing it as the most enchanting time of the year in Pennsylvania. Even though we lived outside Philadelphia, we had the ceremony in Pittsburgh, about five hours away, because Mark's parents and close friends were there. It seemed the ultimate choice because our friends and family must travel regardless of location. This decision gave us a comfortable two-year timeframe to plan and prepare for the most important day of our lives. I purchased a book called Bridal Bargains and armed myself with all the right questions.

"What is all that stuff?" Mark asked, his eyes wide as he surveyed my desk covered in notebooks, sticky notes, and highlighter pens.

"Well, this book says to locate a locale first because they may recommend vendors for flowers, DJs, and videographers—you know, all the good things."

He studied me, sensing this celebration would be expensive.

"You lived in Pittsburgh. What can you tell me about the Downtown Westin? It looks amazing! And they have a wedding planner, which would be a tremendous help since I am planning this long distance."

Mark was an intelligent groom, staying out of it. "Yes, dear, whatever you want for the special day."

I arranged a consultation with the wedding coordinator at the Westin. She had agreed to meet with me on a weekend since I was coming in from out of town.

"Wow, you are so organized. Is that a binder for wedding preparation?" she asked.

"Yep! I have everything color-coded! I have pictures from bridal magazines for inspiration."

"That's fantastic. It'll help me understand your vision better." She watched me pensively. "Do you have a budget?"

"Yes, I do. But I may want to spend more on centerpieces."

Relieved, she said, "I can't tell you how many brides come here with no clue!"

We entered the ballroom with mahogany-lined walls and a balcony for the cocktail hour. It was exquisite.

"And if you would like, sometimes we put an ice sculpture over here." An ice sculpture? I had not thought about that. "Yes! That's a great idea!"

We sat in her office, and she offered business cards for the best flowers, photographer, DJ, and videographer we could afford. It had to be quintessential. I set out on a two-year journey with one giant notebook to organize the wedding of my dreams—within reason.

Our wedding day arrived, and it was flawless. Gold Chiavari chairs, exquisite linens, and glistening gold chargers were carefully placed. An ice sculpture and a cake with frosting blossoms were a must, and I dropped an astronomical amount of my allotment on unique centerpieces. Handmade notes tied to individual wine bottles wrapped in gold-colored bows as party favors sat waiting for each guest. I poured my heart and soul into every little detail.

Our perfect day also had its quota of cheesy elements, especially regarding the dance floor. We shamelessly indulged in the limbo and succumbed to the "Macarena" (embarrassing to admit, but undeniably fun!). A particular song had everyone weaving in and out, creating a line that snaked through the venue while dancing to the catchy beats of "Come On Ride the Train". And yes, photographic evidence of our exuberant rendition of the chicken dance exists.

To appear more polished, we took dance classes for our first dance. We wanted to give the illusion of knowing what we were doing. Frank Sinatra's "The Best Is Yet to Come" played as we glided across the dance floor. The moment we stepped off the dance floor, however, we were immediately met with playful heckling. "You took lessons, didn't you? Suckers!" The mischievous voices teased, reminding us not to take ourselves too seriously.

CHAPTER 11

C R A C K S I N
P A R A D I S E

OCTOBER 1998, PENNSYLVANIA

Mark and I were starting our lives together, working towards our goals, and excited about what would come. He had formed a college refrigerator rental company with an old friend. However, what started as a dream collaboration soon became a nightmare. Mark discovered the partner had been embezzling money from the business. When Mark confronted him, the partner locked Mark out of the building and had his company vehicle repossessed.

Mark was forced into a heartbreaking situation. He had poured his heart, time, and energy into establishing the business and had built relationships with many employees. These were not just colleagues—they were his friends—and most of them lived in Redding, Pennsylvania, one of the poorest cities in the country. Several had faced personal battles with addiction and were turning their way of life around. Mark believed in second chances and had given them the opportunity they needed.

Eddie, a Black employee and recovering substance addict, was one of his closest friends. Mark was even the godfather to one of Eddie's children. Their bond went beyond the workplace.

Only then did I consider that even as a dancer I had led a sheltered life compared to challenges I was witnessing now with the truly poor. The way Mark interacted with his friends and their families, so naturally and with a sense of humor, put me at ease and imparted valuable lessons in empathy and understanding.

So, when Mark lost his job, it wasn't only his world that crumbled. It was theirs, too. The bonds he had forged, the hope he had instilled, all seemed to evaporate. It was a devastating blow that deeply affected Mark, and left his friends and teammates, like Eddie, facing an uncertain future again.

Mark proposed a change of course: he would take on a part-time position at United Parcel Service while pursuing his goal of becoming a golf pro in his free time. I accepted his decision, which meant paying the bills and paying down his debt. I didn't realize how demanding it would be. I pored over the monthly statements, the numbers blurring into a jumble. I was used to seeing something I wanted, working hard, and getting it. Stripping had always been a tremendous incentive, but *this*, this was different.

It was a role reversal for both of us, and I often wondered if I could handle it. Every time I made a payment, the interest seemed to swallow it up. I was fighting a losing battle. I asked my boss for more night and township hearings to manage the payments and started taking on freelance work. I spent long hours hunched over my desk and devoted my weekends to proof-reading while Mark went to the golf course. I was hoping Mark would find a full-time job and begin helping us financially. Even paying off my wedding ring, symbolizing our love and commitment, felt like a minor victory.

Finally, after two years, I was nearing a zero balance. Mark continued working part-time at UPS, and we began looking for a new house. We were outgrowing our apartment, and I desperately wanted to be in a community. I was dressing the part of an average professional—well, maybe not every woman in local neighborhoods had black patent leather thigh-high boots in her closet. I had broken that suburban wife stereotype. Oh, if they only knew where I had come from!

House-hunting was an adventure, and we were at odds over personal preferences. And then we found Stonegate.

Stonegate was a new development with six standard home models, set apart only by their exterior finishes and varying floorplans. Stonegate

appeared upscale because it was sandwiched in between two pricier neighborhoods. Mark was invested in every detail of the house's construction, dropping in daily after his early morning shift at UPS. A brotherhood evolved with the Amish crew and other workers on the site, who bonded over his love of cigars and outgoing personality.

Fourteen months after discovering the property, we moved into our home. Mark did his own upgrades, installing chair railings, French doors, lanterns, and stone finishes. Each evening, I would arrive home to a perfectly maintained lawn with a perfect shade of green. Mark prided himself on making diamonds in the grass with the lawnmower. Flowers of various colors splashed against the red brick facade, white trim, and hunter-green shutters. I was proud of our house; it resembled a *Better Homes & Gardens* magazine spread. I identified with that little girl playing with dolls in the basement, fantasizing about a home and a husband. Aspirations do come true.

We'd worked hard to get there. All the ingredients were there to live the stereotypical suburban life for the first time in my life. Stable job: Check. Husband: Check. House in a suburban development: Check. All that seemed to be missing from the Norman Rockwell painting was a white picket fence, two kids, and a dog. (Close, we had cats.)

I had come a long way and looked forward to my journey with Mark. I desired to complete the trip from stripper to suburban working wife.

As more families moved into the community, a "ladies' night" started up. Each month, one person would volunteer to be a hostess. The ladies would chip in with either wine or an appetizer. All that was required was an exquisite decorative home. I picked up from Mark how to interact with others, particularly in connecting with people. It wasn't about superficial interactions like a strip club where I could appease the male and be cute. Going to ladies' nights was about engaging with people, taking an interest in their activities, and asking meaningful questions to establish deeper connections with them, something more than surface chit-chat.

I hoped to connect with other women in the neighborhood, especially since I had taken up jogging when I could around the neighborhood streets, but visiting someone's home made me feel uncomfortable. Alone. Being married to my biggest supporter and someone who wanted to see me grow, Mark often encouraged me to do what I was afraid to do. Eventually, I wormed my way into a few friendships with the stay-at-home moms, and I am so grateful to them for inviting me in. But we couldn't completely relate. They would be home with the little ones all day, hosting playdates and drinking mimosas while I was at work. I longed to be a stay-at-home mom, but Mark still worked part-time, and the bills kept coming in.

I would not volunteer for a night hearing on ladies' nights, but sometimes I had to work and so would arrive a little late, usually still in my work ensemble. On one particular ladies' night, after a night hearing, I went straight to the hostess's home. Inhaling and slowly exhaling, I reached for the door handle. It was unlocked, so I went in, checked the entry for shoes (just in case the hostess insisted we take them off), and headed to the kitchen, hoping to run into a familiar face. My friends Jessica and Kaylee said they would be there.

I scanned the room for my friends when a tall blonde woman wearing a stylish bob, white slacks, and a red and white striped sleeveless sweater advanced towards me. She held out her hand, scrutinized me up and down, and said, "I don't believe we have met. I'm Meghan."

I was suddenly self-conscious. I was the only one not dressed casually, and I was sure my black pumps were out of place.

"Hello, nice to meet you."

"Jane! You made it," Jessica slurred as she lunged at me. I laughed, and Kaylee handed me a glass of wine.

"We were just talking about you. We're planning a girls' weekend. Wanna join?" Jessica was straining to remain standing.

"I would like that," I said, sipping my drink. "Just for the weekend?"

"Just the weekend."

I wanted to be included. Female friends who weren't strippers? This was different for me.

Initially, I hesitated. Could we afford it? *Would they still accept me after spending an entire weekend together?*

I then broached the topic with Mark one Saturday evening as he was grilling. The sun had sunk behind the trees, and I took a swig of wine and said, "So Jessica, Kaylee, and Julian are going to New York for a girls' weekend."

Mark flipped the steak, closed the lid, and exhaled. He focused on me. His cigar smoke rose to the sky. "Did they invite you?"

"Yeah, they did."

"You should go."

Later that week, he surprised me with a gift: a set of luxurious pajamas, suggesting I would fit in with the moms during our New York weekend. Over that weekend, my relationships blossomed with the women. Jessica had us howling with her chronicles of sex, marriage, and birthing kids. It was strange to be in this environment, surrounded by women who seemed to have it all together while I struggled to balance my job, my finances, and my marriage. But as the weekend went on, I relaxed and enjoyed myself. I found the women were more than just their perfect houses and designer wardrobes. They had their struggles and challenges, just like me. As we drank and giggled, I realized how stay-at-home moms were desperate for time to be themselves. They didn't even have time to go to the bathroom without the child following them. I listened to their stories between frantic phone calls from their husbands, who were left at home with the kids. I witnessed their frustration and anger. "Seriously? He can't even figure out how to feed them! He wants me home as soon as possible on Sunday. He's freaking out. Fucker! What does he think I do all damn week? He can't survive one night?"

When the getaway ended, and we devoured our final breakfast together, I noticed how the moms were eager to return home to their kids. However, my

emotions were conflicted. I was on the brink of turning thirty-four, and Mark and I were far from financially solid enough to start a family. While Mark had expressed his disinterest in having children, I couldn't help but envy my younger neighbor, Brooke, who was expecting.

The desire to be a mother was strong, but Mark still worked part-time. Mark had given up on his aspiration to be a golf pro but morphed into a recreational golfer as an alternative. He spent a lot of money on expensive cigars, golf club fees, golfing with his buddies, and hanging out at the 19th hole, having drinks after a round. While our funds were stretched thin, I couldn't deny I, too, had a shared responsibility for our economic situation. Whenever Mark suggested a new home improvement project, I accepted extra night shifts, bent on making our desires come true.

At the golf course, Mark crossed paths with a young man in whom he saw potential. Mark affectionately nicknamed him the Kid. This young man was growing up in the care of a single mother and had his share of adversity. Mark took the Kid under his wing, dedicating countless hours to mentoring and guiding him. Mark's efforts resulted in the Kid receiving a scholarship for a country club membership, ensuring economic constraints didn't hold him back.

Unable to resolve the discord with Mark being so caring for others and my wish for financial stability and a traditional family life, I had difficulty communicating my feelings, which led to emotional distance. While I dealt with my resentment, I acknowledged Mark's good intentions and couldn't label him as terrible for leaving me to shoulder the monetary burdens. Our connection was far from one-dimensional.

But after the weekend in New York, I needed to talk to Mark about our finances. I gathered the courage to address my unhappiness with our current circumstances. As I approached him in the garage, he stood admiring our yard, cigar in hand. Breathing in the scent of fresh-cut grass, I drew a deep breath, knowing our exchange may become a disagreement.

"I'm not happy working so many hours," I blurted, my voice trembling.

He placed his cigar in the ashtray and turned to face me quizzically. "Is that why you have seemed distant and emotionally disconnected?" he responded. His words stung, but I found it almost impossible to articulate my thoughts and responses. I shut down and went numb, feeling rejected. This was my fault.

"I don't know why you can't be happy," he said. "Life is too short."

That conversation could have stamped an indelible turning point in our relationship, but I was entirely unaware that a life-altering diagnosis would eclipse all my previous concerns.

CHAPTER 12

THE
DIAGNOSIS

MAY 2002

Almost six years after our wedding day, and a few weeks after my New York trip, I grabbed my briefcase and hurriedly walked towards the glass revolving door of the attorney's office, avoiding eye contact, and announced, "I have to go! I'm late."

I caught my co-worker rolling her eyes at me. With a resigned sigh, she accepted she would have to take over for me while I took time off. I'd hoped the case would finish before lunch, but it went longer than anticipated. I had no choice but to ask for help. I didn't abuse my time off, and I needed coverage for the afternoon, because I had to join Mark at a follow-up appointment to learn of the outcome of a recent biopsy taken during a routine exam.

Rushing to the parking garage after a taxing day, I felt the pressure of being a part of a demanding career. While driving on the highway, I got lost in my thoughts, and the song *Love Bites* by Def Leppard played on the radio, reminding me of my past life as a stripper. A lifetime ago. Mark had rescued me from that world, and we'd been together for twelve years. I couldn't help but reflect on all that had happened since those early days—our life, home, and dreams.

Mark had been experiencing difficulty swallowing, so his doctor recommended he undergo an esophageal dilation process, during which a balloon would be inserted into his esophagus. The doctor assured us this was a standard test for a man of Mark's age—forty-five. As I sat in the waiting room, not surprisingly I was uneasy. When the doctor returned with Mark, my fears

were confirmed. The procedure revealed a mass in Mark's esophagus and a biopsy was taken. As a thirty-four-year-old, I never expected to be dealing with health concerns—mine or my husband's. We scheduled a follow-up appointment and continued on with our lives.

When I arrived for the follow-up consultation, I saw Mark's truck. He had gone in without me. I felt as though he was shutting me out. I took a deep breath, keys in hand, and then hurried into the office. I went straight to the receptionist. Her head was down, but with urgency in my voice, I said, "Excuse me, I'm meeting my husband, Mark, here."

"He's in with the doctor. Come with me."

I followed her down the hallway. She knocked gently, and as she opened the door, I slid in next to Mark. The doctor had already conveyed the bad news to Mark. I could read it on their faces. I fixed my gaze on the doctor as his words pierced the air, each syllable landing with a heaviness. "Your husband," he began, "has been diagnosed with esophageal cancer."

Cancer.

My heart jumped in my chest, making breathing hard, and my ears filled with a hollow noise, like water surging through my head. I was in a tunnel and could scarcely absorb the words. Noises outside me were an echo. The doctor listed our courses of action and gave us the names of specialists.

Why was he talking so fast?

He said, "You need to call them ASAP."

What was happening? Mark gazed at me, then at the doctor. "I won't do chemo. I saw what that did to my grandmother."

Not knowing what to say, I couldn't speak. *I will support you, Mark,* is what I wanted to say, but nothing came out.

On my drive home, I started processing what we had just heard from the doctor. Okay, so Mark has cancer. Lots of people survive cancer. We can do this. Oh, but after I got home, Google said otherwise: "Esophageal cancer: 5%

survival rate." Everything we read made the situation sound more and more grim. We called our parents to give them an update.

I started with my mom. "Sit down. It's bad." What began as a typical day for her ended with questions and unknowns. My mom, who had grown close to Mark over the years, listened intently as I delivered the news. "Mark has esophageal cancer. Depending on the types of cells, there are two: one treatable with surgery, the other more aggressive. Doctors are being interviewed. Mark will choose the doctor and what type of medical care, possibly chemo, to shrink the tumor and then remove it surgically."

Mark sat me down and stated, "I want you to know I don't want to go through chemotherapy, but I'll do it for you because I love you."

I looked in his eyes and said, "Mark, I appreciate your willingness because I'll feel better if we at least try chemotherapy, or else I'll always wonder *What if?* for the rest of my life."

He nodded. "Okay, if it means that much to you, I'll give it a shot."

Our first appointment was with an oncologist. He was a young man, gentle and sympathetic. Addressing both of us, he said, "Good afternoon. I'm Dr. Philips, and I'll review the chemotherapy treatment options with you."

Reassured, I said, "Thank you, Doctor. We're grateful for your help."

"I understand this is a difficult time, but we're here to provide you with the best care possible. Let's discuss the choices and develop a plan that suits your needs."

I asked him, "Someone told us we should freeze Mark's sperm before beginning chemotherapy if we ever wanted children."

Dr. Philips peered up from his paperwork, adjusted his glasses, and looked at me with warm eyes and a quiet smile. "That's an excellent suggestion."

He recognized as sick as Mark was, the chances of him being able to produce healthy sperm were low. The odds of Mark surviving this cancer were even lower, but he was kind and appeased me with his response.

We've got this.

Mark reluctantly agreed to go to a fertility clinic and freeze his sperm. But he wouldn't do it before saying, "Again, I am doing this for you. But if I die, I hope you won't use it. I don't want my child out there without their father."

We traveled to the hospital at the University of Pennsylvania to meet with the leading surgeon who would treat his cancer. All the idle time in the various waiting rooms was tormenting. No way to ignore the reason you were waiting. Even if you tried to escape, you couldn't disregard all the other patients surrounding you. It was a time before smartphones. We couldn't disappear through video games, texts, or Facebook, and reading a book was hard to concentrate on, so we sat silently. Waiting.

I didn't know what to say.

As Mark sat on the exam table, legs dangling, I sat in the chair on the other side of the room. I longed to be closer, so I climbed up next to him. The crinkle of the tissue paper broke the stillness. I reached for his hand. He held my hand loosely before pulling it away, inhaling, and crossing his arms.

I felt helpless.

I wanted to say *I can't stop thinking about the worst-case scenario. What if the remedies don't work?* But I didn't. I had to keep the facade of being strong. I took my seat across the room.

I looked around the carefully curated room. Bottles of hand sanitizer and crystal-clear jars lined with white cotton balls and Q-tips were neatly arranged on shelves. The precision with which everything was organized portrayed a sense of crisp orderliness. This semblance of control sharply contrasted with the sudden upheaval in my life.

The room whirred with the distant drone of medical equipment and the occasional murmur of hushed conversations on the other side of the door. Mark just sat on the examination table, staring at his hands and rubbing them together. Those hands. They were rugged and always busy mowing the grass

or holding their daily cigar. I took him in. He was muscular from loading boxes and had a farmer's tan from the middle of his triceps down from spending days on the golf course. He was blessed to have olive skin, so he tanned easily. His dark skin made his greenish-gray eyes pop. Those eyes. They always drew me in, mesmerizing. I recalled that evening ten years ago in the hotel room in Carroll, Iowa, when he said, "Wouldn't it be weird if I died and donated my eyes, and you ended up with the guy who received them?" I'd stared at him in silence, unable to imagine such a thing.

After knocking on the door, a large man in a white lab coat came in. Without looking up from his papers, Mark's history, he announced, "We are taking you to radiology for a PET scan. Should be able to determine if the cancer has spread. The staff will be in to wheel you down. Here is a gown. The opening is in the back."

He turned to leave, but Mark stopped him. "Doc, what is a PET scan?"

"Oh, I apologize. It's a full-body scan, a positron emission tomography scan. Radioactive material is injected into the body and collects in areas with cancer."

After he left, Mark took a glance my way.

I read his green eyes. "You want me to go away?"

"Yeah, you don't wanna see this train wreck."

"Mark, I realize you're losing weight, but ..."

He cut me off. "Jane, please. Just give me some space."

I slipped out of the room and stood in the hall, taking in the smells of cleaning products. The floors gleamed with a polished sheen. I closed my eyes and wished for this to all go away. Even though Mark was not as muscular and getting skinnier every day, he was still my husband, the man I cared very much for. Doesn't he understand I'm in this with him? A young doctor walked past me. His squeaky shoes on the tiled floor brought me back to my new reality: I was just thirty-four years old, and my husband, only forty-five,

might die. Mark's illness terrified me. How could I live without him? The only man I ever loved?

A nurse brushed past me and entered the room as she tapped on the door. I snuck in behind her.

"Oh, are you family?" she asked.

"Yes, I am his wife."

She looked at Mark and took a step back. I could've sworn she said something under her breath like, "He's so *young.*"

She had Mark hop onto the gurney and rolled him down the hall.

I stayed behind, sitting in a single black plastic chair. Was this an indication of things to come? Party of one?

The room was chilly, with olive-colored walls and no window. The fluorescent lighting and the facts of our state of affairs hit me hard. Mark was young, too young to be going through this.

As I waited in the hospital room, I did something I had not done since I was a child. I closed my eyes, put my head down, and laced my fingers together. "Dear God, I feel You. I know You are here, and I will be okay no matter what. Please give me the strength to get through this. Please forgive me for worrying about the little things."

The door burst open as they wheeled Mark back into the room, with his doctor. With an air of confidence he said, "I have combed through your history and tests. We will start with chemotherapy, shrink the tumor, and then perform the surgery. Done."

He made it sound so easy and doable. Mark and I held hands as we left, and the warmth of his hands beneath my fingertips was calming. I didn't feel the distance anymore; I was tight with him again. I admired Mark and saw a determination in his eyes as if he had a newfound appreciation for life and a desire to make the most of every moment. I was hopeful.

CHAPTER 13

NO LONG OR SAD FACES ALLOWED

As we accepted the daunting challenge of beating cancer from our hilltop house in Stonegate, every day seemed like an uphill battle, and we were constantly reminded of our battle as we viewed neighborhood moms pushing strollers, walking their dogs, or going for their morning jogs. But even when we felt alone against the world, we had the constant support of our dear friends. They were there for us every step of the way, with regular calls, visits, and deliveries of warm meals which brought much-needed comfort during a trying time. Their kindness and selflessness reminded us that there was still goodness in the world, and we were blessed to have them in our lives.

Right after we connected with the surgeon in May, a feeding tube was inserted into Mark's abdomen for sustenance. When he woke up from the anesthesia, he cringed in pain. The nurse pulled back the sheets to show us a square patch of white gauze, about four inches by four inches. Like a bendy straw, a clear plastic tube stuck out of his stomach, with a seal at the end that resembled the plug on an inflatable pool toy.

The nurse showed me how to use the feeding tube. I paid close attention, not wanting to screw up something so critical. It would be my job to feed Mark, and she taught me to pour protein formula into the tube slowly and also demonstrated how to keep the tube clean.

"Make sure you pour it in slowly," she warned, "or he will be constipated and we will have other problems. It also must be at room temperature. It's going directly into his tummy, so it can't be too cold."

I tensed up, wondering if I could handle what was necessary.

Mark called his boss at UPS, assuring him, "Yes, I planned to be in tomorrow, but I may need a few more days." I wanted to believe him.

An aggressive treatment plan was put into place. He started chemotherapy immediately after the feeding tube and had a battery-operated pack he would wear like a fanny pack that would inject chemo into his bloodstream seven days a week, twenty-four hours a day, for two months. He also had radiation five days a week.

My once-formidable husband was now vulnerable, dependent on his wife to look after him. At home, I poured the protein formula as slowly as possible, making sure not to do it too fast. I didn't want him to suffer more discomfort, much less the humiliation of constipation. We had been in this routine for a week, and he was constipated. *Had I poured it in too fast? Too cold?* He had not gone to the bathroom in days.

"Towels," he said, pointing to the floor. He crouched with his hands wrapped around his abdomen. I grabbed as many towels as possible and laid them in multiple layers on the cold, hard floor. Mark lay down by the toilet in a fetal position. The situation called for me to be tough and not freak out. It was so painful to watch, and I felt helpless.

"What can I do?" I asked, knowing there was nothing and hoping Mark would not lash out at me or blame me. It must have been my fault for not warming up the liquid enough. He had to know it, too. I was the one responsible, and I had fucked it up.

"Call the doc. Tell him it's not working."

He doubled over on the bathroom floor, willing his body to sit down and go to the bathroom, but nothing worked. When I called the doctor, he recommended I give Mark an enema, something I had never done before. I

experienced all the fears a new mother must feel—terrified I was doing something wrong, such as giving him an inaccurate dose, forgetting a dose, or somehow hurting him. We were only a week in. How would we get through weeks, if not months, of treatment?

As Mark battled through his chemo treatments, I put on a brave front. I hid the depths of my concern and distress. I knew he needed me to be strong. The surgeon explained Mark would need to sleep in an upright position, head above heart, for the rest of his life. And what if the cancer came back? I felt selfish in my fears, but I only wanted our old life back.

While faced with his illness, I continued to work. We had the one-two punch of medical bills and diminished income, and he refused to let me risk losing our home if he didn't make it. My coworkers were often puzzled over my presence in the office; they couldn't comprehend the intricate web of emotions leading to my resolve to work at my job. They couldn't fathom that I longed to be by Mark's side, day and night, but he yearned for a semblance of control. His body was failing him, so he controlled what he could—me. We had our share of disagreements, yet he emerged victorious in this matter, and thus, I fulfilled my duties at work. He wanted to ensure I was provided for and could work through this difficult time.

Two months into our routine, we received good news. Mark had completed his chemo and the tumor had shrunk. The feeding tube was withdrawn, and Mark had a brief window to consume whole food again. We had two months of reprieve until the surgery, during which Mark was more like himself again. He cooked our dinners and seemed much less worried than I was about the pending operation.

During that time, my mom and stepdad, Brad, visited. One of my favorite memories is our Atlantic City, New Jersey trip. On a humid summer day, we strolled along the boardwalk, inhaling the scent of the sea breeze and the food vendors' enticing aromas. Mark spotted the corn dogs and indulged

himself with three. After being unable to chew food by mouth for two months throughout chemo, he savored each one, bite by bite. His jaws slowly moved up and down. It was a sight I had missed. He finished by licking his fingers after relishing the last bit of his corn dog.

Brad and I found a bench as we watched my mom and Mark stroll along the beach.

I broke the silence. "You know, when my mom met you, I never considered myself Daddy's little princess. I had a lot of unmet needs in that relationship, a lot of holes, gaps, and a lot of 'daddy' issues. I had no clue how important you and Mark would be in my life."

Brad turned to me, put his hand on my leg, and said, "Do you remember the first time we were introduced?"

I smiled, sensing where this was going. "Yes."

"You showed up at my condo wearing a white leather mini-skirt. I think you brought your boyfriend, Troy, by the house."

"Oh, God! Troy! You took us out for a nice dinner for my birthday. Did you know how troubled I was or how much trouble I could and would cause? If you only knew!"

"Oh, I knew something. You and Steffanie roamed around in hardly enough clothes, copious amounts of makeup, and boyfriends in and out, left and right."

"But you were patiently waiting. Maybe you knew I was a lot like my mom—independent, a bit rebellious. Perhaps you realized I would not have listened to you anyway."

He was quiet.

"Then I linked up with Mark, and I moved to Iowa. And when you visited us, I remember venting to you and my mom about how my marriage was strained. I was starting to resent Mark because I had become the main breadwinner, and it seemed like all he'd do was spend more money. You were attentive. You didn't say much. You didn't give advice."

My mom and Mark removed their shoes and socks and waded into the ocean. It must have been cold because my mom jumped back before reentering the sea to her ankles.

"Well, I'm proud of you, kid. You have handled this all so well."

If Brad could read my mind, he would know all my doubts and worries. I wanted my old Mark back. I didn't want to go through the rest of my life speculating if every cough or sneeze meant the cancer had come back.

In a hushed tone I said, "I'm so thankful to my friends. They've been persistent in invitations to join them for coffee, to coax me out of the confines of the house. And running ... Thank God for running."

Brad's gaze met mine with a knowing look. Could he see through my feeble attempts to outrun Mark's illness? I clung to the belief I could outrace anything, even cancer.

As the day of the surgery approached, we were filled with anticipation and apprehension. My mom and Mark's mom, Janice, were in town to assist us through the surgery and aftercare. Janice was a petite woman with bluish-gray hair and beautiful hazel-green eyes, much like Mark's. After getting Mark settled, we learned our way around the hospital. We had another opportunity to kiss Mark and wish him luck before they wheeled him away. He was wearing his hospital gown and a blue cap. The blue cap made his beautiful green eyes stand out.

He was cheerful and charming to the nurses, something that had served him well over the years, always able to tease in a flirtatious way. "Do I get to keep the gown? I mean, it goes so well with my eyes and easy bathroom access."

The nurse, Tammy, smiled at him. "Are you always this much trouble? Your wife has her hands full."

He grinned at me. We both knew I would not have it any other way.

As the hours passed in the waiting room, my apprehension grew. I had started the day with hope as they wheeled Mark into surgery, but now uncertainty loomed in the air. The initial optimism had worn off. Now I was anxious. I glanced at my watch. We had been in the waiting room for three hours. I sat in silence, not moving, sitting in a fog. Mom sat across from me, reading a book. Janice sat hunched over in her chair, half dozing, half watching TV. It was surreal. When lunchtime rolled around, Janice encouraged my mom and me to go to the cafeteria and grab something to snack on while she waited in the waiting room. I wasn't hungry, but I was ready for a change of scenery.

The cafeteria was empty. The breakfast crowd had come and gone.

I ordered a few items and was lost in thought when Janice popped up from around the corner. She reached for my arm. I was holding my tray of uneaten food. Something snapped in my brain, telling me to hold on to my tray or I might drop it.

Holding my arm, she said, "Janie, something is wrong. They have stopped the surgery. The cancer has spread, and they can't remove the tumor."

I dropped the tray. I yanked my arm away, covered my face with my hands, and cried, "NO!!" The cafeteria had certainly been empty only a few minutes before, but I sensed the alarmed gazes of the few people in the room.

This was not happening. No! Not my Mark.

I raced to the waiting room, desperate to talk to the surgeon. *He had to be wrong. There had to be a way. What now? Back to chemo? Could we try again?*

After what seemed an eternity, the surgeon arrived to give us his report. Mark was still in the recovery room. We were given x-rays to look at, on which tiny spots had been marked, showing cancer cells. The cancer had spread to Mark's lymph nodes and his liver. He was riddled with the disease. The surgeon couldn't do anything for him except close him up and send him home to die.

We had so many questions. I was sure we'd asked them, but we couldn't remember a thing once the surgeon left that room.

I was afraid to tell Mark. I had imagined countless scenarios after the surgery, but not this one.

Mark's room had a window. Food trucks were parked below and we could see college students hurrying by. Mark was barely awake, but he looked down at his chest. It only took moments to register what had happened. The surgery had not been performed. He looked up at the three of us. He read in our expressions the news was not good. He locked eyes with me, and we stared at each other for seconds. But it felt like forever. Without words, we shared the fear, worry, defeat, and sadness, aware the fight for his life and our future together had been lost.

Not wanting to be the ones to say the words, we let the doctor give Mark the news.

Mark shook his head. "There will be no long or sad faces allowed."

His attempt at levity fell flat. We remained quiet, solemn. *Does a person even know what to say at a time like that?*

But Mark hadn't given up. In his usual style, he started cracking jokes and making us smile despite ourselves.

I called anyone planning to visit Mark that afternoon to brief them on what had happened in the operating room and what it meant. When the neighborhood friends arrived, they received the same instruction from Mark—no long faces or sadness—and they followed orders, happy to bring cheer and laughter into the situation.

A nurse came in and seemed relieved to see smiles.

It was next to impossible for the nurses, visitors, and our family to connect a terminal diagnosis with the robust young man in front of us. It was even more impossible to dwell on Mark's diagnosis once he turned on the charm. If you didn't know any better, you'd think he was a patient on the road to recovery. Not someone headed home to hospice care.

By the time he went home, Mark had become the best-loved patient on his hospital floor. The staff had all been positively affected by Mark, as had so many people in his life. And all were heartbroken for his and our imminent loss.

At home, my mom helped by running essential errands like picking up prescriptions, groceries, and supplies while I helped Mark settle in. After a week, my parents went back to Denver, realizing they would be back when Mark's condition inevitably worsened. He had been given months—not years.

I found myself in a state I had never imagined. It was a time filled with immense stress. People often ask me how I handled it, and I just did what had to be done.

I didn't have the luxury of time or the energy to question the circumstances. It was a matter of necessity and survival. I became his caregiver, advocate, and emotional support system. Every day presented new hurdles, and I had to tackle them head-on.

While it might seem like I was strong, it was more about resilience and adaptability. I didn't have a magic formula for dealing with the stress; I dealt with each moment as it arrived. My love for my husband and the aspiration to provide him with the best possible care kept me going. I discovered an inner strength I didn't know I had.

On the advice of his care team, we began applying for hospice. This care would help Mark and the family through the final stages. The sooner we arranged it, the better, so the team could familiarize themselves with Mark's case and determine which services were essential to get set up so they'd be prepared as the disease progressed.

As Mark's caregiver, I identified as small and powerless, smashed by the significance of his serious illness. I struggled to keep my composure for him. Tears streamed down my face when I went to bed in the looming dark. I masked my pain. He was dying; I was not. Once again, my heart constricted, so not to be able to feel all I wanted to explore because it would have crushed

me. My anxiety and uncertainty made it hard to stay grounded. The pressure of the situation was suffocating, but we learned to cherish every moment and make the most of each experience, to embrace our time together.

CHAPTER 14

R U N N I N G
O U T O F T I M E

NOVEMBER 2002

The sunlight filtered through the window, giving the yellow walls a muted glow. The space was cozy and inviting. But the air was heavy. Roughly six weeks after Mark's surgery, Paige, the social worker assigned to Mark, came for her first visit to the house after we'd accepted we couldn't put off hospice care any longer. He'd been sleeping more and was weaker. We had already moved him to the guest room full-time. I remained in the primary bedroom but had a makeshift bed at the foot of his bed to be near him. Mark lit right up when Paige came in, turning on his charm. She drew up a chair next to his bed.

"You have a lovely home," she said.

"Thank you! You should see all the beautiful things he's done to our house."

Mark blushed as he looked down at his lap.

"You're lucky! My husband's relationship with tools is like a blindfolded squirrel! What's worse is he thinks he's handy!"

Mark couldn't help himself and said, "Well, I managed to hang a picture straight once, but it only took three attempts!"

"Oh my God, that's hilarious! You should see our garage. Mark has three lawnmowers! Our front yard used to look like a golf course," I continued.

Paige opened her mouth in dismay.

"Oh, yeah. Perfectly trimmed hedges, you name it. The garage is so full of tools, there's no room for the cars."

Paige turned her attention to Mark. "What's your favorite thing about this house?"

He fixed his gaze on me and answered, "Jane, my wife."

"He loves you. You can note it in his eyes."

What was so beautiful about that statement was Mark had focused on making our home a home with arduous work and love. All the chair rails he had added, the retaining wall he built, the patio design, and the kitchen updates. His passion for me never wavered, even though we faced difficulties and I resented our financial situation. What mattered was I was loved—unconditionally. And, for the first time in my life, I felt worthy of his love. In this way, his illness was also somehow a gift.

Paige discussed our options with us and helped us make arrangements for hospice to come in on an as-needed basis, which began with visits twice a week. But as time passed, he became weaker and couldn't keep food down, and needed changes in his medications, so the visits became more frequent.

I stood by one day as he reached into the refrigerator and grabbed a carton of lemonade. He shuffled across the room, I said, "I want to spend more time with you and take personal leave from work."

"That's like pissing in the wind."

He held the carton over the sink and didn't have enough strength to shake it.

"You need to go to work. Don't let the judge down. He's been good to you over the years."

I took the carton of lemonade from him and shook it for him. His words hurt, but I forgave him. He needed me. I didn't want to spend our last weeks, or days, arguing over whether I could stay home full-time to care for him, so I conceded and continued to work.

Soon the nurse was coming by every morning to examine him and assess whether the meds required adjustment. Meanwhile, I was in court listening to divorcing couples brawling over Tupperware and calling each other nasty

names. I desperately wanted to race out of the courtroom to be with Mark. My life partner was facing death and people were wrangling over whether a new fence was more than the code allowed. I was very much afraid Mark would die while I was at work. I didn't want him to die alone.

I came in one evening after a night hearing ran late and tiptoed into his room to check if he was awake. He was lying in bed, only the TV light flickering on his pale skin. His farmer tan from being on the golf course had long since faded. He held the remote loosely in his hand. He had slipped into sleep while watching TV. I leaned in to make sure he was still breathing. He was. Relieved, I spun to head to my room, but he called out to me. I nestled onto the side of the bed. Holding his hand, I said, "I don't want to miss it. I know you may not have any control, but if you do, I want to be with you when you go. I can handle it."

Taking a deep breath and looking me in the eye, he said, "I don't deserve to lose my best buddy. I promise I will wait for you if I have any control."

Mark bent over the side of the bed and began throwing up into the bucket. To manage his ongoing nausea and vomiting, we devised a solution—an orange Home Depot bucket with a trash bag for easy disposal.

As the dry heaves dissipated, he slowly raised his head, closed his eyes, inhaled, and said, "I feel like I'm being cut in half by the pain. I'm in trouble. I can feel my insides changing. I will need more help tomorrow."

I held the bucket for him and stroked his back. Finally, I could stay home with him, but I sensed the end was coming. And soon.

Continuing to hold his head over the bucket, he didn't make eye contact with me as he said, "Have we decided who will take care of me when I die? Better get on that."

He was talking about his cremation.

"Yes. I met with someone at Founds Funeral Home. Since we have some time, we can personalize your service."

He said, "We may be out of time."

I felt a punch in the gut, unable to get enough air, and I shook like I had loaded up on caffeine, adrenaline high, but I knew he was right.

Mark and I had come to the acceptance phase, fully aware of the reality of the circumstances. However, we were getting perturbed when people spoke to us as though we were naïve, offering hollow words of comfort like "You can fight this; have faith; don't give up." They were overlooking the profound lessons God had provided us through this difficult journey.

Two days before he passed, Mark had been up most of the night again with nausea. My mom came in to relieve me that morning so I could shower. When I returned, he had opened the shutters and sat in front of the window, enjoying the scenery and sunshine. It had snowed a few days before. The snow glistened on the ground and clung to the trees, pure white as if it had freshly fallen. He said it reminded him of a painting by the fine artists, Currier and Ives. He enjoyed the view as I removed his pajama top and gave him a sponge bath. I took in his features. He was still my Mark, but bony. He had the body of an older man but the face of a forty-five-year-old. He was withering away—maybe only 120 pounds. But it was a close time between us. He said, "I'm sorry you have to witness this."

"Are you kidding me? I love you."

I couldn't help but reflect on when I was naked on stage, needing his rescue, requiring him to teach me how to dress and socialize, cooking for me, raising me from a young girl into a woman, and now we were here, and I was helping him get dressed, trying to feed him. Somewhere along the journey of our relationship, our roles had reversed. After years of Mark being my safe haven and protector, I was now his lifeline. We had come full circle.

I had spent the last few months wanting to protect him from the cards and letters littered with the words, "Don't give up! Get well soon." Those were well-meaning words, but he was not giving up. His body was.

On the day he died, I had been sitting with him. He was in a coma, and I looked down at him, caressed his head, and whispered, "I will be okay. I love you. I always will. You can go."

Within minutes, his breathing pattern alternated, slow and fast, with long gaps between exhales and inhales. The only thing left in the room was breath. I stared into his green eyes and listened to the erratic rhythm of his breathing as time slipped away. He showed me the way and guided me as though he knew how. I can only describe what I saw when he leaped into the light. He took a few more shallow breaths and then didn't breathe again. Mark had kept his promise. The very thing I had been the most afraid of, death, was a beautiful memory that changed me forever. Death no longer scared me. Death was both peaceful and strange—and unfinished. Without Mark, I was incomplete—a puzzle missing its most vital piece. Who had I become? My body seemed foreign, as if I were an outsider looking in. My heart was breaking, and painful sensations ran down my arms. I was detaching from my physical being, a surreal experience of fragmentation. I was dissolving, becoming smaller and flatter, like a snowman melting into a puddle in a cartoon.

I grew still. The past was gone. There was no future. There was only the present. Stillness embraced me.

ULTIMATE GIFTS
AND GROWTH

One week after Mark's passing, my mom and Brad guided me through the church lobby, one on each side, extending gentle support like a friend stumbling after a long night of partying. My feet moved forward, one step at a time, but it was as though they were disconnected from my body and the ground beneath.

People on every side of me spoke, their lips moving, but their words were muffled as if my ears were stuffed with cotton. People moved slowly, their forms blurry and distant.

People gathered for sandwiches and coffee and looked at pictures of Mark and me, Mark alone, and Mark with his friends. The images had been carefully curated by my mom, who, as an artist and teacher, had arranged them alongside words like "family" and "friends." Mark had seen and approved of the photos we chose.

As I walked into the dimly lit chapel, the flickering candles cast a warm glimmer on the room. I inhaled the perfume of the flowers and released my sorrow for a place of calm. I didn't cry. I seemed to feel relief and heartbreak, joy and sadness, freedom and confinement all at the same time.

On the one hand, there was relief Mark's suffering had finally ceased. He was no longer enduring the unbearable agony that had consumed him. Yet, he was gone forever out of my life.

I went into sensory overload. It was as if someone were to touch me, it would sting. I had been masking torment my entire life, but I could not hide this misery. It had to be experienced, and I was aware of new life in that sorrow. I had awakened to something similar, to a dewy spring morning of

renewal, born out of intense sadness. *It's impossible he's gone. He is a part of me. How do I leave him behind? He is in my bones, my blood.* My hands shook, and I was breathless, sinking into the trenches of loss as though I were being pulled underwater.

I grieved for the past, the unlived future, the imagined life. I still longed to have our life before the diagnosis back. Yet, through the darkness, I was to discover that Mark's illness would transform me into a better person. The ache had opened my heart. I couldn't explain it, but I felt alive.

One of my coworkers, Carol, approached me and said, "Take all the time you need. We will cover court for you."

"I appreciate that," I said, but I thought, no. Mark's death won't slow me down. And I hated being alone in my house, bumping into the walls like a rubber bouncy ball. When Mark was dying, he craved to control what he could because he could not control the cancer. Now I wanted to maintain what I could, my schedule. I desired normalcy. I expected to head back to work as soon as I could. I had to stay busy.

Mary, the judge's secretary, overheard my discussion with Carol. Mary had been widowed eight years earlier and said, "The annual courthouse holiday party is next week. Maybe you can come by for that and get accustomed to seeing people again. It will take some time. You can dip your toe in. I will be there for you."

"Thank you. That's a great idea."

Mark was gone. His celebration of life was over. It was time for my mom and stepdad to go home to Colorado. They needed to get back to their life, and we were all aware I needed to settle into my new routine at some point. We said our goodbyes for now. When I looked into Brad's eyes, I knew he understood. He sensed my discomfort, but he believed I could do this. My mom was torn. She was hurting with me and wanted me to consider going with them, but she recognized I had built a life here, one with friendships and

stability. I could come home if I desired. They climbed into the camper. Brad drove slowly down the lane, and I watched until the bright red brake lights disappeared. I felt small, swallowed in the house's shadow, which loomed over me. A chilly breeze kicked up. There was no sense in putting it off any longer. As I turned to go inside, I registered that this would be the first time I'd enter my home solo—no one to come home to. No one was coming home. No guests would arrive. Just me and the two cats. Uncharted territory.

I went up to Mark's room. I wanted to feel something, anything. The night before my parents left, my mom encouraged me to sleep in Mark's room, in Mark's bed. His room haunted me. It reminded me of his suffering, commiserate with his death.

Whenever I thought about him as *my healthy Mark*, I could breathe again. But when I walked into the room, my arms and heart hurt, a dull stabbing—a physical stinging.

Amid it all, I underwent a new sense of awakening. Despite the heartbreak, I felt a light burning brightly inside me. This crossroads provided me with an acute appreciation for life. Mark had already given me so much in the twelve years I was with him, and in his death, he gave me one ultimate gift— the fortune to learn, grow, and find a deeper purpose. I was only thirty-four, but I had gained an eternity of wisdom. Caring for the man I loved and saying farewell to him offered me a precious opportunity some people never have. In loving and losing him, I discovered a life-changing sense of meaning and reason that would stay with me always.

No matter what I did or didn't do, I had to accept change as a constant and inevitable part of life. I believed in my strength to persevere and not fear unexpected opportunities, even if they might not go as expected. I unconditionally accepted who I was, my past, and others. Looking back, I can appreciate how these principles helped me navigate the many obstacles I faced after Mark's passing.

Sitting on the bed after my parents left, I stared into the open closet, which was now empty. The medical supplies had been cleared out. I clutched the small wooden cross a friend had gifted Mark and appreciated the softness of the mattress beneath me. I conjured up the odor of death, the bile—another flashback to the afternoon he died. The bile smelled like rust. I remember the young woman from the hospice coming into the room. She had long red hair. She gasped and put her hand to her mouth. "He's so young."

She lingered for a few seconds. Then, realizing she had a job to do, gathered up all of the narcotics. "Is this all of the medications?"

All I could do was nod. I didn't have the energy for words.

She proceeded to take inventory and then flushed the drugs down the toilet.

I stayed with Mark, holding his hand, which was cool to the touch, and stroking his soft blonde hair. On this very bed. In this spot where I was sitting. Feeling nothing.

Now, sitting here, I wish I could feel Mark. I thought I would be conscious of his presence, but I wasn't.

I meandered into the family room, searching for something or someone. I found only gloom. The air had been sucked out of me. This isn't real. I had just witnessed the man I thought I could never live without *die*. For me, grief was love, joy, excitement, loss, melancholy, confusion, numbness, autonomy, appreciation, heartbreaking, eye-opening, full of anticipation, and exhausting. I felt a sense of accomplishment. I had just gotten through something big and survived it.

But, on the other side, there was tremendous agony and palpable anguish. My body hurt. The pressure was building in my chest and my throat. It was like a dam holding back a flood. Tears were forming at the back of my eyes, but they needed permission to flow. I was not an actress who could turn sobs on and off. The wall I had built to keep them locked in did not crumble easily. I had worked hard to keep the crying in.

The room was dark except for the lamplight in the corner. The decorative throw pillows were placed neatly in the corners of the plaid sofas Mark and I had handpicked. I could still discern tracks on the rug left by the vacuum. I had hired a cleaner—life is too short to chase dust bunnies. I studied the stereo cabinet, a light-colored armoire, the first piece of furniture Mark purchased for our little apartment in Iowa. I switched the stereo on, grabbed the remote, and pressed the play button for the song du jour. But has it been on replay for a week? A month? Time is mysterious in the midst of despair. You lose track of time; it flies by, yet sometimes a second seems like an eternity. The song was by Chevelle, *Send the Pain Below*. It started measured and deliberate. My body was full of the beat, and with eyes closed my head bobbed up and down to the rhythm. The drums were thumping. I depressed the volume control. Louder. Louder. Louder. I screamed out the lyrics. My fists reached for the sky, and I pulsed with the music.

Eyes pressed shut, I punched the innocent pillows. The singer screamed in the background. Louder. The windows vibrated. I briefly wondered what the neighbors must be thinking, but the piercing ADT alarm cut through that thought. Note to self: reset the alarm after my intoxicating release. I hit play repeatedly, getting it all out, ugly bawling, the kind I only allowed myself to release when I was alone.

The music stopped and my breathing slowed. The pressure in my body melted away.

I began to understand that grief was complicated, a complex and deeply personal experience that was both challenging and transformative. Disease and death had cracked open any notion I had of control, control over anything, the weather, health, others. Managing uncertainty is a fool's game. I knew I could not control every aspect of my life. I let go of my grip on what once was and my longing for what should have been. Being vulnerable was being alive.

PART THREE

CHAPTER 16

N E W
B E G I N N I N G S

MARCH 2004

It was another spring. I sold the house and moved into a townhome, bringing my window-shaking stereo system with me. I still sought release in blasting my favorite songs. It was like a means of escape, a refuge of sound that inexplicably calmed me after a triggering event. It was healing. But living in a townhome had the drawback of neighbors on both sides of my unit. Regardless, I turned up the volume dial and Limp Bizkit's screaming occupied the room with profanity and raw emotion. The intensity of the tunes matched the many dimensions of my emotions—sadness, anger, elation, and a sense of aliveness.

I poured myself a glass of red wine and hopped around the kitchen, punching my fists toward the ceiling, head-banging with the rapid slang words as they pulsed through my body. For a time I thought my life was over after Mark passed, and I prayed I would die of a broken heart. But here I was, still standing, still discovering who I was after death. I had learned to pick up the pieces of my new life while letting go of one thing after another. My marriage, my home. Letting go of his clothes, buying single woman clothes. Letting go of his tools, hiring a handyperson to help me. One thing was dying at a time. I was a young woman in my home but surrounded by "our" things. He was still there but he only entered my space when I let him in. I was still alive. He was not.

As I reflected, my phone interrupted my thoughts. It was Meghan.

"Hey, what's up? Everything okay?"

Meghan's tone was playful. "Are you positive you won't come line danc-
ing with us? Sitting home alone is *not* living!"

I pictured the lively dance floor atmosphere with people tapping their
boots and laughter in the background.

"I'm sure," I responded, "but thanks anyway."

"Ha! But remember what Mark said to you before he died?"

How could I not remember what Mark had said to me? He held my hand
one evening about a month before his death, and he said, "I love you. And the
thought of you being with someone else ..." I squeezed his hand and tried to
picture my life without him, but I couldn't.

"I want you to remarry. But if you do anything stupid, I will return to
haunt you. I will slam doors!"

He was trying to be funny and lighten the mood, but I was grateful he
was permitting me to remarry. As hard as it was to visualize being married
to anyone else, I did not want to live forever on the hill with cats and be con-
sidered the baffling cat lady.

As Meghan let out another sigh, she said, "Okay, but I'm here if you need
anything! *Anything!*"

As I settled into the plush cushions of the couch, the television flickered
to life, casting a soft glow across the room. The soundtrack of the movie *How
to Lose a Guy in 10 Days* flowed through the air. I welcomed the peace that
came with being solitary. I liked being alone, but not lonely. I was becoming
a new me.

Yes, my husband still resided in my heart, memories, and the subtle
touches that beautified my home. But now, I had embraced my individuality
and identity apart from him. I had discovered that life still held moments of
pleasure and contentment, even without his presence. As I got comfortable
and ready to enjoy the movie, I was thankful for my inner strength and resil-
ience that steered me to this peaceful moment.

A ritual had taken root within as I neared the two-year anniversary in my townhome. Every Saturday morning I hit the treadmill, where the steady rhythm of my footsteps echoed off the walls of the basement. It was here, on the treadmill, where I embarked on a transformative expedition—training for my first half-marathon, a grueling 13.1-mile test of endurance. In the coming weeks, I would join a group called Team In Training, where my passion for running would find a home with others in a like-minded pursuit of purpose. Yet, as I approached the end of my workout, a surge of apprehension coursed through me. The question loomed in my mind, pecking away at my determination—was I up to the challenge? Could I run a half marathon? I was still doing the walk–run routine: run for five minutes, walk for one minute, and repeat. One more minute until I had to run again, but this was my last push. *Just five more minutes.* And what about the fundraising? I had to raise $2,500. Raising money for the Leukemia and Lymphoma Society to give back to cancer research was a way to honor Mark. I had mailed all of my fundraising letters. I was committed now. And who knows? Perhaps I would meet new people or a new man through the team?

I dialed the treadmill speed up to 6—last five minutes. I glimpsed myself in the mirror. I had lost weight and had kept it off. Of course, the regular workouts helped. I looked appreciatively at my toned legs. They hadn't been this muscular since I'd left the stage. My eyes ran up to my chest. *Oh, Mark. I know, I know. You always said you loved me just the way I was. But you died. This is my life now.* I admired my new breasts as they spilled out of my sports bra. It had been almost a year since I had them done. *Mark, you would not recognize the woman I have become. I never thought I could make momentous decisions the way I have these last few years. Selling the house. That was a big one.*

I had made it through all my firsts: my first Christmas without him, my first New Year's, my first birthday, my first missed wedding anniversary, and then, the first anniversary of his death. I had made it! But the second year

was more challenging. The false sense of security, believing I had made it, then when the second year came, WHAM! No longer in shock and denial; it was like being smashed over the head with a two-by-four, and I was back to the beginning of my grief cycle. My insides felt like a ping-pong ball, bouncing through rage, acceptance, and bargaining.

The days leading up to an anniversary would loom like a gray cloud overhead. I tried to ignore it, but the only way was to go through it, so I created a new custom. I would set time aside to be alone, light a candle, pull out pictures, and cry. I would tell myself to grieve, to get it out. Bereavement will not slow me down or define me. I allowed myself to feel it fully and release it. But subconsciously, I would protect myself and stay physically and emotionally safe. Trauma had rewired my brain. I knew my life was unfinished and felt mentally adrift and desensitized. But I took that emotional baggage and stowed it away in the attic of my brain with the hope of it vanishing. And it did, but only briefly. If I sat still too long, the heartbreak and the reality of my loss would wash over me. My breathing became shallow, and I was hit with a stabbing pain in my heart as I let out an ugly cry. So, I would distract myself with alcohol and movement, staying busy.

Although I considered it my townhome, I'd brought many of our things. Mark's cookbooks were lined up on the baker's rack. I decorated with our sofas and our paintings ... but this was my home. I selected all the upgrades. I added the deck. I chose everything. *Mark, you would be proud of who I am today and who I am becoming. I think you would like the new me.* I even threw myself a housewarming party! It was a success. I pulled out our nice things, ironed and folded the white cloth napkins, and chilled the drinks. We had Kamikaze shots and smoked cigars on the deck in remembrance of you. *I even remembered to put the salt and pepper shakers out, Mark.*

The treadmill's console read two more minutes. *I can do that.* And I put one foot in front of the other.

The townhouse's walkout basement featured tall windows, allowing the sunlight to create a pattern on the fluffy carpet and white walls. The reflection bounced around, generating a cheerful radiance despite the fresh coat of snow on the ground from a gloomy winter. My favorite song came onto MTV, inspiring me to run faster and faster. I let my body take over as I stepped into the familiar territory of running, running away ... but from what? One step after another, faster and faster ... I let my mind drift. Thoughts I would only think of, but never share with another soul. I had never been single for long, going from one relationship to the next like runners in a relay race, passing the baton to the next guy, never slowing down. Even after Mark's death, I should have spent more time grieving instead of meeting men just three months after he died. None of them had worked out anyway, and I was settling down into a regimen of being single and okay with it. I had placed myself in a dating intermission.

I shortened my skirts, wore sexy stockings, and seduced men. The wrong men. I got into some predicaments, much like I had done before I met Mark, but this time I was armed with knowledge, commitment, courage, self-esteem, tenacity, and a health certificate stating I was STD-free. Memories of past relationships inundated my thoughts as the endorphins from my workout flooded my body—the runner's high. I abruptly turned the treadmill down to a walking pace and pressed the power function off on the TV. The room was empty and detached without the striking of my Nikes on the treadmill and the tunes playing on the TV. Familiar? But why?

I had so much to look forward to. With only the sound of my pounding heart, I peeked at the treadmill screen and giggled as I thought of the day it was delivered to our Stonegate home.

"You have got to be kidding me. Why on earth would you spend so much money on a clothes hanger?" Mark teased. He took pleasure in teasing me that I would not use the treadmill, but now I was alone. It had become a lifeline for me, an instrument to keep depression at bay. And now I was

preparing for my first half marathon. I took thirty more seconds to walk it off and have a break before beginning my core routine.

I laid my yoga mat on the floor and started in my plank hold. Why did two minutes seem like an eternity? Feeling the burn in my lower core, I was relieved to move into my side plank hold. Then I laid down on my back and rose into a crunch, twist, crunch, and twist to work on my obliques.

I had long ago mastered existing in more than any one world at a time, so I shifted into adding another world after Mark died. There was the world of Mark and his death, heavy with sadness, and then there was the world of new opportunities, happiness, and abandon. I would go from one world to the next, moving through them like a revolving door, one way in, one way out. But so much happens in between. I revolve. Worlds blending into one another.

Never quiet, never still, rarely present. I was doing the best I could, following my instincts. My proclivity was to disassociate, numb out.

With my new freedom came partying and going to every happy hour. Mark's illness and death taught me a valuable message. Ultimately, we have minimal jurisdiction over things, so I craved to manage what I could. I could not control his exit, but I would try to control my future. Lying on the yoga mat, I began the leg raise portion exercises, focusing on the lower abdominals. I rolled over for some final plank holds. I was okay. I liked my life.

I snatched my water bottle and told my two striped cats, Buster and Taz, "We're going to be okay, guys." Both cats were from the same litter. Mark and I adopted two because they had major shoes to fill after Sneakers died just after we moved from Iowa to Pennsylvania. I wanted to name them Saddam and Hussein because, as kittens, they were crazy, but Mark didn't think it was a good idea.

Taz squinted his eyes at me and stretched in the light of day, ignoring me. I headed upstairs to the kitchen and prepared my new breakfast of choice after a run—scrambled eggs with spicy Monterey Jack cheese and turkey

bacon. While the bacon sizzled, I cranked my music up and unloaded the dishwasher. I held my shiny Cuisinart pans and was smacked with a flash of clarity: I was single and didn't have a boyfriend, nor was there anyone waiting on the sidelines. I have had someone queued up or in the works all my life, not because I was unwilling to be single but because someone was always next in the queue. I was thirty-six years old. It was conceivable I wouldn't meet someone and may never have children. But also, I loved myself for the first time in my life. I had a job. I was independent. I liked who I was and where I was.

As the snowflakes continued to fall throughout the day, I cocooned in my home—such a peaceful night. I sat still, not having to keep active doing something all the time. I had survived an entire weekend at home. I was healing. The recent coating of snow muffled any sound that might sneak into the bedroom windows. I knelt at my bedside with darkness and silence engulfing me, wrapping my hands in prayer. Tears rolled down my cheeks. I slid down onto the floor and crumpled up into a ball on the floor, knees to chest, and I cried. I just cried. Then the tears stopped coming. I kept my eyes closed and felt at peace from releasing pent-up emotions. I felt like a little girl again. Jesus was in the room with me. He scooped me into His lap and cradled me. He told me everything was going to be alright. And I believed Him.

As I reluctantly said goodbye to my brief reprieve, Monday morning came with its usual drill. I dragged myself to work and tried to conceal my red, puffy eyes, hoping no one would discern the telltale signs of my emotional rollercoaster of a weekend.

"So, are you still interested in going to the Red Ball with me?" Katie gave me the "pretty please" expression, like a child asking for a lollipop. She was six feet tall. I glanced up at her. Way up. I wanted to go to it because I had never been to one. She had been telling me about her on-again, off-again

boyfriend named Richard and his questionable antics. He would be there with his single business partner (a fact she excitedly repeated). I initially told her I didn't care. I was on a self-proclaimed time out from dating! Usually, I would have grilled her for details, but I had not even asked her about this business partner's stats: age, religion, ever been married. The fact I was contemplating these stats told me I was curious, but I wouldn't admit that to her! But going to a ball was a social event I couldn't refuse.

I eventually caved in and told Katie I'd attend. I didn't tell her that I had the dress, a hotel room, and hair and nail appointments all booked. I so wanted to go! And it was for the American Red Cross. Great cause, I told myself.

And then it happened ...

K N I G H T N O . 2

I tried maintaining a calm facade around Katie, pretending the upcoming Red Ball wasn't a big deal. However, behind the scenes, I had meticulously prepared for the event. I made hotel reservations in Philadelphia so I wouldn't have to worry about driving home after drinks, and I packed my running clothes in my overnight satchel for the following day. I wasn't going to let a hangover keep me from my run. I had heard Valley Forge National Park, conveniently on my route back home, offered the ideal setting for an invigorating five-mile jog. With my overnight bag and carefully ironed dress, I went to the hair salon, where Nadine was waiting to work her magic on my hair and makeup.

Kaiden, my always fabulously done-up hairdresser, usually cut and colored my hair, but he did not do hairdos! Ever! Nadine often swung by as Kaiden was waving scissors in the air, telling me a story, and she always had a smile. As I slid into the chair, Nadine angled her head and said, "So, what are you thinking?"

"I've never been to a ball before, and it's been years since I've worn a full-length gown. The last time I had my hair done up was when I married Mark, my late husband. How do people wear their hair for a ball?"

Nadine brought her hands to her chest. "Oh, right. I'm so sorry for your loss. This is an important night for you. Your hair needs to be up. You'll look fabulous!"

As Nadine scrupulously rolled my hair up in curlers and stepped back to eyeball her work, we discussed what the night meant to me. I looked in the mirror and saw a beautiful woman, at thirty-six, finally all grown up. When I was last dolled up like this, it was the day of my marriage. That woman, I

thought to myself, was so naïve. She had no idea what was coming her way. Today that woman in the mirror is strong and independent. I was single, but I didn't have the sensation of being alone. I liked myself. Hell, I loved myself.

I almost started to cry when Nadine spun me around to show me her finished work. "No!" she said. "You'll mess up your eye makeup!"

I was a princess. This was going to be my night. I was achieving something I'd never done before. I was solo, staying in the city in a hotel and going to a ball in Philadelphia. I'd told myself I'd be okay a hundred times. But this time, I believed it.

I stuffed my lipstick and flip phone into my tiny purse—no room for anything else. I double-checked my makeup and added one more layer of eyeliner. Good to go.

Katie and I caught a cab together. As we rode toward the venue, my curiosity got the best of me, and I asked her how old the business partner was. Katie snickered as she peeked at her reflection in her compact. "Steve is thirty-seven."

She seemed happy for an escape from the thoughts going on in her head. Richard would be at the ball but did not want to go with her. He was keeping his options open, and she was going to do the same.

We entered the Independence Visitor Center directly across from the Liberty Bell and headed over to the coat check. My eyes were agape, taking in the sights of the beautiful people, the men in tuxedos and women in sequined dresses. I felt like a little farm girl who had been taken to the big city for the first time—and this wasn't necessarily the who's who of Philadelphia. Anyone could go, as long as you bought your ticket, but I was way out of my league.

Being so tall, I let Katie pave the way through the throngs of guests. She knew a lot of people there that night from spending summers at the Jersey Shore and her vocation as a lawyer. I got a kick from observing and looking

at beautiful women with long lashes, nails, and hot bodies. I started feeling insecure and judging the body parts I didn't like—my arms and my lack of six-pack abs, for starters. *Remember, you're only here because you're curious. You're okay.* I went back to my people-watching.

Katie interrupted me and grabbed my hand to take me up a white marble staircase with copper railings. I focused on getting up the stairs. *Don't trip, don't trip, glide like the sexy goddess you want to be. Don't slip!*

At the top, Katie guided me toward the eligible business colleague. Steve towered over six feet, and his look commanded attention. His white shirt matched his straight, white teeth. His bowtie was perfectly straight. He was stunning in his black tuxedo, which emphasized his trim physique and broad shoulders. He had thick, mousy-blonde hair with a hint of gray, a rugged jaw, and a large nose, but it was symmetrical and fit his chiseled face. As he drew near, moving with self-assuredness, the subtle fragrance of Calvin Klein's Obsession drifted on the air. His eyes glided right over me, seeming to stop at my chest for a second or two. But he settled his gaze on the appetizer table in the corner behind me. He turned back to give me another inspection and said to Katie, "I didn't realize you were bringing someone."

Katie explained, "We work together." As she tilted her head to the side, she raised her eyebrows as if to say, "So what do you think?"

Steve's eyes shifted back to the food. He seemed conflicted: woman or food? I detected his decision-making process as his eyes darted back and forth between me and the food.

Katie chuckled. "Steve is a foodie. We have all been warned never to mess with his food."

I laughed nervously. *Was this guy going to choose a cocktail weenie in a bun over me?*

"Would you like to grab some food?" he asked us. Gotta give him credit for problem-solving. We accompanied him and snagged a few appetizers.

"Come on over and join us. We got here early and grabbed a high-top table with a view of the room. It's our landing spot to set our glasses down."

I was introduced to Richard. He was nothing like I thought he would be. As arrogant as he had been described, I expected more than a six-foot, almost overweight, average-looking guy. Noah and Doug, friends of Richard and Steve, introduced themselves. As I was shaking Noah's hand, I noticed he was attractive. He smiled at me, and I smiled back.

Steve intervened, "Careful! You might catch something by shaking his hand. Don't know where that's been!"

I playfully yanked my hand away, and we all giggled. That was the first cockblock of the evening by Steve.

We had a superb view of the lower level. We watched the people below milling about like ants, all posturing to capture the best-looking lady or man. Who would they take home with them? It was wild to observe the hookups in action. We could also view the lineups for the three bars to know which one to hit. Katie and I called for a beverage. We informed the boys we were heading to the bar. None of them wanted to join us, so we took our cue. We were on our own. They would hunt, and we would be among the crowds below and be hunted.

As we gingerly descended the stairs, I said, "So I guess Steve isn't interested in me. That's okay."

"Give him time. I hooked him up with someone last year, and she burned him. He takes his time. He's more of a 'catch and release' kinda guy. He wants to ensure you're into him for the right reasons, ya know?"

"How did she burn him?"

"She was all into him, then broke up with him, then came crawling back. She was a money grubber."

"Oh, I can understand that."

"Yeah, that's why I didn't even bother telling him I was bringing you because it didn't work out in the past."

Katie stopped every three seconds to talk to someone. I wondered if there was anyone in this crowd she wasn't friends with. She would introduce me, and then I'd hang back while she had conversations. One such chat with a six-foot-tall, handsome gentleman was taking longer than the other exchanges, and that opened the door for me to be greeted by two men, both in tuxedos.

One of the duo said, "Do you come to many of these galas?"

My mind wandered, and I discreetly glanced around the room. I wasn't particularly attracted to him, but I didn't want to be rude. "No, actually, this is my first one," I said as I pulled my handbag closer to fidget with the clasp.

"Yeah, this is my first, too." He paused. "So you're single? I can't believe a woman like you is still single."

"Well," I hesitated, "my story is complicated. I lost my husband two years ago," declaring I was not damaged goods, not divorced, something I had to explain.

"Oh, wow. I'm so sorry for your loss." He began to tear up. "My wife passed away of leukemia a year ago."

My heart instantly softened.

"I'm so sorry. My husband died of esophageal cancer." We began talking and his friend looked around for a distraction, sensing the exchange was on the serious side. I wanted a distraction too. The small talk was tiresome.

"Would you like to dance?" I heard a voice say. I turned, almost running into Steve, and realized he'd probably figured out I needed saving. This time, he was staring into my eyes.

"Yes," I pleaded. Placing my green apple martini down, he steered me toward the dance floor. In his arms, I forgot about the comparisons I had made with the impeccably groomed women boasting glorious tans, lashes, and bodies. The effects of the alcohol were taking hold, hitting me hard. I convinced myself I was an awesome dancer, although I knew it indicated I had consumed too much. Steve proved an exceptional dancer, smoothly twirling

me around and leading the way. *Was this guy the whole package?* Laughter escaped me, and a genuine smile crossed my face as I enjoyed myself. What a great time I was having with him. *I hope we can have a chance to talk to each other*, I thought.

We left the floor and found a relatively quiet table.

"Thank you for rescuing me from that guy."

"I was worried I'd lost you to the competition. You two seemed to be hitting it off, but something about your body language told me you wanted to bolt."

So he was watching me? Perhaps he was curious about me after all. Not so dismissive!

I tried to read him. He was confident but not cocky, approachable. I dove in. "So, how old are you?"

"Thirty-seven. But I have the body of a twenty-five-year-old."

Tossing my head back, I let out a loud laugh. Too loud. *Jane, play it cool! This guy has game!* "Me too," I squealed! "We have so much in common already!"

He smiled.

"Have you ever been married?"

He hesitated, and he scanned the room. "Yes. I'm divorced."

I felt empathy for him. By the look on his face, it had been a painful experience. "Oh, I'm so sorry." *Had I blown it?* I wanted to get to know this guy.

"Any kids? Do you want kids? How many? Would you ever try marriage again?"

Laughing, he dodged the question and said, "Katie said you two work together. Are you a lawyer?"

"No, I'm a court reporter."

Steve got around to answering my question. "Okay, so, yes, I want to be remarried. No, I don't have any kids, but I really want kids. What about you?"

"I want to be a mom. Definitely."

He sipped his wine. "So you're not an attorney. You just ask questions like one." His eyes softened. "The bar is going to be closing soon. How about one last drink?"

"Sure. One more."

He returned with two martinis. He was a troubleshooter. Bar closing, load up on extra drinks.

I told him, "You know, I can't drink these. I already can't feel my nose!" Another telltale sign I was drunk.

"No problem. You don't *have* to drink both!" he grinned.

The music wound down, the lights were turned up, and people scattered. I spotted a few stragglers, the singles still hoping to find a mate for the night, becoming more frantic like a nocturnal predator exposed at daybreak. Steve took in the dwindling crowd and asked, "Do you need a ride to your car?"

"Well, I took a cab here. I have a room in the city at a hotel." Cha-ching! Did I see a sign of hopefulness on his face?

As we approached the exit, he continued. "I can drive you. Where are you staying?"

Before answering, I motioned toward the lengthy coat check line growing by the second. I needed to pick up my coat. As we stood—okay, I was wobbling from too many drinks and multiple hours in high heels—we made small talk while we waited.

Steve kept looking at the doors to the exit. "You didn't check a jacket, did you? You know it's freezing outside, right?" I asked.

He used his height to survey how long we would have to kill time. "I hate lineups, so no coat check for me. But for you, I will wait." He smiled.

Two young women were sliding jackets off hangers as we approached the counter. The brunette gaped at Steve and gave him a sly smile, but Steve held out my ticket.

"I believe you have this young lady's coat." She studied me. I think she knew I had won the jackpot.

He expertly held my full-length winter coat for me as I managed to work my arms into the sleeves. *Why did I consume so much alcohol?* He gently held my hand and led me through the revolving doors into the cold. Even though he was not wearing a heavy winter jacket, he slowed his pace so I could keep up with his stride in my high heels. He had to be freezing! We set foot into the parking garage elevator, and we both exhaled relief it was just the two of us up to his car.

There was a pause in our conversation, and our eyes locked for a moment. He leaned in to kiss me. I should have seen it coming, but I was seeing double. I failed to see the signal and the movement of the elevator was messing with my head and stomach. I quickly turned and looked out the glass elevator at the people, and Steve missed and did a face-plant into the elevator window instead, leaving a smudge on the glass. Steve played it off as if nothing had happened like he was leaning over to glimpse what was happening with the people outside, but I noted it. I was drunk, yes, but not on the verge of passing out.

We walked up to a silver sedan and Steve opened the door for me. Somehow, I piled into the car with a bit of help. We ascended the winding ramps towards the cashier when Steve applied the brakes. Cars by the score were jockeying to get into the queue.

Steve moved the car forward slowly, never taking his foot off the brake, keeping a safe distance from the vehicle ahead. If I were driving, I would've rammed into the car in front, pushing them out of the way, throwing my money out the window to the parking attendant, and getting us home as quickly as possible so I could tear Steve's clothes off faster. Well, I would have done that in my former dating life. Now, it was back to basics. Date. Build a friendship. No one else in this line seemed to have the same sense of urgency. They were paying with cash and not only waiting for their change but taking their time to count it before driving away.

To keep my mind occupied, I continued with my questioning. With Steve, it was a good use of time. We would know if we weren't a good fit.

Steve glimpsed at me and then the car in front, initially answering my questions thoughtfully, but then he started shaking his head and laughing as he spoke.

"What is your religion? Oh, none? Well, I'm religious. Is that an issue?"

Steve inched the car right up to the bumper ahead of us, willing it to move, but it didn't budge.

"What about pets? How are you with cats?" It was all about saving myself time and effort.

"Did you say 'cat' or 'cats'?"

"Uh-oh. You're not a cat person."

"Well, I've never had cats. I had a dog growing up named Teddy."

We finally made it out of garage purgatory and I directed Steve to my hotel. He drove with extra care so as not to catch the attention of any police along the way. We kept up the banter throughout the ride, and he made me laugh every chance he got. When we arrived at my hotel, Steve pulled up to the roundabout in front and stopped the car. It was busy at the well-lit entrance with valets and several groups congregating. Steve did not go into self-parking, meaning he didn't intend to come upstairs with me. I wished he'd tried to kiss me, but he just took my number and waited until I was in the lobby before taking off. I was slightly perplexed, but I shook it off. I was still on time out, and maybe his face hurt from "kissing" the glass. Just because he had my number did not commit me to anything; perhaps he was looking to get laid, and once he realized that wasn't my jam, he was done. I suppose that had to be okay if I never heard from him. I went to my room and immediately passed out, feeling like a drunken princess.

The following day, I peeled open my eyes. Crap. I must have crashed with my contacts in. *Where was I?* Oh, yeah, the hotel room. *How many green apple martinis did I drink last night?!* My stomach wasn't doing cartwheels, all

things considered. As I got out of bed, I noticed my makeup was still mostly intact, except for the mascara streaks on my cheeks. Peculiarly, I didn't feel too bad—barely hungover.

After devouring the banana I'd thoughtfully stowed in my bag, I swiftly changed into my running attire, splashed fresh water on my face, and set off on my morning jog. I felt sluggish but good enough to meet my five-mile run. The warmth of the sun's rays energized me as I moved into second gear.

With each stride, clarity washed over me, akin to a computer downloading a file, as my mind replayed the previous night's events, line by scripted line. Did I really grill him like that? My God, Jane! Between all the alcohol consumed and my presumption that he was not that into me early on, it made me presumptive. By the end of the night, he was protective and chivalrous. Maybe he was beyond my reach. He said he went to the Wharton School of the University of Pennsylvania, definitely smart. This guy was classy. Well, regardless of whether I ever heard from him again, I had come to terms with the possibility I may never receive a response. Embracing my solitude was empowering, yet a secret longing lingered—I couldn't help but look forward to him reaching out.

Steve called me a few days later. We exchanged quick pleasantries before planning to meet for dinner Friday evening at seven, which was ideal. I could still hit happy hour after work at the local tavern first. My nerves settled as I sipped my beer with my favorite coworkers, but then I peeked at my watch.

Nicole, a single coworker, said, "Are you ready for your hot date tonight?"

"Honestly, I don't want to end happy hour," I answered. I hadn't thought about what I would wear, and after spending so many months trying to pick the flawless outfit for a first date, I was done caring about this menial task.

"Know what I think?"

Oh, here she goes again!

"You're searching for Mr. Perfect. He doesn't exist."

"No, I'm looking for Mr. Perfect for me."

"Based on what you've told me about this guy, I think you're scared ... and insecure."

I didn't want to go on this date anymore. I was over it. I was still on a time-out! But Nicole had struck a nerve. This guy had class. It mattered more than the others. I *was* scared. And intimidated. I could take the easy way out and stand him up. But I was more reliable than that. I rushed home, showered, and dressed in my favorite first-date outfit: a black pencil skirt, a red silk camisole with lace, a black cashmere cardigan, and my highest black heels because I recalled he was tall. As I finished putting my lip gloss on, the doorbell rang. He was right on time, which didn't surprise me after our first encounter. I opened the door and immediately remembered how handsome he was. This might be a good time, after all.

SECOND ROUND

That first date with Steve was a whirlwind. He chose a local Cajun restaurant outside West Chester called High Street Caffe. The windows were dressed with purple sheers and yellow lights. Mirrors and street signs from New Orleans hung on the plum-painted walls. We inhaled the stunning aroma of Creole seasoning as we took our seats.

I took the lead as he pulled my chair out. "I can't believe you wanted to go out with me after I grilled you that first night! I'm sorry."

"Actually, I thought it was endearing. It told me you're not a serial dater and know what you want."

"A serial dater? Never heard that term."

"Yeah, you know, someone who is always looking for something better. They love the thrill of the chase but don't want to commit."

Something told me Steve was not a serial dater or looking for a serial dater.

"You were so busy grilling me, I didn't have a chance to interrogate you! My turn!" I thought he was a little too enthusiastic.

Placing my forearms on the table, I leaned in. *Wait, can you put your forearms on the table? Is that rude?* "Ready."

"I never park in a parking garage. I always park on the street, avoiding post-event traffic for a quick getaway. But there was no street parking that night, so I was stuck in a garage with you questioning me, but I'm glad. I found it refreshing."

Refreshing? And here I'd been so embarrassed. "So you have dated a lot? Are you a player?" He seemed to take it as a compliment.

"I've dated, but I want to settle down, get remarried, and start a family."

Was this guy for real?

"What about you? I didn't get to ask you if you've ever been married."

"Well, it's complicated."

"Wait—you're married?"

Laughing, I said, "No!" I drew in a breath. "I'm a widow."

I always hated disclosing this part of my past. People would go silent, not sure what to say. Then there was the newly single guy I had the pleasure of going out with once, who responded, "You're lucky! I wish my ex-wife were dead." We never went out again.

But Steve didn't avert eye contact. "Oh, I am so sorry. How long ..."

"Excuse me. I hate to interrupt, but would you like a cocktail?" The server was young and she nervously slid her hands down her white apron and thighs.

"Would you like a green apple martini?"

"Oh, no, thank you. I'll have whatever you're having."

"Would you prefer red or white wine?"

"Whatever you order." *Jane, hold it together. Don't let on you don't know about wines!*

"Why don't we have a bottle of the J. Lohr Cab?"

The server replied, "Excellent choice. It's very popular."

This guy seems so put together and successful, yet he ordered a reasonably priced bottle of wine. Nothing extravagant and not pretentious.

We let her walk away before we picked up where we'd left off.

"Honestly, I am blessed to have gone through losing someone. I don't sweat the small stuff, and I appreciate life." I was telling Steve my grief was wrapped up in a benign box, stowed away, and dealt with. I was convincing myself of that, too. Heartache won't define me.

"So you two didn't have children?"

"We didn't. Although Mark was great with kids, he didn't want any of his own." I paused. "But after his death, I longed to be a mother, either as

a stepmother or kids of my own. I can't explain it, but I have a hunch kids unlock your heart."

We sat quietly. It was effortless to be open and honest with this guy.

"Would you ever picture yourself as a mom?"

I giggled, recalling my Stonegate mom friends who often complained about motherhood, yet they couldn't seem to be away from their little ones. "I think I'd love being a stay-at-home mom or working part-time. I think it'd be important to have options."

Steve smiled a warm smile. *This could be a forever match,* I thought to myself.

We carried on with dinner and thoughtful questions back and forth, infused with some humor. It was a captivating evening that cleared the way for what would become innumerable memorable outings. We delved into a beautiful rhythm, our connection deepening with each passing day. Over the next year, our relationship blossomed, and Steve knelt before me with a marriage proposal. I said yes! Packing my belongings, I merged my life with Steve's. I sold my townhome, permeated as it was with memories. It was a bittersweet moment, bidding farewell to a place that had seen me through growth and transformation.

As we settled into our new life living together, Steve's career in the hedge fund industry demanded a dedication to long hours and high stress. He worked a grueling schedule during the workweek, arriving early at the office and staying past when the stock market had closed. Weeknights were simple and uniform: easy meal, a glass of wine, fire in the fireplace, and a show. We frequently picked up takeout from a neighborhood sushi restaurant on Friday evenings and discussed weekend plans.

"I was thinking of trying a new hike. It's eight miles and has amazing views!" Without taking a breath, he continued, "And for tomorrow night, I thought we could go to the Greek place. You know the one where we celebrated my birthday last year?"

"Do you ever slow down? The girls are not running this Saturday, so I'm considering sleeping in."

"It's going to be the perfect temperature, with low humidity. And I need to regenerate. Work was beyond stressful this week."

"You are like the energizer bunny! Does your brain ever stop?"

"Come on. The leaves are brilliant this time of year."

"Do you ever just hang out and chill? Take a nap?"

"I can't nap. You know that. I lay tossing and turning, thinking of everything I have to finish."

He would not give up easily, but I gave it one last try. "I thought you were the master of compartmentalization."

"I am! Weekends are for decompressing!"

I smiled, and he knew he had me.

"I know you want Fairlane pancakes... gotta beat the line! Up before nine."

Before our weekend hikes, we would stop by the Fairlane, a quaint breakfast spot nestled in the heart of the town. The owner, Gerry, held the secret to the most heavenly blueberry pancakes, cooked with a slight gooeyness in the center—my favorite part, with a sprinkle of powdered sugar topping the fluffy stack and a side of crispy bacon to complement the sweetness.

"You got me," I said, caving into his request.

After breakfast, we would go to the Chestnut Hill Cheese Shop, where Steve, with his discerning palate, would select three of our preferred cheeses. Next, we would buy a loaf of freshly baked bread, its aroma wafting through the air, making our mouths water, and we completed our picnic with a decadent pâté.

Equipped with hiking boots, backpacks filled with supplies, and water bottles, we began an eight-mile trek. We climbed to the summit of the ridge and enjoyed scenes of the valley, but the real reward was the fresh bread and pâté at the peak. Grapes and cheese were secondary.

Steve pointed to the sky. "Look at that hawk! He's circling. Bet there's a dead animal in the woods."

Less interested in what creature was being hunted, I said, "Can you believe we're getting married in less than two months? I have so much to do."

"It's the ideal time of year. The weather, the leaves ..."

A chipmunk poked its head up from the rocks and peered at us.

Steve chewed his last handful of grapes and said, "Remember our first date?"

"How can I forget! You selected the spicy shrimp, and you were sweating all over the place!"

"It wasn't the shrimp that made me so flustered! I was nervous. You were so hot!"

"Oh, stop it."

"Do you recall talking about having kids?"

"Oh, yeah. My clock is ticking. That hasn't stopped."

Fixing my gaze on Steve, I sensed he wanted to say more, but he didn't, so I broke the stillness. "I love you and can't wait to spend the rest of my life with you."

"Me too." He went quiet. Then said, "I never want to go through divorce again. You know, for me, marriage is forever."

I nodded. "You never told me why you two split up."

He surveyed the hawk. "Well, we moved from San Francisco to Pennsylvania, away from her family. At the time, she was okay with it but became depressed and moved back home. By the time we went to counseling, she'd already decided. I couldn't talk her out of it. She brought me to the session to tell me she was done. I wanted to work it out, but it wasn't up to me."

"I've seen so much conflict working as a court reporter in family court. I'd rather bury another husband than get divorced."

Steve poked me. "Hey, I don't plan on dying, either. Don't get any ideas."

I laughed. "Remember our deal? I'm going first this time!"

"Oh, no, you don't," he said, leaning in and kissing me.

We both took in the beauty of the canyon. The leaves began changing to bright yellow, orange, and vibrant red. The sun was going down, and the trees looked as if they were glowing. Another beautiful East Coast early fall sunset. Steve and I descended the mountain quickly, enjoying the downhill momentum, and headed home.

We sped along the highway. The top of the Mercedes convertible (Steve's most recent purchase) was down, and the wind whipped at my hair.

"So, what do you think about going off the pill and working on becoming pregnant? We're tying the knot in a month anyway."

I felt my eyes widen as I stared straight ahead, trying to hide my excitement and be cool, but inside, my heart was smiling. I loved hearing those words from Steve. I was thirty-eight, and we both wanted a family.

I toned down my eagerness. "Sure. Let's see what happens."

Was I able to get pregnant again after my antics?

I thought back on my first and only pregnancy eighteen years earlier in some small town when I rolled over, unable to remember where I was, with my head spinning from multiple glasses of champagne, only to note the stranger in the hotel bathroom. I recall my dress lying on the floor in a messy pile. When the man shut the bathroom door, I was in darkness. I couldn't recall his name. At the time, a thought had crossed my mind: *What if I got pregnant?* I wouldn't have a clue who the father was. The man behind the closed door was the third person I had slept with that week.

Several weeks later, I stood nude in front of the mirror. My breasts were tender. And Steffanie confirmed they were bigger. One pee on a stick revealed a positive result. I was pregnant at twenty. No idea who the father was. I had dropped out of business college to become a full-time stripper, so cash was not an issue. What did I *want* to do?

I called my mother from a payphone outside the Bustop strip club.

"Mom?"

There was a long pause. She heard the loud music in the background and knew I wouldn't call her at nine at night with good news.

"I'm pregnant."

Silence.

"Mom, I'm okay. I know what I want to do."

My mom breathed a sigh of relief. It was not her decision to make. And she did not push her opinion on me about what I should do. Instead, she made an appointment with the same therapist I had seen in my teen years when she and my father were divorcing and I had been acting out, all the teenage stuff. My mom was at a loss for what to do with me.

I understood I had to face my situation head-on. I sat on the couch in the familiar room. Dr. Reagan's hair was thinner, but not much else had changed. The last time I was before him, I was bashful and young. I wondered what his impression of me would be now.

"Let's talk about your courses of action and the consequences."

"I want an abortion. I have thought about it."

"Well, it looks like you've outgrown a lot of your shyness. Stripping has done for you what therapy couldn't."

His comment stung. I was a whore who hooked up with anyone. I was knocked up and didn't know who the father was. Stripping had boosted my ego, and I'd shed my inhibitions and perfected the art of schmoozing with strangers, all beneath the blazing lights of that stage. But under it all, a nagging sense of unease lingered. The little girl inside me yearned to speak up, to assert my innocence, but I forced her to remain voiceless as I pressed forward. The applause and adoration made me feel special but exposed. Men's lustful gazes held me captive, and I had grown to resent it all.

He missed the warning signs. Over the years I had come in and out of his office with tense body language, balled-up fists, and clenched teeth. And that day, as I sat declaring my resolve to have an abortion, detached from emotion, not even knowing who the father was, he complimented me on my progress.

My progress? I had drifted through a slew of encounters, my relationships transactional at best, my link to this pregnancy virtually nonexistent. But he saw a confident young woman who knew what she wanted. I went forward with the abortion and had no regrets. That was my most sensible option at that point in my life. I am grateful my mom let me arrive at my solution. She questioned whether she did the right thing, but I assured her I needed that choice and needed to make that determination. I did not need someone to tell me what to do with my body.

God, I hope I can get pregnant. As our car careened down the expressway, I cranked up the volume on the radio, focused on the sky, and whispered a prayer, my voice quivering with both gratitude and longing. *God, please forgive me. I don't regret the past, but now I want the opportunity to be a mother and start a family with Steve. Please, please, let me conceive.*

PART FOUR

CHAPTER 19

B A B E S A N D
F L A S H B A C K S

Steve and I wedded on October 21, 2006, and we hardly had time to place our thank you cards in the mail from all the wonderful wedding gifts when it was time to take a pregnancy test. It was the Monday after Thanksgiving. Steve was in his bathrobe, moving back and forth, getting ready for work. I kept an eye on the clock. Five minutes had passed. I went to the bathroom to check the results. This was it. I carried the stick into the bedroom, where Steve was waiting. As he placed his hand over my shoulder and stood behind me, I pulled the stick out of its container to reveal a plus sign. I was pregnant! Joy filled my body, followed by relief. God wasn't mad at me after all. God had forgiven me.

"We're pregnant!"

Steve began hopping around the room. "I knew it! See? I told you!"

Our excitement was interrupted when Steve peaked at his watch. "Oh, jeez, I have to go. I'm late. We have an important meeting today." He came back over to me and clutched my shoulder. "Aren't you excited?"

I hesitated—scared and thrilled all at the same time. Steve grabbed his coat out of the closet. I was grateful I didn't have to go into the office that day. It allowed me space to soak up my new adventure. As Steve bustled around the house, snatching his briefcase and keys, he gave me a quick kiss goodbye, and I reflected on how blessed I was to be pregnant. Again. Just another secret I had not told Steve. The weight of my past, the choices, and the traumas hid like a shadow behind every shared moment with him. Steve scuttled out of the room, and I sat on the bed looking at the positive test strip.

Instinctively, I rubbed my belly. I would be a good mother—no, the best mother—despite all my father had preached to me over the years. He would talk *at* me, not to me. He had strong unshakable beliefs. He believed abortion was murder—no questions asked. I tried to tell him I had had an abortion, but he was too busy preaching his beliefs to me and anyone else who would lend an ear. Every morning, he pinned an American flag on his lapel right next to a tiny pin of two feet that represented the size and shape of the average termination. They resembled the "hang 10" logos. People asked, "Why do you have a pin with feet?" And that would open the door for him to remind everyone within hearing distance that if a woman had an abortion, she would struggle with infertility and regret her decision to kill her baby. I took his views seriously. I never regretted my decision, but I often wondered if God would punish me and not allow me to conceive again. So that morning, as I observed the plus sign, I was grateful for a second chance at motherhood.

Tate, our firstborn, was born in August of 2007, and I was pregnant with Chase four months later. Two kids a year and a week apart. I was grateful to be a mom twice. But I was also melancholic. I had resigned from my court reporting position just after finding out I was pregnant with Tate, and I used my time to organize the new house for kiddos. With two kids so close in age, it was a good thing we were prepared when Chase came along. Steve was still working with the hedge fund, and I was finding my way as a stay-at-home mom, all the while sliding into depression. I tried to explain it away. I used to be a professional dressed in a suit every day. I had my paycheck and my bank account. I was self-sufficient. I still missed Mark. But surely I was not depressed. I had been through so much in life and survived. This gloomy phase would not last.

One morning, as I opened the closet, trying to figure out what to wear, I noticed the business suits, collecting dust. As I scanned the few casual clothes on hangers, I knew they would no longer fit my mom's body. I flicked out

the light, went to the dresser drawers, pulled out my baggy cargo pants and a knit top, and remembered I would be covered in spit-up in two seconds, so I grabbed an extra shirt to take downstairs with me. With two littles, leaving them for a second was impossible, so I planned the day to the minute. I just needed to make it to nap time.

After one particularly long day, I breathed a heavy sigh, looking forward to dinner plans later that evening with friends. These plans meant drinks, and drinks made Steve hopeful, thinking he was going to get lucky. His job had taken an even more stressful turn right after Chase's birth due to the collapse of mortgage-backed securities tied to real estate and the bankruptcy of Lehman Brothers, a major global financial firm. This triggered an international banking disaster, leaving him constantly on edge. And when he was on edge, sex was a release, but I found it challenging to respond. With two young children demanding my attention all day, I developed an aversion to being touched by him, and our emotional connection was dwindling, making intimacy out of reach.

When Steve sprinted in the door that evening, a rare weeknight when we had plans with friends, he asked, "Are you ready? Let me get changed, and I will be right down."

The kitchen was a battleground. Dirty dishes and sippy cups were piled in the sink, and stray Cheerios were under Tate's highchair. "Do you not see what I'm dealing with here? I'm in the middle of feeding two kids. I won't be ready for a bit."

Chase screamed. Again.

I took my eyes off Tate long enough to scowl at Steve and then heard a splat. Tate had pushed his bowl of mashed peas off his tray. The green concrete-like concoction made nickel- and dime-sized dots all over the stove and the floor. I wanted to yell at Steve, tell him it was his fault. But it wasn't.

So, I poured a second glass of wine—anything to numb my reality.

As Steve returned to the kitchen, noticing my glass, he said, "Tough day? You can have another glass at dinner, too."

Chase was still shrieking.

"Can't you give him a binky? Make it stop!" He demanded.

"He has a binky. He's screaming through the binky. And don't you think I would make it stop if I could?"

"I had a day from hell. My business partner and clients were yelling at me. You could be nicer," he snapped.

"When you're nasty to me, I pull away."

The tension was thick like a heavy cloud as we finished our usual bickering. It was a competition, as always. Who had the worst day? We had only been married three years. How were we going to make it a lifetime?

I went upstairs to change while Steve watched the two littles, and then I heard the doorbell. Natalia, our sitter, had arrived. I freshened up the best I could, welcomed Natalia, and said goodnight to the boys.

"Ready?" Steve asked.

I hung back, torn between the natural parental worry and the anticipation of a peaceful night out. I leaned in to kiss Tate and Chase one more time. Tate was engrossed in his play with Thomas the Train, and Chase was content in his swing.

Natalia reassured me, "They're in excellent hands. Enjoy."

I nodded and added a reminder, "Don't forget to read *Goodnight Moon*. It's part of their bedtime routine."

"They'll be fine," Steve said.

"I know," I replied, trying to suppress my lingering worries.

As we settled into the car, I continued, "I'm looking forward to a sit-down meal without toddler interruptions, shrieking and spitting up!"

"Me too," he agreed.

We pulled into the parking lot, and reminders of our early parenting days resurfaced. "Remember the first time we left Tate? He was only six weeks old! I was terrified. I thought he'd break if someone else were to look after him."

Steve chuckled, sharing in the reminiscence. "But look at us now."

As we held hands and entered the restaurant, I said, "One thing we've done right is continue to have weekly date nights. Thank you for pushing my comfort envelope."

Steve stopped to gaze at me with a genuine expression of remorse. "I'm sorry about snapping at you tonight."

I turned to him, offering a smile and forgiveness, "Me too."

"Work has been so demanding," he confessed.

We squeezed each other's hands, and he kissed me.

"Tell you what," I said, "If you take kiddo duty Saturday morning, I'll get a run in, and during nap time, you can get a bike ride in. I think we both need it."

"Deal," he responded. "But Saturday seems so far away right now!"

"I know, right?"

"Now let's go devour dinner!" he said, opening the door, escaping the havoc of the day and the concerns of parenthood for a little while.

We were greeted with warm air and the scent of the kitchen. Our friends, Barbara and Max, were already seated. Barbara said, "We've ordered a bottle of wine."

Thank goodness. It had been a hell of a week. Steve had had a rough week with the stock market, and Tate had shortened his afternoon naps.

We dove into catching up about kids, work, and life.

"How are the boys?" Barbara asked.

Steve pulled out my chair and said, "They are growing too fast! Tate is walking!"

Max chimed in. "Oh, just wait! We have a story for you! Wait until they're teenagers!"

Barbara had been married and had a teenage son from her previous marriage, and she began telling her story. "Okay, so you know Kevin is fifteen, right? Well, we leave him at home sometimes to babysit Brendan, who is six. But listen to this! The other day, I was in the family room and picked up the throw blanket. And guess what? It was all crusty. And I was, like, what is this? Did Brendan spill something?"

We hung onto every word, expecting to learn of some glue catastrophe for a six-year-old's kindergarten art project gone awry.

"Kevin has been masturbating in the family room!"

I held back a giggle and raised my hand to my mouth.

"I mean, really, kid? Do it in your room!"

Steve and Max began to laugh and make jokes.

"I told him, hey, if you're going to jack off, don't do it in the family room, and don't leave the crusty blanket behind!"

We laughed at the story and tried to picture our then-four-month-old and almost two-year-old boys doing the same thing to us. Then it hit me. There was a heaviness in my chest. I felt hollow. Impressions were coming at me faster than I could process them. I had repressed so many memories, and it was hard to wrap my head around them. The funny story was less amusing now. I was horrified and full of shame. My cheeks flushed with embarrassment as I couldn't wait... to get out of there as a wave of anxiety washed over me, urging me to cut and run to the safety of my home and bed.

M E M O R I E S

I was quiet on the ride home. Steve asked, "You tired? You sure were in a rush to get out of there."

"More like exhausted," I replied with a sigh, the weight of my earlier emotions still heavy on my mind.

Steve's busy job and active mind made it hard to wind down, so he changed, brushed his teeth, and relaxed in the family room to watch TV. I began my nighttime skin routine and was one hundred percent ready for bed before heading down to say good night. I planned to escape back upstairs quickly.

As I bent in to kiss him, Steve said, "I love you. You're a great mom. And you're still hot!"

"Not tonight. I don't feel well. I'm going to bed," I said and kissed him. I hoped this would be the end of the conversation. Anxiety surfaced in my body.

"Night," he said as he fumbled with the remote, trying to decide whether to pursue me or leave me be, but before he could react, I left the room. I climbed into bed, hoping Steve wouldn't come up right behind me and try to talk me into sex.

"Damn," I said, feeling the cold sheets hit my legs. I had neglected to turn on the heated blanket. I lay in the dark, struggling to get to sleep. But I could not close down a memory. I couldn't grasp it. All I knew was it involved a young boy and a young girl. I was about six years old, snug in bed one night, and I overheard my mom and dad arguing. My mom thought James, my oldest brother, was masturbating too much. She wanted my father to talk to

James about it. My father disagreed with her. "It's natural. It's what boys do. Masturbation is okay and normal."

That sent the message that what we were doing was okay. It was okay for a twelve-year-old boy to be curious. It was okay for me to be fondled. It was "normal." And this "normal" continued on and off for six years.

I cringed at the image that had bubbled up during dinner earlier in the evening and pressed my hands over my face. "Fuck!" Like a prisoner, I was trapped and confined by discomfort. I wanted to leave this horror behind and fly away, but couldn't move. In my head, I was on a far-off island, isolated from the entire world. My eyes could not find a focal point in the absence of light. I tried to doze off and push the thoughts away, but shame came in lock-step with a memory from many years ago.

At almost twelve, I was home alone with my brother, James, who was home from college on a break. I went to my room and tried to watch TV, but I couldn't get settled. I undressed down to my underwear. Should I leave my panties on or take them off? I left them on. I scanned my room to find something to cover up with. I grabbed my favorite brown fleece blanket with the shape of a horse's head on it. Its softness and warmth surrounded me. My body tingled in anticipation as I headed to his room in the basement.

As I walked into his room he glanced up at me, maybe unsure as to what to make of me.

My memories became fuzzy. It was as though I was watching a black and white television that kept cutting out. Fragmented images, sounds and feelings.

Blackout.

We never went past fondling, but he often masturbated with me in the room. My body was awakened to desires and sensations before its time. My body craved it, wanted it, desired it. It was real—a byproduct of sexual abuse.

Disgrace. *When I was in sixth grade, I intentionally went to my brother's room to seduce him and wished for more.*

I tried to bargain the dread away. If only I hadn't gone into his room.

If only I had told on him after the first time he touched me.

It was my fault.

I asked for it.

Did I enjoy it?

I was ravenous for touch.

Fear and anxiety ripped through my body followed by disgust. I became nauseous.

My body responded.

What was wrong with me?

Steve would be revolted. My friends would be horrified. I wished for that little girl to go away, back off forever. Go back to where you came from. I separated in two, experiencing simultaneous conflicting reactions, beliefs, and impressions.

I heard Steve coming up the steps. He flipped on the bathroom light, and I kept my eyes slammed tight. I didn't want him to think I was awake or available.

I sensed him watching me. I silently pleaded with myself not to move or open my eyes. The switch clicked, plunging the room into blackness once more. He slid into bed next to me. There was a familiar movement of his hands as he stroked my shoulder, an invitation meant to be caring, but it took me back to the many times my older brother had snuck into my bedroom when he thought I was asleep and put his hands on me. My eyes snapped open, only to be greeted by an impenetrable darkness. Bile rose in my throat. I was suspended, unable to move or breathe. I wanted Steve to stop.

The following day, I whisked the Cream of Wheat until no more lumps were visible. Steam rose in my face, and my arm was cramping with each flick of the whisk, but it was the only thing Tate would eat. I drizzled sugar

into the mixture and watched, mesmerized, as it melted, creating a sweet and syrupy swirl surrounding the creamy concoction.

In his usual hurried manner, Steve swept past me as he snatched his briefcase. I couldn't help but sense the tension between us. As he leaned in for a goodbye kiss, I tensed. There were days, not so long ago when Steve would wrap his arms around me in the kitchen, the world outside momentarily forgotten. But today struck me with a distinct contrast. The distance between us was expanding.

He scooped up the Mercedes car keys and jingled them, "Bye. I'll call you on the way home. Good luck! At least it's Friday!"

Two children under three meant I would need luck. My body slackened a little as the garage door closed behind him.

"Tate, you hungry?" He ignored me and amused himself with his blocks. Chase had quieted from being rocked in his swing.

Tate inched toward the swing, intending to play a favorite trick on his brother by stealing the binky from Chase's mouth and waking him up. "Tate," I whispered. "Want some breakfast?"

I lifted Tate into the highchair with a bright green background and colorful zoo animals. I spooned the sugary blend into Tate's mouth and thought about the previous night. The fear had been acute. I didn't understand why I'd had such an instinctual reaction to the husband I loved (loved most days, anyway!) climbing into bed and stroking my shoulder. As Tate reached for the spoon, signaling he wanted more, I drifted back to another time I was aware of another atrocity teasing me from the boundary of my mind, slightly out of reach.

I'd experienced something similar after my dad's death a few months ago. My two brothers and I were going through my dad's Colorado home. My father had always believed the world would end so he would stockpile supplies such as cereal, canned peaches, and containers of freeze-dried fruits. I was throwing out stale cartons of food, and with each trip to the dumpster out

front, I walked past my dollhouse. It was the one thing my father built for me in his woodworking shop, and we'd painted it white with chocolate-colored trim. Years ago, before moving in with Mark, I had boxed up all the little people and the small wooden furniture and left it behind at Dad's.

But as I made my trips back and forth to the dumpster, I felt a need to look inside the box. The memory was strong and vivid—a little girl playing with her dolls while a boy is watching her. More reminders. I closed the box, shutting out the memories.

Then I spotted the bug boxes stacked on the pool table. My father spent hours building them for my brothers, who were amateur entomologists and won many ribbons in 4-H, a US-based youth organization. I viewed the beetles and butterflies all splayed and labeled. Some parts were crumbling off their bodies. There was a small sack containing mothballs in the corner of each box to preserve them. Death by cyanide poisoning.

More recollections threatened to reveal themselves—a bug net. Bugs are laid out in the basement. A boy and a girl.

Chase began to stir, bringing me back to the present. The motorized swing had stopped. Would this child ever nap on his own? At least he wasn't screeching. Yet. A blob of cereal bubbled out of Tate's mouth. I glided the blob up his chin. "Yummy?" I put the spoon and bowl onto the tray, knowing Tate would pick it up and toss it onto the floor, and went to Chase.

"Hey, buddy. Did you have a nice nap? Are you ready to eat?" I pulled him out and placed him on the floor near Tate's highchair in the vibrating chair. Plop. The bowl of cream of wheat hit the floor.

"Tate!" I drew in a breath, and he giggled.

I smiled, but felt far from being amused.

CHAPTER 21

A MOVE ACROSS THE COUNTRY

OCTOBER 2010

I acknowledged to myself that my unhappiness resulted from multiple factors: the ongoing grief from Mark's loss, which persisted eight years later, coupled with the challenges of raising two toddlers. Adding to the strain was Steve's demanding job in the collapsing financial sector, which led to instances of crankiness for both of us. And then there were the nagging memories that had been awakened in me that refused to go back into the shadows, and I was becoming increasingly more angry and out of control.

Steve and his business partner decided to close the hedge fund, and we decided to move to California—a new beginning for us, and a chance for Steve to be close to his parents. Things would undoubtedly be better in the California sunshine. Moving across the country with two little ones was a blur. On the day of the move, I tossed objects into unmarked boxes. The boys, barely two and three years old, stood in the driveway wearing baggy jeans with diapers peeking out of the tops, striped shirts, and matching baseball caps, waved "see you later" to their toys being shipped across the country.

Once we made it to California, Steve began working from home as a self-employed stock administrator and managed our family finances. In time, he would find the right opportunity to restart his career. It was a balancing act—juggling the needs of our young children, Steve's career shift, and the care of his parents. But we were determined to make it work.

But it didn't take long to concede our marital difficulties had followed us. Steve chipped away at me. He tore me down. I built walls. I sank into hopelessness. I was filled with animosity and easily enraged.

The more Steve tried to take control over things—and me—the more I rebelled. The more he clung to me, the more I attempted to break loose, physically and emotionally. We were in an exhausting, hurtful tug of war that never ended.

Soon after settling in, I found a group of men and women who ran up and down the hills of Burlingame and Hillsborough. We would meet at 5:45 a.m. on Mondays, Wednesdays, and Fridays. The pre-dawn sky was usually painted shades of pink and orange, and the air was crisp and charged with the faint scent of eucalyptus from the nearby trees. The rhythmic sound of our breathing generated a comforting cadence.

Because I was desperate to run more than three days a week, through a neighborhood running store I discovered two more groups of runners, one of which was all-women—the Ladies of Sawyer. We would run the popular six-mile Sawyer Camp Trail back and forth every Saturday, our footsteps crunching on the gravel path. Then there was the Tuesday night speed workout crew. We cheered each other on, pushed our limits, and often wrapped the evening up at Hola's restaurant for drinks and chatter.

But, I still required more movement and escape, so I ventured into spin classes. I'd pedal furiously in the dimly lit studio, pulsating with music, sometimes letting tears flow freely. The instructor's enthusiastic shouts penetrated the room, sweat glistening on my skin—it was a cathartic experience.

I added boxing sessions, guided by Patrick Ragan, to my weekly routine twice a week. It was liberating, throwing punches with all my might. Patrick didn't ask questions but sensed I was grappling with something.

I took on double workouts to intensify my health regimen, adding Lagree Fitness, a Pilates concept focusing on slow, controlled movements. As my muscles burned, the mind-body connection strengthened. I was trying

to outrun and out-exercise depression, anything to avoid dealing with the thoughts in my head and the sensations in my body. I was addicted to motion.

One morning, after a seven-mile run, I told my Monday, Wednesday, and Friday running group, "I don't want to go home."

Doug said, "Come on, Jane. Let's do one more lap around the block."

As we began our extra loop, Doug asked, "So, what are you and the kids up to today?"

"Well, Steve has the day off, and it's Friday, so kids don't have preschool. We are taking them to Great America Amusement Park."

"Oh, fun!"

"But I don't want to go. Steve is fraying my nerves. Again."

"You know what you should do? Hop on one of those scary roller coasters and scream your head off!"

I laughed, but that's precisely what I did. When we arrived at the amusement park, I got on the Flight Deck roller coaster, which had twists and turns and went upside down, while Steve took the boys to the Crabbie Cabby kids' roller coaster. I screamed my head off. It was exhilarating.

My runner circles were there for me through all my difficulties. When you're running in the dark, side-by-side, with no eye contact, secrets and frustrations spill out, and we leave them all on the run. Unspoken running rules like "What happens in Vegas, stays in Vegas" mean that what is said on early morning runs is not repeated.

Even with my newfound surroundings and friendships, I lodged petty complaints against Steve. He was constantly on trial. I was always on guard. He sought my love, affirmation, and attention, but when I withheld it, he became defensive, protective, raw, and fearful. He attempted to cope by trying to gain and maintain control. He couldn't help himself. Neither could I. We were in a tangled mess of he-said-she-said. He wronged me, and I wronged him back. I was distant. It was ugly. And painful. I was buried in the mire; I couldn't see straight.

Amidst this emotional turmoil, life carried on its usual course. Steve continued to work from home, and I enrolled our kids in preschool three days a week. But tragedy struck when Steve's dad passed away, adding another layer of sadness and sorrow to our already taxing circumstances. Despite the heartbreak, we tried to find moments of normalcy by sticking to our weekend practice of taking the kids out for an easy hike, offering a brief getaway from the chaos that was our domestic life.

However, one particular weekend, tensions boiled over, and Steve and I had a nasty fight. In the heat of the moment, I couldn't have foreseen how deeply this argument would affect our relationship.

While Steve was driving us all, he asked, "I need you to jot down some things for me to add to my to-dos when we're back home."

I grabbed the small packet of yellow sticky notes and a pen. He was a man of lists, and sticky notes accompanied him wherever he went.

"Fix the springs on the garage door. Check the sprinklers, ensure the timers work, and invite mom for dinner next Sunday night."

I wrote the notes as legibly as I could on a bumpy gravel road. My handwriting is poor even on a good day. I recalled some of my own to-dos as I took down Steve's list, so I wrote mine down on a separate sticky note. As the car stopped, I placed the pen and the notes in the console.

We hiked—or rather walked around the lake. Birds were chirping, and pine needles crunched under the weight of my feet. I inhaled the aroma of the pine trees as I drew in a deep breath, felt wonder at the sky, and enjoyed the sun on my skin. Chase held onto Steve and Tate's tiny hand squeezed mine as we navigated the tree roots. When we came to the flats, Tate ran ahead of me. We enjoyed a picnic lunch, feeding the boys grapes while trying to spread pâté over fresh bread for me. As the boys snickered, I bit into the bread, its crust crispy and center soft and chewy. The pâté was smooth and buttery, with a hint of herbs and spices that lingered on my tongue.

Tate reached out with his small hands, "More, more."

"More grapes, buddy?" He popped them into his mouth like a chipmunk and giggled. Grape juice ran out of his lips. Why couldn't I be happy? Why wasn't I laughing with him?

We were having family time. I should have been enjoying every minute. He was a dedicated husband who prioritized his kids and planned family hikes and picnics. Yet I wished for time alone.

We loaded the kids back into the car and made our way towards home. Steve turned onto the main road and asked, "Can you read what I had you write for me?"

I stuffed the backpack with the kids' snacks and sippy cups by my feet and retrieved the small stack of yellow notes. "Sure."

I held the jottings and surveyed my chicken scratch. I couldn't make the words out, nor which list belonged to whom. As phrases came into focus and my memory was being jogged, Steve said, "How the fuck long does it take you to read a goddamn sticky note?"

I quivered inside. The boys were in the backseat, so I tried to remain calm and not lash out. Steve stared at me. I glared at him.

"What?"

"Don't talk to me like that!" I snapped.

"Jane, can't we discuss this without you erupting?"

I said through gritted teeth, "Don't talk to me."

"Jane, what do the notes say?"

"I am not having this conversation with you. Just stop."

He mumbled a few things, but I couldn't bear to listen.

"No. I am done. Just stop." I put my hands over my ears and turned toward the window. I wanted to jump out of the car and disappear. I wanted to shut out this horrible moment and all the ones that had come before. But I couldn't run away from my problems forever.

He carried on, questioning me with the kids in the back, even though I repeatedly told him to stop. As Steve's voice rose, my heart pounded, and my

chest tightened. My throat was dry and constricted. I was desperate to yell and defend myself, but my tongue was heavy and clumsy as if glued to the roof of my mouth. I couldn't say a word. And his refusal to discontinue pissed me off more. At that moment, in the car, I knew I could not stay married to him unless we got some professional help. I was bitter at thinking that moving to California would mend everything in our marriage. I was stupid for believing that.

Within my core was an entire war going on. I fought to survive, but I was dying inside. I wanted to die, not by suicide, but had fantasies about a terminal diagnosis or a car accident. Whenever it rained at home, I showed the kids how the rain was pounding on the skylights above our heads. "Isn't that amazing? I love that sound!" Knowing one day, when I die my premature death, they will have cemented in their brains how much their mom was infatuated with rain and puddles. They will never forget me. Death seemed like the simple answer.

Instead, I went for a long run.

The day after the sticky note dispute, I dropped the kids off at nursery school and set out to run the trail. I listened to my favorite playlist. I felt untethered but I still cried. I gazed at the sky. I hurt enough to think about a way out. But the kids. I had to think about the kids. They were young. But then again, maybe they would be okay. I kept running, running, running. After ten miles, I had cleared my head enough. It was time. I had to tell Steve I wanted to go to therapy with him.

I pulled into the garage. I put my armor back on. I turned off the ignition, closed my eyes, and held my palms out and up in surrender to God. Why was I so full of outrage? I couldn't master my fury. I wanted to shout at the world, at him. At least in Pennsylvania, he would leave the house for ten hours to go to work. Now, in California, he was always at home.

Before I headed into the house, I said a prayer: "Dear God, please help me with this terrible irritation I have towards Steve. Could you guide me? Where

am I supposed to be heading with this? I know a few things: I am growing through this. I am getting closer to You. I am craving You. I am in a gaping hole of displeasure, hurt, and hatred. I can't imagine ever allowing myself to sink this low again. Please continue to hold my hand and lead me. I know You are here."

I went to the kitchen. Steve was sitting at the table, flicking through the newspaper. I exclaimed, "I want to go to couples counseling."

Without looking up, he said, "Fine, just give up then."

"I'm not giving up. I'm trying to make things better for both of us."

"I went to therapy with my ex. It was a place for her to beat me up, and I will not tolerate that again."

"Steve, that's not my intention. I want to give this my all."

He didn't look up. "My ex-wife dragged me into counseling, telling me the marriage was over. It was humiliating, and we spent money on something that was broken and, in her eyes, could never be fixed."

Finishing his last bite, he said, "I have no interest in going."

"Well, I'm going to go by myself," I stated.

He rose and said, "I'm going for a bike ride."

It was a relief. I would have some time to be alone.

I heard him zip his jacket as he said, "I don't know why you can't be happy. You're always focusing on the negative."

I held my breath as the door slammed behind him. Part of me relished the space. But I wanted to chase him down the driveway and holler at him. I stayed back. I respected he needed his time. I said what I had to say and at least I'd have the house to myself for a few hours.

I went upstairs, curled into a ball on the bed, and cried. I missed Mark so much. Why did he have to die? Our marriage was perfect ...

I walked over to the closet, where I kept a box of letters from Mark. I sorted through the cards and napkins with love messages, a beautiful re-minder of a time in my life when Mark worked part-time and lovingly packed

my lunch, taking the time to inscribe thoughtful notes on the napkins. Even though they were over fifteen years old and turning yellow, they contained a sentimental value.

They were fragile in my hands, like they could disintegrate at any moment. I cherished them, holding them tightly as a precious memory of a time long gone but not forgotten. They became more than physical objects. They were a reminder of the love, the loss, and the lessons that come with time.

But it wasn't just the napkins that held meaning. Revisiting Mark's love letters transported me back to when I was in love with him. I gripped them as if they were a means of escape.

I pulled out an envelope, and inside was a letter I couldn't remember ever reading or receiving. It had no date. As I read the words, it felt like I was being punched in the stomach. Mark's words reminded me that the troubles Steve and I were experiencing were not unique to us. Relationships have complexities and we can be guilty of repeating patterns without realizing it. Mark's letter, from years ago, could undoubtedly have been written by Steve.

Reading the letter repeatedly, the burning in my chest increased. I began sobbing. I read,

The realization that from my perspective, things are not the same between us and that, in reality, our relationship may have never been what I thought it was, has left an emptiness in me I can't fill. Was it an illusion that I created because I loved you so much? Was it an illusion you created to mask the pain of life before us?

The pain of life before us? I resumed reading the letter: *The reality is that things will never be the same. Where is my Jane? Was she real, or did I create her?*

Who was I then? Who was I now? I didn't know.

In the gap between our bodies are confusion, doubt, anger, defensiveness, and loneliness. I withdraw. I hurt. Where is my Jane? We are important. I'm not the enemy. Did she ever really love me? Was the connection that I felt with

her real? Were Jane and Mark just a vehicle to transport you from where you did not want to be? Where is my Jane, my love, my life? If only I could find my way back to you.

I reread the words "just a vehicle to transport you from where you did not want to be?" Was that what Steve was to me? A way out of my unhappiness? But I loved Mark. Why did he question it? Where had I gone? Did he ever give me this? Why didn't it have a date? Why didn't I recall receiving it—or had I blocked it? I had no recollection. I was pushing Mark away before his diagnosis. Was I angry then, too? I didn't dare to stand up to Mark and tell him I resented him for not sharing the bulk of the finances, but now I was standing up for myself with Steve, but with anger. So much anger. Is Steve paying the price for me not speaking up? Why am I driving Steve away?

The memories of a boy and a girl. Were they part of this? No, that's not it.

I don't know why you can't be happy. Weren't those Mark's words in one of our last significant conversations? Didn't Steve just ask me the same thing? Am I a negative person? What happened to me? After Mark's death, I had joy. Now, I am left with rage. But Mark was supportive of me, and I focused on the negative. Was I repeating this dance with Steve?

I started questioning everything.

Why was I always on the run?

Why couldn't I be happy? Why was I always pessimistic about Mark and Steve? Why can't I appreciate what I have? I stay busy and circumvent living in the present. Running had become an obsession and a way to evade confronting what was inside me. Why couldn't I give Steve a break? He had recently lost his father. I was so selfish.

I heard Steve come in through the garage door. I wiped my eyes, blew my nose, and got ready to face him again. And as I put my hand on the doorknob, I asked for God's guidance, straightened up, stood tall, and went downstairs.

As he came up the stairs, with downcast eyes, he said, "I almost got hit by a car on my ride. I didn't know if you'd be happy about that."

"It's not like that," I tried to reassure him. "I just think we need help with our communication styles, and I want to save our marriage." I remembered Mark telling me in counseling, "I want you to use your voice. Share your feelings with me. I won't leave you. I promise."

"Fine. I'll go with you," he stated, flatly.

B E C O M I N G
A T E A M

When Steve proposed marriage five years ago, I sensed this marriage might not be easy, although I couldn't articulate why. On paper, he was the right match. He had been married before, which I considered a positive sign, showing his commitment to making it work this time. He shared my desire for children, possessed an intelligent sense of humor (most of the time), and values I felt were important.

So this time, I approached counseling with a more pragmatic mindset. I didn't need rescuing; I had Steve in my life because I wanted him, not because I needed him. I couldn't help but reflect on my past love with Mark, wondering if a deep connection like that would ever happen again, but I had grown since my time with Mark; I was more independent and mature. But I had also built new emotional walls. Somewhere along the way, I resolved not to let anyone hurt me and then abandon me.

Dr. Bill Holden's office was located in my local church, which also housed the preschool Tate and Chase attended. Dr. Holden listened carefully as we openly expressed our thoughts and feelings. His questions helped us to see the other's side of things. We felt we had made a reasonable start.

We would end up seeing our counselor for five long years. During that time, so much resentment was locked inside me that I met him one-on-one in addition to our weekly group sessions. In one of our one-on-one sessions, Dr. Holden said, "You and Steve have a lot of work to do."

I nodded in agreement. "But is there any hope for this marriage?"

"Steve is emotionally detached, yet so sensitive that he can and has to emotionally remove himself from the pain and risk of being hurt. You knew

you could never replace a love like Mark's, so you chose the opposite: a man you could not love, nor he love you back."

What? But I do love Steve, and he loves me—I think.

He suggested I had married someone emotionally distant due to my fear of abandonment after Mark's death. Vulnerable, I clung to his every word. Seeking answers, I bought into his theory. Now what? Was having a "manageable relationship" the most we could hope for?

I was desperate for solutions, yet they remained elusive. In my quest for resolutions, I woke up at 4:30 a.m. three days a week for my 5:45 run. Before my run, I poured my thoughts into my journal, venting my frustrations in all caps. And when I got it all out, I composed a prayer, begging God to release me from my marriage. Afterward, I concluded my written rant with gratitude lists, celebrating simple things like the scent of brownies or the sensation of grass beneath my toes. I survived, one day at a time.

I didn't want to acknowledge it, but I was depressed. I told myself I had experienced Mark's death with grace and devoid of antidepressants, and I could push through this, too. But I had to be honest with myself. I yearned to die, and yet I wanted to live for my kids. My kids ... I pulled away from them. I couldn't shut out my spouse without shutting out my kids too, but I didn't recognize that. They sensed it in me. They reached for Steve. I stared at the sky and said to God,

I thought I was a strong, graceful woman. Turns out I'm not. I am a coward who did not face her fears and anger about Mark's death. Instead, I ran to a man to fix things because I was worried and afraid of being alone. I feel weak and like a failure. It is nine years after the fact, and I'm all fucked up and angry and pissed. I can't blame anyone but myself. What am I supposed to do now? I am crying and pleading, God. Heal me, please. Please give me something soon. My heart is still broken and bleeding. His death took away my ability to love and was replaced by fear, anger, resentment, and feelings of abandonment.

I reached a point where I couldn't carry on any longer, and after careful consideration, I sought help by going on antidepressants. I conceded to my struggles, almost as if I were admitting defeat in my fight against depression. However, as the days grew into weeks and the medication took effect, I felt the clouds of despair lifting. Slowly I regained control over my emotions, and my overall well-being improved. Starting antidepressants turned out to be a pivotal step in my journey towards healing and rediscovering the joy in life.

As we continued our weekly appointments, Dr. Holden said, "You both must open up."

I shared, "When I take a deep breath, you ask me, 'What's wrong?' I glance out the car's side window as you speak, taking in the sights, and you ask, 'Why aren't you looking at me?' Why are you so needy? I need space to breathe."

Being able to say those words was like a release. But Steve said he felt picked on. We argued. I wondered if we should just file the divorce papers and get it over with. I prayed for guidance. I trusted God more than myself. Every move I made was erroneous.

The amount of energy I spent withholding what I thought was my true feelings—and the amount of energy Steve spent trying to hold me, keep me in, save our marriage, our family—it was exhausting. We built tension and resentment. Blame. Bickering. I wanted out, but I was worried about my kids. He was impatient. In turn I was impatient—and volatile. I stayed. We were throwing bricks at one another, building walls so high we couldn't reach over them to connect anymore. We lived in the same home but separately.

I experienced the pressure to decide. When Steve went for bike rides, I went to the guest room to pray, scream, and cry.

"God, I want a divorce," I begged.

I could've sworn I heard Him speak to me, saying, "No. I hate divorce." Staring at the ceiling, I cried but now knew what to do. "But are you sure, God?"

No response.

He clarified His answer to me the following day when Steve and I were in Dr. Holden's office. Steve was opening up about his father's death and how it had affected him. I said it sounded like we were way off-course.

Dr. Holden glared at me and said, "Jane, you need to not talk about leaving in the short term and stick it out while these wounds are fresh for Steve. I need you to stay in this a little longer."

My eyes bugged out. What the fuck? I want out of this now!

"Can you do that?"

I nodded.

"Steve is opening up and trying."

"Okay," I whispered.

"And I'm not making excuses for Steve, but losing his father may contribute to his stress."

Well, God was serious. He didn't want me to leave. I knew what I had to do: pray more. So I prayed. "God, you have to provide me leeway if You want me to stay in this marriage. I can't do this anymore and can't do it alone."

I surrendered my marriage to God. I commenced praying to please change my heart. Help me. We would have one good day, and I was hopeful, only to be deflated by a hurtful word.

A few weeks after I surrendered my marriage to God, Steve found a new job and began commuting to and from Palo Alto. I now had some space and time for myself. And Steve started making my gratitude list. I wrote, "I am thankful for my marriage. I am thankful for Steve." Although I didn't mean it, and it was hard to write, in time, I believed it and was grateful for Steve and our marriage.

A year into counseling, the counselor finally earned his keep. "You two are different people, yes. But can you find the positives in that?"

"Well, Steve is very detailed. He plans amazing trips. He searches for the best restaurants. I take a week to accomplish what he can do daily, and he's a loving father."

"Steve, what about you? Can you list some positives about Jane?"

"Jane is funny and light-hearted when she's Jane. She's a wonderful mom. We never argue over where to eat because we like so many of the same things."

We began to look anew at our differences as strengths. Dr. Holden pointed out we had the same morals. We were a team with parenting. I saw Steve from a new standpoint. He drove me insane, and I drove him up the wall, but we balanced each other. We may have gotten into this union and parenting thing quicker without knowing one another or understanding our communication styles.

We discussed other contrasts but with open minds. Steve liked to be home with the family. I was more social and independent. I called for freedom, Saturday runs with friends, mom's nights. Dr. Holden helped Steve understand that these things fueled me and helped with the depression. It was nothing personal against him.

The reason for my depression? None of us knew, including me. But then, in the fall of 2012, I hit rock bottom as I approached the tenth anniversary of Mark's death. I was overwhelmed by an unrelenting sense of longing and a constant wish he was still alive. The impending date cast a shadow over my life, making me wonder if what I was feeling was normal or a manifestation of my grief—a decade seemed like an eternity and a mere blink of an eye simultaneously. Triggers and reminders resurfaced the raw and initial pain, and I underwent a relentless onslaught of sorrow, crashing over me in waves so intense and rapid it sometimes became a struggle to catch my breath.

Upon further questioning, Dr. Holden realized the anniversary date was approaching. I sat in his office, tears welling up as I tried to put into words the overwhelming sadness I was experiencing. "Shouldn't I be over it by now?" I asked, my voice trembling with self-doubt.

His empathy was evident as he replied, "Grief is not just one event in time. It's a process that changes us permanently but also adapts as we change and grow. It's not something that happens once and goes away; it evolves. Ten years, for you, feels like a momentous anniversary because of how much your life has changed and been shaped by losing Mark. It's a significant milestone."

I nodded, understanding my grief was a journey, not a destination. Dr. Holden continued, "Over time, reminders will bring back the pain you initially bore, particularly on anniversaries, but you are no longer in shock or denial, so you lose those coping mechanisms, and it's like being back there on that day but worse."

Slowly, I accepted I might never be "over it," but I would always carry it. The finish line I had been searching for, that elusive moment of complete healing, might never come. I had spent years thinking, "Once I survive the first year, I will be okay." I wasn't. "Once I'm remarried, I will be okay and over it." I wasn't. It was sinking in that losing Mark was a part of me, an indelible fingerprint on my heart.

But Steve, my partner in this journey, understood my need to reflect on my relationship with Mark. And I was beginning to understand Steve was not the enemy, my depression was because of several stressful life events, and I was finding relief with the use of antidepressants. Steve was not to blame for everything—quite the opposite.

In honor of the tenth commemoration, I set a challenging goal: I wanted to run the Philadelphia Marathon. Steve stood by me, supporting my efforts by taking the kids on adventures while I went on long Saturday training runs. And on race day, even from California, he and the kids cheered me on. And

when I crossed the finish line in Philadelphia, I had achieved my target and qualified for the 2014 Boston Marathon. Steve had been my rock through it all, occupying our children while I pursued my dreams. We had become a true team, navigating the complexities of life and grief together.

I was torn between my past self with Mark and my newfound independence with Steve. I grappled with moving forward without the person I once relied on, questioning my identity and desires. It was a complex mix of emotions—grief, personal growth, and self-discovery. When I married Mark, I had been hiding out in the relationship, suppressing my wants to prioritize his, content to do what he wanted and who he wanted to spend time with. I never went out without him or made decisions without him. I never challenged myself to go outside my comfort zone. I rarely spoke up and was not in touch with what I needed. I had fused my identity with his in an unhealthy way, often feeling small and helpless, especially during our conflicts, which prompted me to run away the minute he raised his voice. But that was the past. My alliance with Mark had shaped my beliefs and behaviors, but it was time to make healthier choices for the future.

Personal agency and independence were called for with Steve. He challenged me. It was necessary to set boundaries. Setting boundaries with Steve was crucial to improving our relationship, and it was about addressing something deep within me, something I had not fully understood or was able to disclose. These restrictions allowed me the space and time to confront my internal struggles, something I had avoided for far too long. I sensed that healing from this undisclosed issue was essential for my well-being and the health of our relationship, but I still wasn't ready to go there.

Adding to the complexity was the role of parenthood, which forced me to balance my needs and responsibilities as a parent. I struggled with asking for help and admitting I was vulnerable. I learned expressing myself clearly and listening to Steve's perspective were crucial. Steve and I acknowledged and valued our differences, recognizing how they could complement each other.

Our connection began to thrive and evolve through patience, open dialogue, and a genuine appreciation for one another, but it didn't happen overnight. We slogged through four more years of counseling.

WHERE THE ANSWERS MIGHT LIVE

2016

Steve and I had entered our fifth year of marriage counseling, but my struggles persisted. One afternoon I picked the boys up from school and couldn't even find enough energy to inquire about their day. Thankfully, they sat silently in the back seat, sparing me the need to feign cheerfulness.

As we turned the corner, the three-story stucco house, which was supposed to be home, appeared. But lately, I'd felt disconnected from my life again, like I was going through the motions.

The boys eagerly rushed out of the car towards the front door, excited for our after-school routine. After snacks, we got organized for the afternoon. I felt a kind of desperation to connect with my boys. I sat down with Chase on the floor. The afternoon sun highlighted his golden hair and blue eyes. "Anything you want to share with me about your day, buddy?"

He giggled. "I don't know," he replied.

I took his hands in mine. I wanted to hold him close and confess my inadequacy as a mother, as if he would understand what I was going to do. Could I actually shatter my boys' world?

He pulled his hands away and disappeared into the playroom, joining Tate at his video games. I looked around the room. Vibrant art adorned the yellow walls, injecting bursts of color into the space. But my world was gray. I drew my knees to my chin. A profound sense of loss and anguish enveloped me. On the surface, it appeared as though I had a picture-perfect life. Nestled in the San Francisco Bay Area suburbs, our elegant home spoke of comfort

and stability. I was blessed with two adorable children, a loving husband, and a cherished canine companion, Leo, a playful Pomeranian. As a stay-at-home mom, my days were filled with the joys and responsibilities of raising a family. Yet, I still wanted more.

I would miss this place. Dread rose into my chest. I sensed my death was near, my life growing shorter with the passing of each day. I had to finish what I'd started in my life—raise my children.

I could not figure out why I felt such deep despair. Was it my voice or something lurking within me that yearned for an escape from existence? It was a question I had never dared to confront. The longing to detach from my body haunted me, but it was distinct from a yearning for death. So why did I find myself in such a state of emotional wreckage?

The pressure of my inner conflict spilled over into my role as a wife and mother. My inability to be a proper wife and fulfill my husband's needs gnawed at my core. Intimacy remained an insurmountable hurdle. I couldn't find the strength to satisfy him, adding another layer to my self-doubt.

I glanced toward the top of the staircase. The door to my office was ajar. Another door. Another world. Was it just this morning I'd journaled the words *I want to die, die, die?* I had a sixth sense of what was inevitable. Yet my rational side needed to understand why my life was out of order. Looking back, I did not recognize it, but it was all about grief. I had been grieving since I was six years old. Where could I start to find out the truth? Which hurt should I unearth first?

Like a small child with too many toys to choose from, I was overwhelmed by distant memories. But each little toy called to me, "Pick me up. Question me. I hold the answers." I turned over every painful moment and scrutinized them. "Write, Jane, write," said the voice inside my head. I had something to say; the only way to get it out was to jot it down.

I had tried marriage counseling, one-on-one counseling, and antidepressants. I had given up alcohol. So far, nothing was taking the inner pain away.

I had periods where I felt better, and Steve and I had made progress, but there was still anger inside me. At a recent session, Dr. Holden said, "Jane, your anger does not match the circumstances. Is there something else we don't know about?"

Maybe he was right. Perhaps the answer was inside of me.

N O L O N G E R
A L O N E

I was tired of attending so many counseling appointments, it was time for a new approach. I texted Dr. Holden and he told me I could see him the next morning.

I pulled into the parking lot a few minutes early, and I watched the children as they played tag and raced each other on their trikes. The crisp scent of autumn was in the air, carrying with it the promise of change. I remembered the days I volunteered in the classroom and my children were running around the playground. I smiled, recalling a memory of Chase holding little Maria's hand. So sweet and innocent. My boys were in middle school now, and I couldn't help but feel the weight of time bearing down on me. We had been at this for a long time, and I was exhausted.

But today's appointment was going to be different. My heart was pounding as I walked through the doors of the church. Pastor Walker greeted me in the hall. He was a big man with white hair and kind eyes. The office staff had all seen Steve and me come and go from Dr. Holden's office. They had witnessed my tears on Sundays in church and knew I was struggling. I had been on their prayer lists, but the darkness persisted.

As I continued down the hall, I noticed that Dr. Holden's door was still closed, so I made myself as comfortable as I could on a hard plastic chair in the hallway. Steve and I usually had the first appointment, so we rarely spent time in the vestibule. I noticed how the linoleum floor had been worn smooth by countless footsteps. The air was stale, a mixture of old memories and faded hopes. I glanced at my watch. It read 10:55; there was still time to kill. I turned to a shelf of self-help pamphlets. Some were about grief or elder

care, their colorful covers contrasting with the drab surroundings. I scanned the grief pamphlet, the words blurring as my thoughts raced.

Footsteps snapped me back to the present, and Dr. Holden appeared from around the corner.

"Good morning," he said, as he reached into his pocket to unlock the door to his office.

"Hi again," I answered, my voice betraying a hint of nervousness.

"Come on in."

He tossed the keys onto his desk and sat down. I settled onto the sofa, its worn cushions enveloping me like a familiar but uncomfortable embrace. It was almost impossible to sit on its edge unless I perched on my tailbone. How often had I thought I needed a hand to escape its grasp? Like when I was pregnant, Steve had to tug me out of the car. That's how this sofa made me feel, pregnant and helpless.

Over the last twenty-four hours, I had contemplated what I would say and how I would preface it, but now, sitting here across from Dr. Holden, the words did not come easily.

"My brother messed with me when I was six years old until I was twelve," I stated matter-of-factly. "But it didn't really bother me."

Dr. Holden remained seated and did not move. Perhaps he was trying to conceal his surprise. He asked me questions gently. "How did it start? Have you ever told anyone?"

Avoiding eye contact. "It's not a big deal, is it? He was my brother. I mean, it never went too far, and he apologized. I've dealt with it."

Dr. Holden tilted his head to the left and leaned in towards me as though he was about to break out in prayer for me. "I was never afraid of him. He never threatened me."

"This is kind of a big deal," he said.

"Are you sure this is a big deal? Aren't kids curious?"

He reassured me. "Yes, kids are curious. Once or twice. Curiosity does not span six years."

"But I'm guilty too. I sought him out … I … even tried to, um, seduce him. I asked for it, so who am I to be fucked up over it?"

"Your body reacted the way it was designed to react. The touch may have felt good. You became hypersexual because of this. It's what you were taught. It made relationships and sex transactional."

I kept fighting back. "But it was just my brother."

"Yes. It's a complex relationship and situation. You need to tell your husband."

"No, I can't! He will blame all of our marital problems on me now!"

"He loves you. He is loyal to you. He would want to know."

I stared at the floor.

"You need to tell him for your safety. Now when you turn him down sexually, he will understand. This will give you well-being and space."

"I want to move into the guest room. Would that be okay?"

The doctor said yes. It may help me. But I needed to tell Steve.

I asked him questions. I have had a temper all my life. I thought that was part of my makeup, all my screaming and vexation with Steve and the kids.

"I was always full of shame, feeling not worthy of love."

Maybe that was it? My anger was disguising the shame I felt?

"Steve loves you."

"But why? I'm a lot of work."

"It's possible you chose someone safe after Mark's death. Someone who could pay attention to details while you sorted out your grief."

My mind went to all the times Steve had hurt me—the walls I had built. I reminded the doctor of this, but …

"You need to tell him," was his only response.

Fuck.

Dr. Holden helped me walk through how I should tell Steve. Should I write him a letter? Tell him at home? I decided to tell him in person at our next scheduled joint session. I spent the week thinking he would ask why I never told him. He may not trust me. He may say to me I need to forgive or move on.

The following week, I sat on the couch as usual, while Steve sat on a chair. I was always relieved to have the couch to myself. It created the distance I needed from Steve, from any other human. Dr. Holden entered the room and closed the door behind him. I looked at him, hoping for reassurance. He greeted us. "Good morning."

Steve crossed his legs as though it were an ordinary session. He did not know what was coming in his direction. "Good morning, Doctor."

They both turned to me. "Hi," I said, wanting to jump off the sofa and race out. But I didn't.

Every session, Dr. Holden always began with, "Who wants to begin?" There was usually some awkward silence unless one of us had an agenda. I knew this news and the discussion would take up the entire session, so I dove right in.

"I will."

Steve breathed noisily, perhaps sensing he was in trouble for some offense he had committed during the week.

"I need to share something with you about my past."

He visibly relaxed. This time, it wasn't about him. I told Steve, "My brother messed with me when I was little. On and off for six years."

He was quiet. When he finally spoke, he said, "I'm so sorry that happened to you."

"I'm so sorry that happened to you." His words were so simple. But they weren't filled with anger or judgment. Just sadness. For what I must have gone through. I was no longer alone. Now the real work of healing could begin. For

the first time, I knew I was building a relationship based on full disclosure: no more secrets or masks. Steve's immediate acceptance of who I was protected and empowered me. I realized my past trauma had a more significant influence on my present life than I could have imagined, including my marriage. I was beginning to understand the impact of my trauma and could take steps toward recovery. Steve's nonjudgmental response showed me the power of empathy and compassion in supporting a loved one through difficult times.

That evening, as I placed a plate of hot pasta smothered in red tomato sauce in front of Steve, I said, "I want to stop going to marriage counseling."

He placed his napkin on his lap and said, "Okay. Why now? I have wanted to quit for months. What made you bring this up?"

I suspected he would not put up a fight. Our relationship had improved over the past five years, especially in terms of being open to hear what each other had to say. But the next step was obvious to me: quit marriage counseling and find a female therapist to work with one-on-one.

"Want me to call the doc?"

I immediately said yes.

PART FIVE

CHAPTER 25

D I S S E C T I O N
D U N G E O N

2017

A few weeks after sharing my past with Dr. Holden and Steve, I searched the attic for photo albums, hoping to find answers to my past. Upon combing through the albums, more questions arose than answers given, leading me to call my mom and ask her about my birth story. On that spring day in 2017, after hanging up the phone with my mom, I better understood my place in the family. My father didn't want a third child and told her he didn't know what to do with a girl. Exploring the albums had taken me to that night in the fall of 1974, when I was six years old, the evening we were watching TV, and my mother called down the hall, "Hey, kids, it's time to get ready for bed!"

With the swift agility of a jackrabbit, I hopped up, eager to shed my day-time outfit of shorts and a tank top and slip into the comfort of my jammies. Delicately embellished with little white flowers on the chest, the light green fabric enveloped me. Its airy texture gave me the sensation of weightlessness. As I slipped on the sheer nightgown, which revealed glimpses of my skin, I slid into the character of a little princess in her ethereal attire.

Little did I realize my oldest brother was watching me, his gaze filled with curiosity as I turned to head to the bathroom to brush my teeth.

I slammed the album shut. I wanted to save her. I wanted to tell the little boy, "Don't touch her. It will change the course of her life. And your life." I pulled my knees to my chest, and my hands rose to cover my face and eyes. I screamed in frustration, hurt, and anger.

More memories of that little girl flooded my mind. I couldn't help but think about how the encounter with my oldest brother that evening changed my life. I remembered how that little girl had tried to communicate with me in the past, just as she was doing now, and how I'd pushed her away. But I couldn't dwell on that now. I needed to understand why she had come to me. With a deep breath, I reached for the next album and turned the pages. She was trying to tell me something. But what?

I recalled the revolving doors from my past: the hotel doors with Biz, the entrance to the emergency room, and leaving the lawyer's office on the day I found out Mark was terminal. And then the revolving doors at the Red Ball when I met Steve. I followed my instincts through them, not letting anything in or out. But the little girl had been there, watching me.

I flipped back through the pages of the album, searching for clues. And then it hit me. The doors weren't just physical barricades. They were a metaphor for my emotional walls.

I studied the little girl looking back at me in the photographs, and I experienced her in a fresh light. She wasn't a silly little girl, after all. Instead, she was a messenger sent to help me break through my barriers and find resolutions. Together, we walked through the revolving door and into a new chapter of my life, but I still kept her at a distance. I tried not to think about her.

I began to see I needed to trust my intuition as I explored my past to better understand myself. It was a reminder to pay attention to those feelings which nagged me and seek answers. I surveyed the stacks of albums on the dining room table, wondering which one to tackle next. I selected a maroon album with gold trim.

WHEATRIDGE, COLORADO, 1974. EARLY OCTOBER.

It was a few days after the argument at the table between my parents, where they "discussed" having Gianna live with us for a short period. My

father convinced my mother to meet with Gianna's mother, despite my mom's objections. As a result, my older brother, James, who was twelve at the time, and I were at home, and Joey was at a friend's house. James was tasked with getting me ready for bed. What had initially started as a playful game by a headstrong child ultimately led to me receiving another spanking from my father.

My brother told me to go to bed and that I could not leave my room. I took his order as a challenge. I taunted him by sneaking one toe over the line between the tan-colored carpet of the hall and the bright lime-green rug in my room. I giggled. James heard me and came around the corner. I thought he would think I was being funny and cute, but instead he yelled at me to get into bed. I drew my toe back an inch. "There, I'm in my room!"

"Get into bed! Now!"

I didn't move right away, now scared of his anger.

"You are so spoiled!"

I didn't want him to be mad at me, so I did what he said and tiptoed to my bed.

He went to the kitchen and hollered, "I never get away with the stuff you get away with."

I tucked myself in, squeezing my stuffed brown dog, Brownie. *"That's not true," I thought to myself. "I am the only one in this house who gets spanked."*

The following day, my father came into my room and sat on the bed. "Janie, this will hurt me more than it will hurt you." My body tensed. "I want you to get dressed, and I will be back."

I leaped out of bed, knowing I didn't have much time before he returned. Quickly, I layered on three pairs of underwear and two pairs of shorts, hoping to cushion the impending sting from the switch. He came into my room, and I stood with my legs locked together, my shoulders hunched to protect my aching heart. My hands twisted and clenched tightly on my tummy.

My father settled on the edge of the bed. The ominous switch clutched in his right hand. I couldn't tear my eyes away from it. This switch, typically used to support potted plants, had a different purpose in our home. My parents had bought a bulk bag, always ready to replace the worn ones. It was slender and dark green, and it packed a stinging wallop.

"Come over here." I stepped forward. "Stand still." Whap. I felt the snap. Whap. Another snap. I held my body rigid in expectation of the third whap. But nothing. "Janie! What have you done?" He realized I had extra layers. His face turned red and his lips curled. "Take them off! Now!" I obeyed, and he began spanking me. Hard. Again and again. It felt like ten times, but it was only three.

My mom ran in. "Keith, what is happening here?"

"She is a willful, stubborn child. You spoil her! She refused to go to bed again last night."

I was sobbing.

Looking down at me, he said, "Your mother and I need to leave the house for meetings, and we need you to behave and obey your brother."

Later that day, I frolicked in the open space behind my house in my navy swimsuit with white hearts and a tiny red bow at the neck. It was a hot October day; there were not many more pleasant days left before the chillier days and snow.

I often explored the landscape and discovered many treasures that made our hilltop home a magical kingdom. The backyard was sloped, so rolling down the hill was one of my favorite activities. I took in the sweet scent of the grass. When I reached the bottom, I couldn't help but giggle with delight in anticipation of returning up the hill to do it all over again.

I looked at James who was nearby. He was concentrating. His brows furrowed as he stalked the bushes with his bug net, trying to capture butterflies. He wanted to catch new ones in advance of the weather changing, which

required skill and timing. He planned to put them in the boxes he built with my father for next summer's 4-H exhibit.

His room was decked out with handmade display boxes. They were not just boxes; they were works of art. James and my dad made them with sliding Plexiglas fronts to showcase the beautiful butterfly specimens. Each box was a demonstration of his dedication and craftsmanship, and they lined the walls like a gallery of natural wonders.

Inside those boxes lay a world of color and intricacy. He had collected unique butterflies, beetles, a praying mantis, and a stick bug. No wonder his efforts earned him many first-place ribbons at the 4-H exhibits.

I was about to roll down the hill when I glanced up. My mom had car keys in hand. She peered over the deck balcony (another of my father's home-built designs) and called to my brother, "I have to go to the grocery store. You're responsible for watching Jane. I will be home in an hour. Can I count on you?"

James, with his net in hand, nodded in agreement.

"Good luck catching a tiger swallowtail! That will complete your exhibit for 4-H."

She turned to leave, then peered back at me. "Janie, please pay attention to your brother. We don't want any repeats of last night."

My heart sank as I recalled the events of last night.

I sat at the top of the hill and could still feel the redness on my bottom, and my cheeks felt flush. The car engine began purring, signaling my mom had left, and I slowly rolled down the hill. The memories of last night had sucked the fun out of the hill, and I was tired from rolling. I brushed the grass clippings off my swimsuit and lay with Freckles, who was lounging in the shade of a tree, using her tummy as a pillow.

My brother moved through the grass and scoured the bushes, his net resting on his shoulder. I use the word "net" loosely. The net was a hockey stick with black electrical tape wrapped around it and a wire rim made from

a hanger my mom had sewn a lime green net onto. It was an excellent butterfly trap, though. He raised it over his head slowly, paused at the top, and threw it down, crushing the flowers. He leaned over, careful not to step on the blossoms and damage them further, and sealed the end of the net, holding it closed so his hostages couldn't break free.

Exiting the garden, he asked, "Want to come downstairs to help me with the butterflies?"

I enjoyed spending time in Jame's bedroom, a place where we could escape the strict rules my dad had set for our household. My dad was adamant about what music we could and couldn't listen to, and had a particular aversion to rock and roll. In his eyes, it was a corrupting influence on young minds. However, country music was deemed acceptable as long as it didn't mention drinking or other "rebellious" behaviors. James had won an album from a local radio station that miraculously met my father's approval, but was only to be played when he was out of the house.

So, whenever we found ourselves alone, my brother and I seized the opportunity to sneak into his room. I bounced down the basement steps to his room, inhaling the musty scent of cardboard boxes and dust of the basement. As I entered Jame's room, cooler air hit my face. He was putting the record on the turntable.

Jame's bedroom was what I called the Dissection Dungeon. He was fixated on how things worked, so the dissection dungeon housed many dead insects that had been captured, dismembered, and displayed on every usable surface. Fittingly the carpet was dark red. The wallpaper was red, white, and blue with gold eagles and the American Flag, all symbols representing "freedom."

What the bugs and butterflies experienced in that room was anything but freedom.

An extended counter that my father handcrafted was littered with glass jars that had suffocated various insect victims with cyanide. Bugs and

butterflies were spread all about. Some were in wooden boxes with glass tops on display like small coffins. Others were still waiting to be situated. It was gross and creeped me out.

The music started as I inspected a cocoon. I remembered my brother had caught the caterpillar and explained its transformation into a butterfly.

I watched as Jame's latest prisoner slowly quit flapping its wings, thinking it must be sad. Did the butterfly have a family? I couldn't help but experience a twinge of sadness as I watched this beautiful creature meet its untimely end. Finally, it died. As the butterfly gave its last flutter, relief washed over me. At least it wouldn't have to suffer any longer.

He called out, "Come over here, and I'll show you my *Guinness Book of World Records*."

Excitedly, I joined him on the floor, engrossed in the enchanting pages of the book that revealed a world of amazing records. I delved into the remarkable tales of the World's Tallest Man, marveling at the staggering heights achieved, and was equally fascinated by the World's First Conjoined Twins.

Distracted and unassuming, James gently nudged me down, pressing his hands on my chest. I thought he was trying to make me more comfortable. I held the book above my head, paging through the black-and-white pictures. Finally, he straightened my legs and dragged down my yellow shorts and flowered cotton underwear.

My limbs were languid—surrendering to his touch. He charted my body, twisting and turning me like a doll. Undressing me and touching and examining my private parts. What was happening? Why was he poking and peeking at my body like some science project? Time slowed. I tried to gather up the courage to ask him what he was doing. I whispered, "What's going on?" He continued to prod and examine me. I wrapped my arms around myself, and blood pounded in my ears. I was frozen, unable to break free. I wanted to scream and run away, but my body wouldn't cooperate.

I asked again, my voice barely a whisper, "What are you doing?"

"I'm just curious. We watched a film in health class, and ..." His voice trailed off.

As I lay on the floor, I noticed the decaying bugs and the blood-colored rug, adding to the repulsiveness of the situation. I observed my surroundings, now the sinister trappings of the chamber I had been coerced into. The bugs gave off a putrid odor. I shouldn't have gone down there. It was a mistake. I questioned what happened to me. Did it happen? My eyes were downcast. My brother, who was supposed to protect me, had broken my trust, and I was six years old.

A hummingbird flitting outside the window snapped me back to reality at the dining table. I wondered if it was true that sighting a hummingbird signals challenging times are over and healing can begin. I sensed these albums were the beginning of my healing. I reflected; much like a caterpillar, I had wrapped myself into a cocoon—for forty-plus years—and would emerge as a butterfly.

I'd endure Jame's intrusive touch again and again over the next six years, powerless to say no to him and unable to tell anyone. My brother's actions confused and clouded my understanding during my innocent childhood. I didn't realize what had transpired was a grave violation. As my brother continued to abuse me, I learned to disassociate from my body. I would float above myself, detaching, hovering. I removed myself from what was happening with our bodies by thinking about paper dolls and the aroma of freshly baked cookies in the apple-shaped cookie jar, creating a "safe" distance from reality.

It took me a long time to grasp the gravity of what had happened. Through the years, I blamed myself, convinced that my perceived compliance and my body's physical responses made me complicit. These self-imposed beliefs lingered for decades, further imprisoning me within my silence. But seeing the hummingbird gave me hope. Perhaps going back through the albums would give me answers. Painful truths, but it was time, so I pressed on.

A N G E L S

Sitting still among the albums, I couldn't believe what I had just processed. My fingers traced a photo of me at age six, costumed as an angel, smiling, looking over the back of a chair, and I was transported to late November 1974. In second grade, the children's choir director, Mrs. Taylor, called for my mother and me to come to the chapel. I couldn't help but worry; was I in trouble? Did they know about my brother? As we entered, the iridescent stained-glass cast a rainbow of colors onto the hardwood floor, tempting me to play hopscotch on the stage. I shook my honey-blonde curls out of my face and took a few hops but stopped as soon as Mrs. Taylor arrived and I hid behind my mother's leg.

My mom patted me on the head as I continued to hide, and she asked, "Is Jane in some sort of trouble?"

Mrs. Taylor was a sizable woman with gray hair. She wore an oversized dress that flowed in the back of her as she moved. Her blue eyes stood out vividly against the emerald green fabric enhanced with bright pink flowers. She laughed. "It's quite the opposite. Jane will be the featured baby angel in the school's Christmas production. Since it's such a prestigious role, I wanted to congratulate you both."

My mom's smile widened. "What a considerable honor for my baby. Janie will be a living, breathing angel."

The two of them grinned at me. As my mom stroked my head, she said, "Thank you so much. I can't wait to tell Keith, Janie's father, this evening."

On our drive home, Mom asked me, "Do you remember visiting North Dakota last month to visit your cousins and aunts? It was freezing, unusual even for late October!"

"Yes," I said. "You were sitting on the stairs talking to Aunt Matilda and Aunt Esther."

"That's right." Mom smiled. "You were the only kid not running around in the group. You were lying on a layer of fresh powder, making a snow angel with your limbs. You were always my baby angel."

She kept both hands on the steering wheel, eyes straight ahead, and said, "You may be independent, feisty like me, but you're still my angel. You always will be."

I wanted to believe her, but I was filled with doubt. I was no angel. If she only knew what her angel had been doing in the basement.

DECEMBER 1974, ONE MONTH LATER

I was the only one who flew out of bed, already excited about the upcoming festivities later in the evening. The living nativity! But I stopped when I caught my reflection in the mirror. There was a strangeness in my eyes. Something had irrevocably changed. I studied my curls. They lacked bounce, and I turned away, not wanting to look at my image. The rest of the house moved at an average pace, like an ordinary day. Every morning, my father would quiet the alarm at half-past seven and be awake within seconds. He dressed in his typical work attire: brown polyester slacks, short-sleeved dress shirt, and brown wool blazer. He put his pocket protector and blue ballpoint pens in his shirt pocket. Then, he attached two pins on his coat's lapel: a pair of tiny feet and an American flag. He sat on the bed and slid into his well-worn cowboy boots.

We gathered around the table, hastily shoveling cereal into our mouths—the sound of the cereal crunching mixed with the aroma of coffee and toast. My mother stood at the counter, packing lunches. My dad joined us. As he reached for the cereal box, he boastfully recounted his breakthrough with Gianna the night before and how he had found her temporary housing. Relief

crossed my mother's face, and she attempted to change the subject. "Remember, Jane is in the nativity scene tonight."

My father smiled at me but then talked about another rescue, which made me feel left out and sad, like I was always the second choice.

My brothers left for school after breakfast, while my mother and I drove to my elementary school, the Calvary School.

I loved going to school with my mom, spending hours playing on the playground with friends, and hearing my gray-haired music teacher, Mrs. Phelps, sing songs about Jesus. As we drove, we sang along to our favorite melodies, and my mother's perfume permeated the car. I sat in the front seat, safe and content next to her.

"Are you starting to get excited about tonight?" my mom asked.

"I'm getting a little nervous," I said, staring out the window.

"You're going to be great! No lines to memorize. You just have to sit there looking adorable," my mother replied, glancing at me with a smile.

I shared stories about my teacher, Ms. Kennedy, and my mother listened attentively. "Sometimes I don't think she likes kids very much."

Mom momentarily took her eyes off the road. "Oh? She always greets us with a warm grin."

Glancing at my hands in my lap, I said, "Yeah, but she gives a lot of spankings. I kind of wish the school wasn't so strict. Sometimes, her firm voice scares me, like Daddy's."

Mom didn't respond. Most teachers at the Calvary School, a private parochial school, meted out corporal punishment and spankings.

"But she's so pretty," I said, giggling. "I want to grow up just like her and have a boyfriend like her."

My mother chuckled. "You have plenty of time for that, Janie. Right now, enjoy being a little girl."

Mom accompanied me to my classroom, planting a tender kiss on my cheek as she bid me goodbye just outside the door. Stepping into the familiar

space, I was content, knowing I was among friends. Taking a moment to settle in, I stowed away my jacket and lunchbox in my cubby.

Standing before us was Ms. Kennedy, a tall and slender woman who commanded a graceful presence. Her dark hair cascaded elegantly, perfectly complementing her piercing sapphire eyes. Clad in a plaid skirt paired with a navy blue sweater, she exuded an air of professionalism and warmth. She completed her ensemble with black one-inch loafers, a wise choice for a second-grade teacher.

After taking attendance, Ms. Kennedy raised her arms toward the alphabet banner on the ceiling and began dictating letters. We put our heads down, practicing our writing. I was listening but was enjoying rubbing myself on that tender spot on my body on the corner of my chair.

I looked up to find her glaring at me. She slowed her speech and lowered her arm. I paused.

She stopped talking.

I maneuvered myself back into my seat and sat still, thinking she would forget what she observed and move on.

Sit still, Jane. My chest constricted, and I held my breath. I thought she would not see me if I didn't flinch, much like a mouse a cat had spotted.

But she walked toward me. I was aware of the danger and my eyes widened.

She said nothing. She motioned for me to follow her to the bathroom connected to the classroom.

Ms. Kennedy grabbed the paddle behind her desk, which resembled something from a row boat, and continued walking. The children were staring at me. My cheeks burned. I knew something terrible was about to happen. What did I do wrong? I had never experienced a spanking at school; I always followed the rules. Against my will, I kept placing one foot in front of the other. We disappeared into the restroom, lined with a tile floor that carried

every echo. I knew this because we all overheard the switch and his tears when Billy got a spanking last week. Was I feeling what Billy felt like?

"Jane, I need to talk to you," Ms. Kennedy sternly said. "You've been fidgeting—or whatever you're doing with your hands—and not paying attention. This is not acceptable behavior."

"But I did nothing wrong," I protested.

She scrutinized me and said, "Turn around." I slowly turned and heard the paddle slap and endured the sting. I whimpered and envisioned the faces in my mind. Could they hear? Another slap, more whimpering. My body temperature shot up.

The sting, ache, hurt. Painful butterflies in my tummy. Shockwaves going through my insides.

I crawled inside of myself.

Echo.

They would realize what was happening and make out my sobs.

And it was over.

Emerging from the bathroom, with my backside hot and my face red, no one looked at me. I didn't understand what had happened or have the words to explain it, but the spanking was a message I was naughty. Was this because of what my brother was doing to me? He wasn't hurting me or threatening me, so there was nothing to tell anyone. I sensed it was wrong, but my body responded and thought I was complicit. If I told on him, I would be in trouble, too. When I rubbed my privates in class, I didn't know it was bad.

Ms. Kennedy gave it to me one more time at the end of the day. "Class, remember tonight is the presentation of the Living Nativity Scene. Some of you are lucky I am not pulling you from the production." She stared me down.

That evening of the Christmas event, the set design team decorated the chapel stage with straw on the floor and placed music stands behind a wooden bassinet. Parents made last-minute costume adjustments, and fake beards

and cardboard wings were being straightened. A shepherd in a blue smock anxiously searched for a lost staff. It seemed chaotic, but we had rehearsed this for weeks.

"Janie," my mother called out, beckoning me to come closer. "We need to get you ready."

We found a secluded area in the back of some boxes, away from prying eyes. James lingered nearby. "James, hold on to Jane's clothes for me." Her hands were already fumbling with the buttons of my outfit.

At six, I was no stranger to changing in front of others. Getting into pajamas or swimsuits was a casual affair in my household. But something had shifted earlier that day when my teacher scolded me for something I didn't understand. Exposed and ashamed, I slipped off my shirt and stood there in my underwear.

After a few minutes, my mother asked my brother to hand her my white tights. "We need to have her dressed and on her way. We still have to meet your father."

Mrs. Taylor entered the room. She was always smiling. I wanted to run to her and hide in her gold-flowing robe. She always felt safe to me, but she was more like a shelter when all eyes would be on me. My mom always told me Mrs. Taylor adored me.

Ms. Taylor bellowed, "Everyone, take your places. And if you're a family member not participating, now is the time to leave."

My mom smiled and kissed me on the forehead. "Good luck. I love you! And as they say in showbiz, 'break a leg.' We will see you out there."

As I watched my brother and mom leave, Mrs. Taylor came over to me, and as she straightened my halo, made of silver pipe cleaner, she leaned into my ear, "You've got this. I recognize you're scared, but I believe in you."

I hoped she was right.

As I stepped onto the stage, the bright lights illuminated my surroundings and warmed the scene. The heat of the lights radiated down upon me,

making me feel delighted and nervous. I was wearing a shiny white dress and white tights, which shimmered under the gleaming glow, adding to the ethereal atmosphere of the performance. As an angel, I had taken my place at the coveted spot next to Mary and the baby, where all eyes could be on me. The other angels stood behind me, their wings fluffed out in a majestic display.

I sat on my knees with my hands clasped in prayer, gazing at baby Jesus with pure reverence. In spite of my fear and nervousness, I was determined to remain still and portray innocence. The stage had become my sanctuary, where I could be transported to another world and join in the magic of Christmas.

I was young and sweet and innocent, but I was in pain. I felt altered. Dirty? Distant. Alone.

A vast and all-consuming emotion washed over me, one that I couldn't quite put into words then. It was a clue that left me with intense discomfort and self-doubt. I couldn't name this emotion, but I would learn it was shame, a powerful force that would shape who I was and my world for years to come.

I exhaled deeply, unaware I had stopped breathing. The room seemed to close around me. Leo, who had been napping in the corner, began to stir. Perhaps he sensed my distress; dogs are good that way. His eyes met mine as he slowly got up from his cozy spot. He reached me and gently nuzzled my hand, his soft fur comforting. With his reassuring presence, I took another deep breath.

I wanted to clutch the little girl in the photo looking at me in her angel costume. "I'm so sorry." I wiped my eyes before the tears hit the antique photo. I didn't want to damage it further. Its edges were threatening to crack and tear. As painful as this memory was, I didn't want to lose it.

I laid the album on my lap and glanced at my cold coffee. I detected a sinking sensation in my chest, and the album slipped, and several pages fell loose. I remembered the day I dressed as an angel, and my parents and

brother were proud, but my heart was ashamed. It all made sense to me now. Remembrances rushed back, including those moments with Ms. Kennedy in second grade. Why didn't she ask more questions about my behavior?

As I picked up the scattered pages, I couldn't help but wonder about the missed opportunities for help and healing. All I could recall were moments of shame. My brother came into my room while I was sleeping; I masturbated in my room and in the classroom—what would have changed if they had only asked? Would I have told, or would I have stayed silent to protect my brother? Would we have gotten help through counseling? Would my life have been different?

Anger towards my father occupied my body. He was busy helping someone else's children, leaving me feeling neglected. I was his daughter, his third born, the one he didn't plan on having, the one he claimed not to know how to interact with. I instinctively recognized my need for fatherly love and attention, so when my oldest sibling began giving me attention, it partially fulfilled that longing. I did not understand how much it would cost me. I would spend countless hours later in life trying to reconnect my mind to my body through exercise to the point of obsession.

Exercise.

It was time to decompress, so I grabbed the leash and said, "Okay, Leo, let's go for a walk." Leo jumped up and began running in circles in anticipation. Fresh air would be good for me.

As we stepped outside, a suffocating perception of disgrace and embarrassment engulfed me as the puzzle pieces of my life fell into place. Finally, everything made sense. With the unraveling of the jumbled mess of my existence, it became clear why I had been plagued by and made countless ill-fated decisions. The realization hit me with an intensity that left no doubt—my past deeply scarred me, and it had shaped the course of my life.

Enough for now. "Leo, you lead the way."

S I X T H G R A D E

Dog walks had served me well over the last several years. It was often a time for reflection and got me outdoors, but as I confronted my past, walks took on a new urgency. Leo and I would come back refreshed. On this day the sun was about to give way to rain. "Leo, looks like we made it back just in time. Looks like it may rain."

Leo headed over to his water bowl, licked his empty food bowl, and gave me his sad brown eyes. "Sorry, Chops," I said, using his nickname. "You gotta wait until dinnertime."

I went to the kitchen in search of caffeine. The coffee maker had been idle for so long it had turned off. I pressed the "brew" button and waited.

The aroma of freshly brewed coffee filled the room as I sat at the kitchen table, mesmerized by the sound of water dripping into the pot, reminding me of a calming melody, like raindrops landing on the ground outside. As I slowly stirred sugar and cream into my coffee, a rush of memories returned, transporting me to a younger version of myself sitting at the table, pouring sugar onto a plate of rice with no idea what would come.

Sipping from my favorite yellow mug, which read "I'm a ray of fucking sunshine," I chuckled at the irony of its message and my sailor-like vocabulary. A blur caught my eye as I gazed out the kitchen window. A squirrel darted across the yard and I couldn't help but wonder why God allowed certain things to happen to me.

I ran my finger over the rough patch, tracing the lingering scar from a fight bite etched into my right pointer finger. Recollections came rushing back, taking me to when I was nineteen and waiting in the emergency room to treat a bite on my hand. There I sat, an unbreakable facade, wearing

a miniskirt, heels, and layers of makeup, exuding an air of arrogance that clashed with the nurse's strained patience. Amidst it all, a question still lingered: where had the sweet little girl from my childhood gone? What had become of her? Why did I wear an armor of toughness?

I went to the dining room to put all the painful reminders and puzzle pieces away, one by one, stacking the photo books back into the boxes. An album at the bottom of the box called for my attention. I paused. I'd experienced so many emotions and wasn't sure I could take on any more. My eyes were red from the tears, and my nose was stuffy. I stood looking at it. Taking it out, I recognized it as an album my father put together for me. The navy blue album, with gold trim, was covered in dust. But I needed to revisit sixth grade. I sensed it was pivotal.

I sat down with my coffee and began again.

Around March of 1980, our family made a significant move, leaving the suburban lifestyle for the breathtaking mountains of Colorado. The move strained my parents' already fragile marriage. Marital discord had always been evident, but the process of building their house exacerbated the conflicts. I had long given up hope of reconciling my parents as they led increasingly separate lives. The fractures in their relationship seemed beyond repair.

It was a modern mountain home with open spaces and tall windows so we could take in the views of the blue spruce trees. I had my room with an attached bathroom. Natural colors were all the rage: browns, tans, and bronze. I chose a brown marble tile for the shower enclosure and a faux brown marble countertop for my bathroom, and the walls were cream. For my bedroom, I selected a rust-colored carpet. I was growing up now. No more pink wallpaper and frilly bedspreads.

It was sixth grade, a new school, and I made a new friend—Meg, who lived down the road. We hit it off instantly and became inseparable. When her parents were away, we had the entire afternoon to ourselves. We played loud music, blasting Pat Benatar's electrifying tunes, and ate cheese puffs.

Looking back, those afternoons with Meg were the stuff of legends, and I wouldn't trade those memories for the world.

"Want to see something funny?" Meg asked. I followed her into her parents' room.

"Who's that?" I asked, pointing at a huge life-size portrait of a naked woman on the wall above the bed.

Meg's cheeks turned scarlet as she said, "That's my mom."

I couldn't help but spot the striking features of the nude oil painting: the curves of her body, the red hair, and the curls framing her eyes. As I stared at the picture, I felt drawn in by her dominance. She exuded confidence and strength, not just with her physical beauty, but the overall effect of the portrait captivated me.

Meg pulled out a box from the dresser. "Come here."

As we both sat cross-legged on the shag rug, my friend opened the box to reveal small cards with pornographic images of naked men and women. The men's bodies didn't surprise me, and we giggled at the absurdity of it all. But as I glanced over at the painting of Meg's mother, I was fascinated by her sex appeal. There was something else too. Meg's dad was unpredictable and volatile, and I'd seen her mom appease him by taking his hand and leading him upstairs to their bedroom—the same room Meg and I had snuck into. Amidst the pornography and the naked image, I was aware of her power and how she wielded it to her advantage.

In sixth grade, at my new school, I was a fresh face. It was a turning point, and anticipation and excitement coursed through me. In defiance of the inherent risks of navigating uncharted territory and the potential for things to go wrong, instead, I found people reached out to be my friend. They welcomed me. I was ready for a new beginning, and so was the sixth-grade class. I swiftly became popular among the boys. However, looking back, it's clear I wore a metaphorical sign on my forehead that read, *No boundaries*.

Will do anything for love and attention. It was only a year, but it was enough time to make my rounds and leave a lasting impression.

I was boy crazy and knew how to manipulate them to get what I wanted. My brother was not around; he had gone off to college. No one to give me the attentiveness I craved. He left me like a crack whore needing a fix of male recognition, and my body desired sexual touch. My body was hungry. Boundaries had been crossed in my home. There was a line, but I did not know where that line was. My body tingled and longed for more. I tried to use the same power I had seen my friend's mom utilize.

I sat perched on a ledge outside my classroom. A group of boys surrounded me. We played "Truth or Dare." I teased the boys, who repeatedly opted for the truth. On the next turn, I only offered "dare or dare." The rest of the group laughed while one of the boys, named David, blushed. He chose "dare." I smirked. The boys cheered him on.

We made out at the back of the biology building, and neither of us knew our way around a face yet. But regardless, it was my first kiss. And I panicked. What if he wanted sex? I pulled away from the boy and warned him, "I can't go any further. I've never gone all the way."

He examined me, perplexed, as if to say, of course, we wouldn't go any further. We're just kids. "Something happened to me, my body ..." I trailed off, not knowing what to say about what unknown issues had occurred to my body, but I knew I could not go all the way. "But we can make out."

Peering at me through his glasses like I had three heads, "You mean sex? We're not having sex. I just want to make out."

I was relieved, but before we mashed our faces back together, a teacher approached us and wrote us up for inappropriate behavior. A pink slip of paper would need to be signed by a parent. No getting out of this one.

I sat at my antique desk, facing the window, and pulled out a notebook and wrote a letter to my mom:

Dear mother,

I feel real guilty about something, and I want to tell you. I have been going with David for three weeks now, and he is a good-minded boy. I am going to put boys away for now until 8th or 9th grade. I am going to follow the boys [Joey and James]. I want to be a good-minded girl and be the kind you want me to be. Please don't yell at me. That is the worst thing you could do to me. If you want to take away my birthday party, you may. The thing I feel guilty about is I kissed David three times, and they gave us a D-Form, a detention form. But all you have to do is sign it. It does not go to the office. I am going to break up with David because I don't like boys anymore. So please come talk to me if you want to. I'm in bed. I am going to be myself (weird and silly.) I love you. That's why I'm going to be the kind of girl you want me to be. Please don't tell Daddy. It took enough courage to tell you. Please pray for me. Please try to come talk to me soon so I can go to sleep without feeling guilty.

Love Jane

P.S. I feel better already knowing that you know.

While my father was still at work the following afternoon, my mom called me downstairs. I had anticipated this moment.

"Come sit next to me," she said as she patted the couch with my letter in her hand. I was frightened.

"Janie, don't be worried. First, thank you for your note and your honesty. I won't tell your dad because I don't think it matters."

I waited for her. There was more.

"Janie, I'm leaving your father."

As I kept my eyes focused on the ugly yellow-and-brown striped sofa, I sighed in relief. This wasn't about the boy at school or about how horrible of a daughter I was. It was an opportunity to escape my father. He yelled at me, and my parents yelled at each other a lot. I didn't like the yelling, but

sometimes, my mom fought for me. Of course, I had hoped to fix things between them, but how could I?

Despite being seen as reasonable by most, my father's temper towards my mother frequently spilled over onto me. His frustration stemmed from his need for control, especially since he could no longer corral my mother. He sensed she had already emotionally left him, and her physical departure would soon follow. As his daughter, I was an easy target for his anger, and he would sometimes lash out, shouting I was just like my mother. These outbursts often drove me to seek refuge at my friend Meg's house at night. My father never bothered to find me; he was more concerned with winning the argument.

But my mother possessed a sense of knowing, always finding me and making me feel valued and cared for. During the car rides home, our conversations revolved around escaping his influence.

I continued to pick at the ugly sofa and asked, "Where are we going?"

"I have found a garden-level basement through someone at church. We can take Sneakers, and he will be allowed indoors!"

"Yay! Now Sneakers won't have to sleep in the cold and smelly garage! I can't wait to cuddle with him in my bed and listen to his purring, all warm and cozy, and he'll finally explore the house and climb on the furniture, just like a house cat!"

"That's right! With Joey going to college and us moving out, no one will shun Sneakers anymore."

I did not consider the possibility of staying with my father. In my mind, he had abandoned me long ago to tend to his darlings at his school. "When are we leaving?"

"I don't know yet," she admitted.

I imagined a home without yelling or hostility, where I could be myself without fear, and I felt excited about starting over. But then my thoughts turned to shame and guilt about my body and experiences with boys. I knew

I was carrying a heavy burden no one else knew about. *Why did I go into his room wearing only a blanket? Was that me?* It felt like I had an almost separate self who sought him out. *I am worthless and disgusting.* I felt intense self-loathing, and I promised myself to stop seeking male attention and never let my older brother touch me again. *Did I mean it this time? Can I keep that promise to myself? Or is this just who I am?* Still, I could have a new start.

Noticing a change in my demeanor, she reached over, took my hand, and said, "I want you to understand something," she said. "No matter what has happened, you are valuable and deserve to be treated with respect and love."

Focusing on her, my chest filled with love and gratitude.

Little did my mom realize I had already become acquainted with the intricacies of my body and the dynamics of relationships with boys. While other girls eagerly anticipated their first kisses, the mere thought of my body left me feeling overwhelmed and uneasy. I headed towards middle and high school in a fuzzy cloudiness of disassociation and confusing desires.

Sixth grade. The blanket. I went to my brother's room when he was home from college briefly. The memories that came flooding back to me on that night out with Barbara and Max, when I felt physically ill from memories that could not be suppressed. The nagging memory that had refused to go back into its box, the memory that had taken me here, to the dining room, sitting among countless albums and memories. It felt like a physical weight was settling on my chest, squeezing the air from my lungs. I wanted to forget this part of my past. My muscles tensed, and my stomach twisted into knots. With a heavy sigh, I closed my eyes, hoping to shut out the vivid images, but they persisted.

CHAPTER 28

F U C K Y O U

I spent the next several days processing what I had been recalling, but as the week went on, I knew there was more. I set aside another morning to go deeper. As I sat in the dining room with my coffee and the albums, the weight of those middle and high school years tugged at me. Despite the warning bells ringing loudly, I returned to the attic to retrieve my yearbooks. I flipped through the pages only to find a collection of messages, predominantly penned by boys—but they revealed a cruel reality. According to their words, I had wasted my junior high and senior high years chasing after their fleeting affections and engaging in promiscuity. From middle school to senior year in high school, my memories unfolded like fragmented scenes of pain and anger, each one a tiny vignette etched in my mind. These recollections housed long stretches of haziness interspersed with intermittent glimpses of attention-seeking behavior.

Desperate for validation and acceptance, I had spent copious amounts of energy hunting for approval. To escape, I turned to drugs like marijuana, cocaine, and mushrooms—anything to become someone different, a person whom everyone would love. The first time I had seen cocaine was when I started dating Trent in my junior year. We were riding in the front seat of Trent's best friend's truck. As Spencer navigated the windy roads with a marijuana blunt in one hand and the steering wheel in the other, he glanced at Trent and said, "Are you gonna open that up or what? It's supposed to be really good stuff."

As Trent placed a mirror on my lap, he said, "Oh, hell yeah! And Janie's gonna join us this time!" Trent and I had discussed my getting high on cocaine with him. He promised, "It will make you horny. Your sense of touch

will be heightened, and you'll have stronger orgasms. And I'll be able to fuck you all night," he'd said, grinning devilishly.

Spencer took his eyes off the road and asked me, "Are you sure?" Spencer had an addiction and was a lost cause. It appeared he was trying to warn me in some way. He inhaled from his joint, held his breath for thirty seconds, and exhaled. The air was thick with the earthy scent of a skunk.

Trent pulled out a small envelope. He poured chunky white stuff that resembled baking soda onto the mirror, its texture rough and grainy, just like I had seen in movies and the media. He expertly cut the material into a thin line with a silver razor blade, moving his hand back and forth like a conductor directing a symphony. The sharp metallic scraping of the blade against the mirror filled the air. The line grew thinner and longer, shimmering in the dim light. Trent bent over and with a short straw and practiced hand, inhaled the cocaine through his nose.

"Have you ever seen cocaine before?" Spencer asked.

I tried to be calm, but my heart was pounding. I pretended to know what it was, but I was nervous, unsure of what would come next after inhaling.

"Of course," I lied.

Trent grabbed the mirror, put it on his lap, and handed me the short straw. "Your turn."

As I bent forward, my blonde curls framed my face. My reflection was staring back at me. I was careful not to exhale for panic of sending the expensive white drug scurrying off the edge. Pressing my left nostril with my left pointer finger, I held the end of the small straw with my right hand, put it inside my right nostril, and inhaled. I got a whiff of metal and gasoline as a burning sensation entered my nostrils, but I kept pushing the straw onward until I reached the end of the line. I closed my eyes and tilted my head back. And as I had seen Trent do, I snorted like I was fighting a cold and didn't have a Kleenex. I sealed off both nostrils and sniffed, not wanting any granules to

break free. A dreamlike euphoria and a sudden rush took over, and I couldn't wait to experience that high again.

Trent licked his finger and ran it along the now-empty packet, scraping up every last granule of the white powder. He raised his finger to his gums and motioned for me to do the same. "Use your finger to clean the mirror and rub it on your gums like this. It gives you an immediate high and improves the drug's effects."

Spencer added, "Fast absorption into the bloodstream."

I did as I was told. I felt like I was invincible and could take on the world.

"Yeah, baby! How do you feel?" Trent leaned in for a kiss. I breathed in the scent of his cologne, Drakkar, before answering him by pulling him to me and French kissing him.

"I feel amazing. I want more!"

I dove into both pot and cocaine like a child at Christmas, barely getting into one gift before moving on to the next. We drank tequila, smoked joints, and did lines of coke. I relished the high, the euphoria of being able to take on the world. I was indestructible.

As I perused through my yearbooks, I stumbled upon some entries that caught my attention. One of them was a cheeky message left by Jim: "Jane, I really hope we get to try out your waterbed. If the heater breaks, call me. I hope you don't forget about me during the summer."

Another line from Travis grabbed my eye: "You should have called me when you got your waterbed. If you ever need ANYTHING, call me. I'll be right over."

And then there was Madison, the first girl to inscribe my yearbook, who humorously questioned why she had achieved such an honor to be the first and only girl, making me chuckle.

An intense sense of grief washed over me as I sat with my yearbooks in hand. I mourned the loss of my self-esteem, the squandered time, and the untapped potential within me. But as I reached my senior yearbook, something

was strikingly different. Its pages, once meant to be graced with well-wishes and shared sentiments, remained hauntingly blank. At that moment, a bitter recognition dawned upon me—I had left those pages untouched as if to defiantly say "Fuck you" to the rest of the class. It was a silent rebellion, a casting back of the rage and resentment that had consumed me. I looked for solace in drugs, alcohol, and casual encounters, and that kept what I really needed away.

Finally, my life made sense and could be rearranged. I realized the root of my disastrous conduct. As I reflected on my life, I saw how the past had shaped my sexual history and my choices. It was a hard realization, but brought clarity to what I felt inside. Stripping hadn't been as damaging as I thought. When I stepped onto the stage as a stripper, I felt in control, and bold, confident, and motivated. I was in command of my life, and no one could stop me. I stood a little taller and carried myself like the strong, capable person I believed I was, ready for whatever bullshit came my way because I thought I could manage the outcome, no matter what, and I didn't care who knew it!! Perhaps not the stage I had envisioned, but the day at the Bustop when I was drunk, putting one shaky heel in front of the other, was the starting point towards healing. I didn't know it, but I could appreciate it now. Stepping onto that stage took courage, even if it was liquid courage. It was the first stage where I was seen. It may have been false confidence, but it was confidence. It was the first step toward taking back and reconstructing my identity. That stage led me to the hotel room with Biz—to perform an intimate lap dance where I had my first flashback of the sexual abuse at the hands of my brother, but I tucked it back into its box. *But now I understood why I had been depressed for much of my life. No one knew the real me. Not even my husband. He needed to know. I had to return to those memories and confront them and be healed. I stood up from the table. My body was heavy like I had taken on a ton of bricks.*

The piercing alarm on my phone jolted me back to the present. It was time to retrieve the kids. I went to the bathroom to compose myself. Glancing at myself in the mirror, I took a moment to wipe away the smudged black mascara from the corners of my eyes to regain a semblance of composure. I ran a comb through my hair, taming its unruly strands, and put on a pair of sunglasses to mask my red eyes.

As I drove through our neighborhood, the skies had cleared, but humidity lingered from the earlier rain, so I rolled my window down. I turned the radio volume to max and picked up speed on the highway. My hair swirled about in the wind, caressing my face. I shouted the words along with the song *Closer* by Nine Inch Nails, and slammed my fists on the steering wheel. It gave this little girl power—even if just for a few minutes—power and strength. And it felt good. I flew off the exit and paused at the stop sign. The driver in the car to the left of me seemed apprehensive. They were probably wondering if I was going to stop at all. The pause allowed me a chance to regroup. I signaled them to say, "Yes, go ahead. Trust me, I'm okay now. I'm done yelling at my radio."

I rolled up the windows and headed toward the last two blocks to the elementary school. I parked and walked into the world of the happy-go-lucky stay-at-home mom who had it all together.

The bell rang and children began streaming out of the school building. I took another breath. *They have no idea the battles I fight in my head.*

"Hi, Jane. How are you?" asked Sofia, one of my close mom friends.

"I'm okay. How are you?"

"Good." She studied me and continued. "Didn't you say you were going to spend some more time going through old photos and stuff to see if you could find some answers?"

My kids walked past me, hardly aware of my presence, and strolled toward the playground. "Guys, we can't stay. Remember? I have an appointment."

Sofia had been an excellent listener as we often hung out after school while our boys played. She asked, "Everything okay?"

"Yeah, it was just intense, but I want to heal. I want to feel better."

"I'm here if you need anything. Or if you want the boys to come over so you can do your thing."

"Thanks, Sofia. I really appreciate that."

Maybe I was getting it all together. I was beginning to feel a sense of closure and purpose, as though each piece was finally coming full circle. I was determined to break free from the cycle of self-destructive behavior and find a healthier path forward with Steve and my marriage, and walking that path meant writing it all down and facing my unfiltered past.

CONNECTING

FRIDAY, MAY 5, 2017

I entered the brown brick building and felt the stress fill my body. I didn't want to be in her office. This was costing me valuable time! I had been seeing Dr. Douglas one-on-one for almost six months since ditching Dr. Holden.

After going through the albums and making sense of my history, I became so obsessed with writing my story and getting it out that I started resenting going to counseling. I only wanted to hole up in my office and write. Writing was more healing than any therapy session. But I was too chicken to pull out a last-minute excuse, so I didn't cancel within the twenty-four hours. Who was I kidding? Therapists have a sixth sense when you're lying, so I went to the scheduled appointment.

I found a chair in the waiting room and began filling out my check for $250. I had barely finished scribbling my signature when Dr. Douglas called me in. I took a seat as she smiled at me. "How are you?"

"I'm pretty good."

"Tell me more," she said as she stroked her blue skirt and sat across from me.

"I'm writing. I'm writing it all down. Everything. I have started a blog. I am going to create awareness."

"You said that last time you were here. Are you still considering going public with your story?"

"Oh, yes. I have to. No one else is talking about it."

She was quiet, pursing her lips, crossing her legs, and looking at her notepad.

"I've been working on a website, too. Perhaps I'll share my story on some podcasts one day."

"About that. I have consulted with another doctor in the area about your situation. Do you recall Dr. Alexander? We discussed EMDR therapy with her."

"Yes."

"With your permission, I have talked with her. Do you recollect that?"

"Yes."

"She and I deliberated over the phone and are concerned about you going public with your story. You have young children. What if someone at their school finds out you and teases your children?"

Her words were a shock to the system. I tried to decide if I had heard her right. A lump formed in my throat. I couldn't move. *Was this woman trying to shut me down?* I was more than familiar with that feeling. I had been shut down for decades. But this story was coming out. I thanked her for her concern.

MONDAY, MAY 8, 2017

I was still exercising at least once a day, six days a week, if not more, and my body hurt from sitting at a desk for hours on end writing my story. More and more answers were revealing themselves through my writing, leading to an understanding about that little girl and the woman I was becoming. The two were starting to become one.

To relax, I booked a massage about every two weeks. On this day I walked into that session as a woman on the mend, finding her voice, untangling her past. I was freeing myself from the shame of experiencing sibling sexual abuse as a child. Then things came to a screeching halt. I was sexually assaulted on the massage table. He had barely left the room when I slid off the table and was instantly overcome with shame. What the hell just happened?

Did that happen? Why didn't I defend myself? Cry out and jump off the table? Was it something I said about being tight all over?

I raced out of the studio, filled with fear and embarrassment. Heat rose in my chest as I drove, my hands clenched tightly on the steering wheel. I took a moment to calm down and process what had happened. Then I got angry. I had been abused and taken advantage of—it wasn't my fault, and I couldn't shake the sense of violation. Memories flooded back to me, and I realized why I couldn't do or say anything when I was a little girl—my body had gone through something similar. Feeling this way as a grown woman was confusing, but I knew what had happened in that room.

That night I had trouble sleeping. My body felt heavy and empty. I wept. I'd never know what my life could have been like if my brother hadn't touched me. I was a happy, silly child once. My brother's actions caused immense pain and confusion, and altered the trajectory of my life. Those actions changed the way I interacted with men. It had to be a piece of the puzzle to my messed-up life. Was it part of the reason I froze on the massage table? I started to understand that little six-year-old girl who did not tell. That six-year-old girl's body responded to the touch. Her body didn't comprehend it was her brother. No wonder she split in two.

Now I had more work to do, and I had to return to that little girl AND the adult, married woman who didn't stop the massage therapist. What was wrong with me? How did I let this occur? I must have a sign on my forehead that says, "Pick me. Use your dominance over me."

Intellectually, I understood why my life had happened out of order, and I had battled depression and used alcohol and drugs in order to hide, but my body was still learning from the trauma. My body did not match where my head was intellectually, so I became paralyzed on the table. I was in a vulnerable position where I expected safety and trust, but I transformed into a victim of abuse. I experienced distress, and my muscles tensed, feeling ashamed of the unwanted sensations in my body. Was chronic guilt affecting my ability

to regulate my emotions? Why didn't I take control in that room? I failed myself. I failed my husband.

I saw Dr. Douglas a couple of times after the assault, but I could not trust her with the incident on the massage table because when I told her I was going public with my story, I didn't receive the support the incident called for. She was more troubled about the potential consequences of going public than my healing process. I told her I wanted a break from seeing her, and never went back.

Instead, I devoted the next two years to the practice of writing, finding relief and release by pouring out my emotions onto the page. Tears mingled with the ink daily as I closed my eyes and let the words flow. When I later revisited my writings, a fresh clarity emerged, and I marveled at how I had navigated such intense challenges. I realized I should never have been burdened with hypersexuality at the tender age of six, nor should I have experienced the heartache of widowhood at thirty-four. So much of my journey had been marred by being out of sync with the natural order of things.

After the sexual assault and my realization of my inner child, I pulled out a photo of myself at around age six. I taped her picture on the mirror, knowing I needed to reconnect with her, forgive her, understand her ... But I found myself looking at her with disgust. I didn't like what she had done. What she had taken part in. I followed my instincts and set foot into the revolving door. It was efficient, just like a revolving door, rotating round and round. Then, I saw her again, the silly little girl, standing to the side, watching me. I made eye contact with her. She focused on me. I felt an internal conflict between being inclined to push her away and wanting to offer her love and support. She reached out to me, but I didn't need her. I wanted her to go away and fend for herself. Figure it out, kid. I did. And I pushed her aside. Again. I struggled with humiliation and repulsion toward my younger self and fought to find compassion for her.

Throughout the course of the last two years, the word "forgive" had come up in various instances. From my mother, in church sermons, through other survivor stories, and even through letters from a niece, which made me realize my trauma was impacting the next generation. I fought it. Hard. If and when I were to forgive, it would be on my time and my terms. Was I ready to forgive? It had been a long and uphill journey to this point. The revolving door trapped me in a self-judgment and emotional detachment cycle. I stood, judging her, even though I recognized she desired empathy and a hug. I had to forgive that little girl for not telling and enjoying the touch. It wasn't her fault. She didn't deserve to suffocate under the weight of my shame. Forgive her?

Forgive.

Was I prepared to forgive?

At that moment, I understood.

I was ready to forgive. I was ready to forgive that little girl... and my older brother.

CHAPTER 30

LETTERS AND FORGIVENESS

I sat in front of my Chromebook on the kitchen island, breathed, and began typing a letter to James—a forgiveness letter.

I typed hastily, straight from the heart, printed it, tucked it in an envelope, slapped on a stamp, and headed barefoot down the driveway with it, fearing I might lose my nerve. I dropped the letter into the mailbox and raised the flag. As I paused, the scorching pavement burned my bare feet.

I hopped up the driveway with a sense of freedom and fear all wrapped up in one.

I went upstairs to the guest room and let what I had just done sink in. I thought about retrieving the letter, but didn't.

For the next three days, I was nervous, watching for the phone to ring. I was sure he would call me to talk. I kept checking missed calls on my cell and home phone.

Finally—a missed call from him. No message. I was so tense I could hardly breathe. A day later he texted me, asking me what number to call me on and when I would be available to chat. We set up a time. On the day of the call, I explained to the boys I would be on an important phone call and not to bother me. Whatever the outcome, one thing I was sure of was James was willing to talk to me.

The call came. I hadn't heard Jame's voice for a long time. He cleared his throat and said, "We need to talk."

I took a deep breath and replied, "I contacted you because I feel obliged to say something. I've been working on forgiving you for what happened when I was a little girl. It's been a long and painful process and is still ongoing." There, I've done it. I'm finally saying it out loud. I need him to understand the hurt I've carried around all these years.

James told me he was listening.

"I remember you apologizing when I turned twenty-one," I continued. "I told you something like, 'It's okay. I participated, too.' Thank you for your apology. It helped me, and without it, I might have carried a lot of anger towards you, thinking you didn't care about the impact on my life."

I paused, taking a moment to collect my thoughts. I want him to know I'm not trying to accuse him or make him feel guilty, but I can't make believe it didn't take place. His apology meant something to me but didn't heal the scars.

I proceeded. "Even though I said 'it's okay' back then, it was never okay, and it still isn't. I never asked for any of that to happen. I was so young and innocent, unable to comprehend what was happening to me. What you did changed the course of my life. I take responsibility for my decisions, but it's crucial to understand I was conditioned at a youthful age to believe being sexual was the way to earn love from a man. I wrestled with self-esteem and rage for a long time without knowing why."

I stopped speaking and tried to contain my emotions. I wish he could identify how it affected my morale and my relationships. Did I say too much? Did I say it right?

What if he thinks I'm blaming him entirely? I had said that it was okay back then. But it wasn't okay. It was never okay. I hope he can accept that.

James broke the silence, his voice trembling slightly. "I honestly didn't realize this was still affecting you. I thought it was all behind us."

I sighed. I overflowed with a mix of concern and sadness. He seemed genuinely surprised. Maybe he didn't perceive the depth of my pain.

Should I have been more gentle?

"You might not have fully understood, and I'm not trying to make you feel badly. I just wanted you to be informed how deeply it impacted me."

We were both silent, processing the heavy conversation. I can't change the past, but I can be honest about how it shaped me. Hopefully, he can grasp the meaning of this exchange, and it will bring us some healing.

"I think we both had two different experiences, and I don't think I can handle knowing what my actions have caused. But I will support you in any way I can."

I responded, "No family is immune to struggles and difficulties. This is a broken world. I've spent a lot of time asking God why he allowed this to occur. This was not something I could pretend to be thankful for, but what you took from me was just a chapter in my life."

I filled the awkward stillness by rambling, unsure if he was listening. "In my heart, I don't think we are the only two out there. I am not the only Jane; you are not the only James. We can help people. I need to come forward. I want to save other children from sexual molestation."

He responded positively. "I will help you."

Those words made me grateful he would assist me, and a sense of relief came over me that the burden was no longer solely on me to carry. To heal, I had to tell my story. I sensed that was how it had to be. I was a survivor. Finally, I was thankful for what God had done in my life and what He continued to do.

I admitted to James, "I do not know if I can ever have a relationship with you. It's too soon, but I will do my best, especially when families come together. This is not about ruining lives or making you feel guilty."

After taking a pause, I said, "But I have to ask: why did you do it? Did someone touch you?"

He took his time to answer. "I was not abused. It all started out as curiosity. There was an evening when we kids were watching TV. Mom yelled down the hall, kids, time to get ready for bed."

He paused.

"We had just had health class earlier in the month, and I had questions. You jumped up and changed into your pajamas. I saw enough. I knew instantly I wanted to see more, maybe when you went to the bathroom or something."

I couldn't move. Or breathe.

He resumed. "Well, I got you alone, my body responded, and I wanted more. I didn't know I was hurting you. I'm sorry."

I was quiet for a moment and said, "I have more than one memory. Did it happen frequently?"

"I made a choice to stay home based on whether you would be there for me to watch."

Oh fuck. I think this happened much more often than I recall.

During the call, he said he was relieved it didn't go all the way, because it could have happened that time when I went into his room with my favorite horse blanket. He was aware I had an intention to seduce him. He further acknowledged he realized that just because we didn't go all the way, it was just as damaging as if we had.

I told my brother that I appreciated his honesty and that I might have more questions. He said he understood. I hung up and sat staring at the wall.

CHAPTER 31

C O V I D A N D A
T U R N I N G P O I N T

In March 2020, COVID-19 hit, and our world changed. Drastically. The global pandemic forced us all to confront a strange reality. The isolation I experienced during my healing journey became universal as people worldwide faced the panic of a spreading virus. Both boys, aged eleven and twelve, were about to complete sixth grade.

Just the week prior, I had hollered at Tate, "Come on, Tate! Please! I want a picture of us! It's a rare occasion. I am not wearing leggings, and you're not wearing Under Armour." We were going to a mother-and-son luncheon, and Tate had to help out. We were both in dress slacks and dress shoes. Steve was taking photos, and I hoped that Tate, not known for smiling, was actually smiling. Steve assured me he got at least one acceptable shot.

Steve asked again, "Are you sure you need to do this? There is this thing lurking, COVID-19."

"Yes. Tate needs to be there to meet his community service hours. Besides, they would cancel the event if it were a big deal."

Minutes later, we arrived at school. Tate headed to the kitchen to learn his duties, serving the moms their meals. I admired items at the silent auction, deciding what to bid on. I laughed and smiled with my mom friends, wondering if I should have stayed home and gotten some things done instead, but my thoughts were interrupted by a pack of students following the drama teacher into the library. Like ducklings they lined up in their place and watched for the teacher's cue. The audience enjoyed the numbers the kids performed from *Grease*. At lunch, we passed pitchers of water amongst the tables, and dry coughs echoed in the high-ceilinged room. I sneezed. "It's

allergies," I told my friends. We traded pens among strangers and swapped cash for winning prizes. Women were chuckling as they toted their winnings to their cars, wine, and gift certificates to restaurants, bowling alleys, and nail salons. We talked intimately and exchanged hugs.

Then, a few days passed, and classes came to a halt. It would be a temporary hiatus, we were told. Distance learning began. Beaches were restricted and trails were limited to how many people could be on the path. We suspected more closures were coming, so we went on an eight-mile hike at Mt. Tamalpais. Two days later, parks were no longer open.

Shortly after the parks shut down, Steve worked from home again, completing a full circle. But this time, I wanted him home. During the most challenging times in our marriage, our conversations were often tension-filled. It had been close to three years since we quit counseling. We had deep conversations about our feelings and struggles, a sign we were recovering. We discussed how best to parent our boys. We opened up about our fears about this unknown virus, and we began forming a strong bond. It was a turning point. We would watch the news at the end of the day in the glow of the fire in the fireplace. Steve working at home made us feel secure, but we were terrified at what was happening. Thousands of people were dying each day. We wanted to keep our family close and safe. Every night, I would kiss him, grateful we were in this scary situation together. We had come so far.

The world was grappling with the uncertainty of a new virus during this period. We had such limited knowledge, and the media made it seem like even a glance might spell doom for all of us. So, I developed a diligent daily disinfection practice, meticulously wiping down everything. After each walk, I wiped Leo's paws with a damp towel, fearing he might have stepped in the virus.

Grocery shopping shifted to a nightmarish experience, which was downright terrifying. We knew so little about the virus, and what if I brought it home with me since I was the only one leaving the house? A palpable stress

filled the air as we queued up outside the store, standing six feet apart. We substituted awkward glances instead of friendly exchanges. The aisles were converted to one-way lanes, and we wore masks for protection. Upon returning home, I placed groceries on top of towels and sanitized each item with Clorox wipes.

And there was Steve, homebound, 24/7, which provided comfort. With schools and businesses closed and lockdown measures in place, it was a reasonable time for me to write full-time. A sense of urgency fueled my efforts. I knew we would live like this for at least two weeks and possibly past spring break. I was determined to make the most of it. This was the writing opportunity I had been waiting for, and an inner voice urged me to seize it. So I did. I wrote and rewrote, embracing the moment.

Steve found pockets of time to review my chapters. Then the school announced the students wouldn't return to school for the rest of the year, granting me the precious bonus of several months to focus on my writing. I entertained the possibility of finishing my work by the end of summer. We established a productive routine as I persisted to write and rewrite. After I completed a portion, he graciously took the time to read it over and offer valuable edits. Although the act of transcribing was therapeutic, Steve had a different observation. Reading my work unsettled him sometimes, and he often had questions for me or points he wanted to discuss. I was only occasionally ready to engage. I found I could write it down, but talking about it or voicing it out loud only made me want to retreat.

We began a new schedule. Previous regimens of commutes and homework had been disrupted. So before dinner, we often enjoyed the hot tub together. But he queried about what he had read earlier in the day. "You mentioned something about Mark that ..." Oh, shit, a question was coming. An explanation must be made. Feelings have to be identified. My heart raced as those words hung in the air. My defenses kicked in. A familiar sense of disassociation washed over me like a protective shield. Steve glanced at my face,

and perhaps he saw anxiety and avoidance in my eyes. Unexpectedly, a different tone emerged: "I'm proud of you. You've come a long way. I love you."

I slid into the foam, the warmth of the water surrounding me.

"I can see and feel you pulling away. Why do you do that?" His voice held frustration, and I knew he deserved an honest answer.

The unspoken words swirled in my mind. *Have you not been reading? I am not worthy. I am fearful of being known and being hurt.* I couldn't let him be aware I had insecurities. I hesitated, my body tightening with the pressure of what I wanted to say, what I needed him to understand. I couldn't speak.

Undeterred, his gaze fixed on me, he said, "It's great we can talk about these things. We wouldn't have been able to do that before."

I nodded, trying to convey my appreciation for his patience, but I was still trapped in the whirlwind of emotions that had been brewing for decades. We sat in silence, enveloped by the hot tub's steam.

I wiggled in the water, attempting to find a comfortable position, desperately hoping he would change the subject. But, in true Steve fashion, he pressed on. "I read the latest segment, and it was intense. So I can follow why this is important for you, to get it down, but it's also hard to read so much about Mark and all the guys you dated."

I looked away from him and silently pushed the mounds of bubbles toward my chest, wishing to be swallowed up by them and disappear. "I may take some bits out, but I just have to get it out."

"Yeah, I don't know if you need all of that. I love you, but it's kinda difficult to compete with Mark."

My heart clenched in response to Steve's words. I thought to myself, *Do you mean a dead guy who is on a pedestal and can do no wrong?* It was true; Mark had never wanted children, and he had been idealized in my memories as a man who could do no wrong. But here was Steve, trying to be understanding, and I couldn't help but wonder if my late husband's shadow loomed too large over our marriage.

His words caused my heart to skip a beat. Steve had always been supportive, but what if he couldn't handle the raw truth I was about to reveal? I gazed into his eyes, searching for any sign of doubt. "Yeah, I know," I finally said, my voice betraying my uncertainty. "It's difficult for me to relive those experiences, but I have to write them down on paper." I detected guilt for burdening Steve with my history.

Feeling the need to let Steve understand how I felt about him, I said, "I love you, too. You are the father of our two boys. Mark can't compete with that!" I was sincere, but I wondered if Steve held any resentment against my late husband and our past life together.

Steve nodded, but I saw the concern etched on his face. "But I also worry about you. You pull away from me, and I don't want that to happen."

I knew he was right. Lately, I'd spent more time in my head than with him, in the self-imposed isolation shelter I called my office. "I know," I admitted. "And I'm sorry. It's just this stuff is hard to talk about. I feel ashamed and don't want you to see me differently."

Steve reached over and took my hand. "I understand," he said, his eyes locked on mine. "But you don't have to be uncomfortable. You've been through a lot, and I admire you for being brave enough to write about it. I still love you, no matter what."

Tears stung my eyes, and I blinked them back, relieved to hear his unwavering support. "Thank you," I whispered, my voice cracking. "But there's still a bunch of shit I haven't told you yet. Things I'm petrified to share."

But as I untangled my story, I healed. And along the trek, Steve understood me better. He loved me, despite my past. Steve's grip tightened on my hand. "I know," he said. "I'm here for you when you're ready. We can take it one step at a time."

I found security in his presence but couldn't ignore the lingering need to keep a measure of emotional space. As he shared ideas about what I had written so far, his eagerness to move beyond the pages about Mark and delve into

the happier parts of our storyline was tangible. But, I couldn't forget about the trials we faced over the almost ten-year span, from our first meeting to getting married and having kids. Our tale was a chronicle of exuberance and struggle, and I needed to find the right balance between sharing it all and preserving our relationship. I wrote every day. I had to. My head was full to bursting. I was desperate to put it down on paper, or I would explode.

I had come a long way in my healing journey, and I wanted to connect with other survivors and let them understand they were not alone. Fortunately, I didn't have to go far before connecting with Sarah, an activist about the problems of sexual abuse. She asked me to join her private Facebook group, which was active and had many advocates. I checked out her posts and responded to questions specific to incest. She launched an IncestAware website and invited people to provide a photo and a short quote. I jumped at the opportunity and helped her, sending her book titles and descriptions for educating children about body safety. She listed me as a potential speaker, podcast interviewee, and co-founder.

When Sarah announced her appearance on a popular podcast and the host wanted more survivor stories, I emailed Tori, the host, and she got back to me. Together we devised a plan for the episode. In the minutes leading up to the meeting, my emotions were a swirling mix of anticipation, anxiety, and excitement. It was something I had been mentally preparing for, and for quite some time. As the clock ticked closer to the interview, I became very nervous. I practiced in front of the mirror and walked back and forth, trying to calm down. I was apprehensive about stumbling over my words, forgetting what I wanted to say, or being unable to articulate my thoughts coherently. I worried about how the audience would receive my story of sibling sexual abuse and if they would judge or criticize me. The fear of public speaking and revealing my innermost reflections weighed heavily on my mind. I tested

my internet connection, camera, and microphone multiple times to ensure everything was operating.

My nervousness did not abate, but as Tori and I started talking, I opened up in ways I didn't think were possible. I divulged my deepest, darkest secrets and talked about my body's reaction to my sibling's touch and the surrounding shame. The vulnerability of that moment was overwhelming, and I endured a sense of being exposed. But liberation and exemption quickly followed. Releasing my experiences was cathartic. That episode was pivotal in my personal growth. By opening up, I freed myself and had the potential to inspire others.

What happened next was amazing. More opportunities for me to be a podcast guest developed, and I connected with others. More messages poured in like, "It's beautiful to see someone else who's been through similar stuff to me and come out the other side. You have given me hope to keep going on my healing journey!" or, "I thought I was the only one. I have never seen anyone talk about this before." The first few times after talking about the sexual abuse with my brother left an emotional hangover that lasted for days. I was vulnerable—as if I'd opened a window into my soul for everyone to see. But as I shared more, I let go of one layer of shame at a time.

I started feeling better as the depression that had plagued me for as long as I could remember gradually faded away, making room for joy. Acknowledging my path to healing, I understood I could not deny any aspect of my story. I couldn't be free if I rejected any part of my life. To be free, I would have to accept everything, both the good and the bad.

As I let go of embarrassment and embraced my story, my marriage began to heal and I gained newly discovered insights. As I uncovered my past, I discovered a more profound truth about me I had always hidden, and I unlocked a new alliance with myself—I was worthy of being loved. I learned to trust and open up and found a kind of love and peace I had never imagined. I allowed myself to quit striving for some destination and owned my story with grace,

and quit trying to deny it or outrun it. Outrunning it had not worked anyway. I only ended up with blisters or running injuries. The elusive finish line I had been searching for in my grief process was much like the fleeting finish line to healing. I applied what I had learned from my grief process to the process of healing from my sexual abuse journey. I allowed myself to grieve the childhood I had lost, and I began to heal, understanding there may never be a finish line.

PART SIX

CHAPTER 32

ONE MORE
COURSE

As I continued to document my story, I came to understand that sibling sexual abuse remained hidden behind closed doors, which deepened my frustration. My annoyance wasn't just with society's lack of awareness or caring, but with my complicity. For years, I had carried the burden of my own experiences, afraid to speak out, afraid of the stigma and judgment. But that distress had transformed into a burning need to bring light to this problem. A fire was lit within me, fueled by the understanding that countless others were suffering quietly, just as I had.

I couldn't stand the thought of more siblings enduring the pain and trauma I had gone through, all because we were trapped in a culture of denial. The knowledge that many suffered while the world looked the other way infuriated me. I had to break the silence, no matter how uncomfortable or frightening it might be.

But the fears were ever-present. There was the fear of not being believed, of being labeled a troublemaker, or worse, a liar. I worried about its impact on my relationships with my family members, who may not be ready to confront the painful truths I was about to reveal. And there was the fear of being perceived as an attention-seeker or exploiter of a sensitive topic.

Nevertheless, despite these fears, my need to shed light on the silent epidemic of sibling sexual abuse was stronger. My story may help someone, let them understand they were not alone and that healing was possible. I pushed past the discomfort, determined to make a difference, one story at a time. It perplexed me why this issue was still taboo, but I was intent on being the one who could start the dialogue.

On a warm spring day in March 2021, I descended the stairs, and the polished surface of the wooden railing was cool against the palm of my hand. The tantalizing aroma of smoky turkey bacon, its salty essence mingling with fried eggs, wafted through the air. Steve was enjoying breakfast in front of the TV. I settled into the comfortable black chair in the family room beside him. Leo leaped onto the sofa and nestled his nose under Steve's left elbow, hoping for a morsel of something, his tail thumping in expectation.

"What's up?" Steve said between bites. "You look like you have something on your mind."

Steve lowered the TV's volume, took a bite of his fried egg atop his toast, and made a loud crunching noise. A knot grew in my stomach. His support meant the world to me, but the worry of not succeeding and the financial consequence was weighing on me.

He sensed I wanted something and suspected it would cost money.

"So you know this course I have been taking?"

"Yes." He didn't glance up but took a swig of his coffee.

"You know I've learned a lot, and it's helped me with going live on Facebook and Instagram."

"Uh-huh." He sunk his teeth into his toast. My tummy rumbled.

"Well, they are offering an eight-week *Be Seen Accelerator* course. It's supposed to help you get on TV."

"Yeah?" he said with a question mark.

"I really want to take the next course. I mean, it's not just about getting on TV; it's about conquering my fears and pursuing my passion. But I don't want to fail or waste money."

He finished chewing, took another sip of his coffee, and said, "How much does it cost?"

I took a deep breath and laced my fingers together, trying to put off the bad news of divulging the price.

Glancing at the TV, he asked, "Can we discuss this later?"

"Well, the sale and enrollment end tonight at midnight."

Steve placed down his fork and fixed his gaze on me. "Well, with the kids still home, you have more time."

"Exactly."

"Okay, just make sure you send me the receipts. Go ahead and sign up."

I nodded, feeling a bit of relief but still hesitant. "Sorry. Everything I do costs money, and I hate burdening you."

"If this course is important to you, then it's important to me, too. We'll figure it out together."

"Thank you!"

As our conversation about the course ended, Steve grinned and asked, "By the way, are you okay with me picking up some treats for tomorrow?"

As our conversation about the course ended, Steve grinned and asked, 'By the way, are you okay with me picking up some treats for tomorrow?' Working from home fostered Steve's love for routines and sugary treats. And during COVID-19, Steve started a tradition to brighten our Wednesdays. Every week, he would bring home a box of treats. Our two boys embraced the custom and pigged out on their favorite sweets, and I couldn't resist either.

"Absolutely!" I replied with enthusiasm.

Steve's incurable sweet tooth earned him the endearing nickname "Pastries."

"Usual? Twelve glazed donuts?"

"Whatever you want—pastries," I joked, knowing since he had agreed to another course, it was only fair he chose whatever he desired.

I began the course feeling confident and hopeful. But the amount of work we were given tested me. I felt inadequate when I compared myself to the others in the class. But I knew I needed to conquer my anxiety and raise my hand, to get over feeling exposed when I needed answers.

When I did speak up, what followed was a pleasant surprise. Instead of criticism, I received private messages of encouragement from others who reminded me of the importance of my advocacy and my desire to help many people. Their words resonated: *Jane, you are an expert. You lived this.* Their understanding helped relieve some of my mental distress. I actually had mentors to guide and reassure me.

While I worked hard to refine and polish my message, a nagging sense of inferiority crept in. I couldn't help but feel uneasy about why any TV or news station would consider speaking with someone like me.

I tirelessly pitched the media, sending countless emails, but many I suspected went unopened, and others, though read, didn't result in a response. The media's primary focus on ratings meant discussing sibling sexual abuse failed to grab their interest. The dark nature of the concept relegated it to just another part of the daily news cycle, overlooked and overshadowed. The lack of response made me question the energy I invested, making me wonder if my attempts were in vain and if my subject matter would ever reach a broader audience.

What kept me going was my steadfast belief in the issue I was trying to address. This issue needed to be discussed openly and honestly, even if it wasn't the most captivating or headline-grabbing feature for the media. This was a reality I had to contend with.

I was not going to give up. I understood my story and content were a better fit for podcasts. These allowed me to explore the complexities of sibling sexual abuse authentically. Each podcast interview boosted my confidence and sharpened my capacity to convey the significance of the problem. Life stories involving such sensitive topics can't be condensed into short news segments. My resolve grew stronger as I connected with those who shared my purpose and narrative. Every discussion on this difficult topic had to matter and have a positive impact, regardless of whether it made headlines.

Raising consciousness about sibling sexual abuse wasn't easy, and I was disappointed the media didn't respond. Then, one day, a proposition struck me like lightning: What about TEDx? The concept seemed to emerge instantly, but various factors influenced it. I remembered a YouTube video with Brian Kenneth Miller, a seasoned TEDx coach, explaining TEDx talks and their authority. TEDx wasn't merely about sharing personal chronicles but conveying ideas worth spreading. I wondered how sibling sexual abuse could contribute to a valuable idea and raise acknowledgment. Putting aside my doubts, I contacted Brian, who offered a free twenty-minute discovery call. It was a step into the unknown, packed with nervousness, doubt, and ambition, but it felt right and necessary.

We met over Zoom, and I told Brian what I was trying to accomplish. He asked me, "So you're not selling anything?"

"No."

"You're not a coach or aiming to fill slots for your next seminar?"

"No. This is just my mission."

"Okay, well, it's a tough topic, but I think we can make something of it. I have never heard of it."

This wasn't just about securing a speaking gig but rewriting the narrative surrounding a problem that had impacted many lives, including mine. As I kicked off the process, I couldn't help but detect a sense of urgency. This represented the beginning of a new adventure, a ray of hope for survivors, and a pivotal move in my mission to create change. My mind wandered back to April 2014, when I initially started addressing sexual abuse and grief. I remember sensing a tap on my shoulder, urging me to talk about sibling sexual abuse.

My immediate reaction was one of reluctance. I thought I'd speak out about sexual abuse and address grief, but specifically on sibling sexual abuse? Hell no. Yet, here I stood, poised to share my personal story of sibling sexual abuse with the world.

With Steve's unwavering support, I commenced a twelve-session package with Brian. I dedicated the first six sessions to crystallizing my "idea worth spreading," a concept that had to do more than capture notice; it needed to break through the walls of resistance often encircling sibling sexual abuse. This was a unique challenge because the subject repelled rather than attracted listeners. I couldn't afford to end up on the list of talks that dwelled solely in the darkness of trauma and despair.

As I scoured TED Talks and TEDx Talks, I saw how the ones discussing sexual abuse and depression were dark. The question was how to open up the discussion about sibling sexual abuse in a way that would not turn the audience away. I voiced my concerns to Brian, and we collaboratively crafted a plan that involved supporting trauma survivors while still meeting our purpose in igniting a discussion about sibling sexual abuse.

We validated that I had an "idea worth spreading," and the exhilarating part of the work began: searching for TEDx venues. Each venue I explored was a potential platform to shift perceptions and give voice to the silenced. This endeavor was about more than just providing a talk; it was about creating a ripple effect of realization and understanding that could transform lives and reshape society's discourse about sibling sexual abuse.

Finding a suitable TEDx event took time because of COVID restrictions and limits on in-person gatherings. Many TEDx organizers scheduled events or hosted events on Zoom, but I wanted the whole TEDx experience. During this search, I came across a TEDx event scheduled for January 29, 2022, in Boca Raton, Florida. The timing provided ample time to craft my talk, and what caught my attention was the theme: "Defining Moments." "Defining Moments" was the ideal theme to house my talk. I went to work defining the pivotal moments around which I could build my talk.

I scheduled a call with Brian and told him of my excitement around TEDx in Boca Raton. Brian pulled up the application, reviewed it, and declared, "This would be perfect for you."

But as we examined the application, it said submissions were due July 31. We were well into August.

"What? There was no submission due date on the site before." My heart sank. I panicked and was afraid of missing out on this great chance.

Brian stayed calm. "It's okay. The application is still up. Let's reach out to the event organizers."

Brian and I connected with Caitlin, one of the organizers, and she emailed right back: "Oh, tell her she can still fill out the application. Our speaker submissions were supposed to close on July 31, but they are still up. You still have a window."

I felt immensely grateful, but also the pressure of preparing my talk.

Because of our busy lives and a nearing deadline, we started working on the three-minute video manuscript for the submission. It involved a lot of back-and-forth communication via email and some phone calls. The backdrop of our schedules added a layer of complexity to this process. Our progress was often disrupted because of my kids' school and orthodontic appointments and Brian's toddler's feeding and sleep routine. We sometimes had to pause our work to attend to our family responsibilities. But we got it done.

Brian said, "I suggest you try to submit it by Monday. Tomorrow would be better."

"Oh, this will be submitted by tomorrow."

I woke up at four in the morning the following day and began memorizing the script. By eleven I had showered and recorded two videos for Brian's approval. The recordings could have been better, but I was tight on time. I closed my eyes, lifted my hands to the sky, and prayed: God, I surrender this to You. This is Your work, Your story. I made a third recording, and it was the one. I knew it, but I produced one more for good measure. Sure enough, Brian picked my third recording. He emailed Caitlin who advised that I send the recording to her.

I stared at the screen, my cursor hovering over the send button. I shut my eyes, raised my hands, and whispered a prayer. "Dear God," I began, my voice barely audible in the room's stillness, "This is Your work, but I really want this."

As the email disappeared into the digital abyss, a rush of emotions flooded me—angst, anticipation, and a profound surrender. This was it, and I sensed it would all work out.

Caitlin emailed me back almost instantly. She wrote,

> Thank you for your beautiful message, Jane, and your heartbreaking
> story. You are so selfless, authentic, and incredibly brave! I've passed
> your submission to the steering committee and will keep you posted!
> I look forward to staying in touch!
> Warm regards,
> Caitlin

Receiving Caitlin's positive response was an incredible moment of triumph. Knowing someone appreciated my idea and story made me feel seen. Her words about selflessness, authenticity, and bravery touched me. It was an instance of introspection, a reminder of why I had begun this journey.

I let Brian know, and we both agreed that while that was stressful, we had made an impression. It may have been the best thing to have happened. My perseverance was finally paying off.

CHAPTER 33

TEDX: "THIS IS IT"

Months ticked by in a silent procession, each day amplifying the gnawing question: Why the deafening silence? I checked the Boca website. The website featured six impressive speakers, and uncertainty crept into my mind. There was a four-time Olympian, a nuclear engineer, an author from Google, a space policy analyst, a solar entrepreneur, and a PhD candidate. I emailed Caitlin to check in. She told me to be patient. Despite her well-intentioned response, it offered me little reassurance. Undeterred, I persevered, sending applications to various TEDx organizers. Every rejection was a step towards refining the message and finding the right match. Yet, my heart was anchored to Boca Raton, its allure impossible to shake. I tried to keep myself busy to distract my restless mind, but uncertainty made it hard to concentrate.

Several weeks passed, and then an email from Derek, one of the organizers, came.

Monday, Sep. 27:

Hey Jane,

I'm the organizer of TEDxBocaRaton. Do you have a few minutes to talk this week?

Thanks,

Derek

I sent it to Brian. He voice messaged me. "This is it. Nobody gets on the phone when the answer is no. Go on there, chat with them, and focus on what you're going to give them, their audience. They already like you. They already believe in your idea. What they're looking for is to let your personality shine through and connect to ensure you're the right person for their

stage and how your talk will benefit their conference, their community, and a wider audience. Keep the center of attention off yourself. Fewer I statements, and I'm glad it's on Zoom because you are personable on Zoom."

Choosing my attire for this meeting carefully, I chose a professional yet comfortable presence, wearing a crisp white blouse. I wanted to convey expertise and competence while appearing relaxed in my skin. My room was well-lit, and I had positioned the camera at eye level, aiming to achieve a business-like and competent angle. I tried anticipating Derek's questions and had a notepad and pen ready to jot down key points. As the clock's hands inched toward 11:00 a.m., I couldn't help but experience excitement and nervousness. Finally, the moment arrived, and I clicked on the "join" button for the call. Derek was waiting for me on the other side.

Derek greeted me warmly as I entered the virtual space, and his friendly demeanor put me at ease. The lack of confidence I was feeling melted away. I scanned the screen for signs of a panel or additional participants, but it was just us. Derek wore a loose shirt and a baseball cap and appeared laid back and easy to talk to.

"We love your topic," Derek said, breaking the ice and starting the conversation. His words reassured me I was in the right place, and I instinctively straightened, every fiber attuned to the screen as my intuition braced for the inevitable "but" lurking in his pause.

"It's between you and one other person. We will let you know next week."

I lowered my gaze away from the screen briefly.

He then went into things they expected. I scribbled like mad.

I should have known it was impossible once I saw the lineup of speakers. *Why would they consider me?* A familiar wave of self-doubt washed over me. Previous setbacks were resurfacing, whispering maybe I wasn't smart enough, didn't deserve this, and was fooling myself by even trying.

But then the exchange changed. Derek asked, "So, with your topic, would you be able to state statistics? We want our audience to be a little uncomfortable."

With renewed determination, I turned my gaze back to Derek, ready to face whatever came next. "Absolutely. See all these books behind me? Yes, I can talk about SSA!" I rattled off some statistics.

He said, "What would we put as your title?"

"Well, I refer to myself as an advocate, but this is your event. Title it however you wish."

"I don't mean any disrespect, but I love your topic. I searched TED and couldn't find another talk on this subject."

"It's a silent epidemic."

Oh no! Was that the wrong thing to say? Maybe he will think, if no one is discussing it, why should we? I need this TEDx talk. The doors that may conceivably open are vast and transformative. Shedding light on this silent epidemic would mean acknowledging a critical issue that has been overlooked for far too long. It had the potential to lead to important conversations and changes that could save lives and improve well-being.

On the flip side, the consequences of failure are equally significant. If I cannot convey the urgency and importance of this topic, the chance might never come again. If we stay quiet, those suffering won't have support, and we might miss the opportunity to make a difference. I had so much at stake. *Derek, please choose me, I thought.*

"Any other questions?" At the end of the call, I thanked him for his time and consideration and told him what this would mean for other survivors and me.

"I am committed to this endeavor. I have even hired a TEDx coach to help make sure I get it right."

Derek nodded as though he understood how important this was to me, and we ended the call.

I sent Brian a voice message to update him. He quickly replied, "This is about as close as you can get. I would say this is a pipe dream, not that realistic for most people. I have a suspicion they're going to come back your way."

Brian's words reminded me I had what it took to succeed. But I also sensed it would be challenging. I learned during my chat with Derek that TEDxBocaRaton was incredibly selective about whom they put on stage. The outdoor amphitheater had room for a thousand people, which was overwhelming since I was used to smaller settings.

My apprehensiveness skyrocketed, and I bombarded Brian with messages. This talk had to be a success—I couldn't bear the thought of letting them down or myself down. I needed more than just encouragement; I required a plan and a strategy to ensure my talk would be outstanding if I were selected, hitting it out of the park.

I found myself at a crossroads in those vulnerable moments after the call. The path ahead was filled with challenges, but I was determined to seize this chance. This was my moment, and I was ready to embrace it, emotions and all.

Two to three days stretched into two more weeks, each day feeling like an eternity. In those first few days after the call, I tried my best to occupy myself with mundane tasks and lose myself in everyday life. I thought by keeping busy, I could keep the worry at bay. But no matter how hard I worked or how many distractions I sought, my mind always returned to the impending decision. What if they chose the other person? What if I had said something wrong during the interview?

And then another email arrived.

Hey Jane,

Do you have some time to talk on Friday?

Derek

This was it. The answer.

Steve and Brian reassured me: "He is not scheduling a Zoom call a few days out to tell you no."

"How do you know? Maybe he wants to let me down personally."

Brian messaged me. "Same thing as the last time. People don't do Zoom calls to tell you no."

And Steve said, "He's not taking time out of his day to have a polite Zoom call to tell you no."

Brian said, "I think you're in."

Steve said, "I think you're in."

I said, "I don't know. I don't want to get my hopes up."

My anxiety built again. I stood in the kitchen and prayed. Then, I headed upstairs to log into Zoom.

Derek said, "It's a yes. We are going to go with your talk."

I was in!

My mind struggled to process what I had been told. "It's a yes. We are going to go with your talk." Those simple words had the power to change everything. Emotionally, I was overcome with joy and relief. I had been working on this for so long, and now it was finally here.

And he jumped right into logistics—flights, timing, sound check ...

"Derek, may I interrupt you for just a second?"

"Sure."

"I just have to take this moment and thank you." I put my hand over my mouth in disbelief. I felt the tears in the back of my eyes, and my throat was constricting. Derek's expression softened, and we shared an inaudible understanding. I leaned back in my chair, allowing it to sink in, before saying, "I mean, really, thank you. Thank you from all survivors and parents who need to be heard."

"Now you're going to make me cry," he said.

We both smiled. After the call wrapped up, I went down the stairs and shouted, "I'm in!"

Steve came out of the office, hugged me, and said, "Congratulations, sweetie!" And he did what Steve does best. He said, "I checked flights while you were on the phone. Here's what I found."

"But I have to tell Brian."

"Oh, yeah," Steve said.

P R E P A R A T I O N

Brian and I devoted the following two months to crafting the talk, attending to every word and detail. We wrote, revised, and revised some more. Every day was a constant back-and-forth exchange of ideas.

Brian listened to the speech. "I think this is it," he exclaimed. "How do you feel about it?"

"I feel good—better than good."

The memorization process began with more tweaks and Voxer messages from Brian. I was afraid I would forget the words under the pressure of speaking in front of so many people, but the more and more I soaked up the talk, the less I worried.

I made a recording on my phone, and during my walks with Leo I would play it at a slower speed, talking along with it. To avoid raising eyebrows from the neighbors, I pretended to be engaged in a phone conversation, ensuring they didn't think I had gone bonkers. I practiced tirelessly, going over it again and again. Circles were my stage as I paced the backyard, meticulously reciting the lines and perfecting inflections and pauses. Before bed, it was a ritual to read it through, allowing the words to settle in my mind. And every morning, before my run, I would revisit the talk, building confidence with each repetition.

Now that I had the talk memorized, it was time to do a video. I'd record, delete, and record again, and repeat this exercise so I could spot what funny faces I was making. Delete, record, delete, record. I adjusted my voice and body language, but some phrases still felt rehearsed and inauthentic. Brian stepped in with his invaluable counsel. "No," he'd say, "that is not working for you. Just be you." He encouraged me to stand my ground, feet planted

firmly, and deliver my message honestly and sincerely. "It's a weighty topic," he explained, "and your movements should mirror the gravity of your words. You haven't done this before." His words sounded reasonable, but remaining still was difficult, resisting the urge to shift my weight. But in the end, it was the quintessential embodiment of what I was trying to convey: to stand my ground, be vulnerable, and let my true self shine through.

Just weeks after receiving the TEDx news, I received a note on Facebook Messenger from someone I'll call Brandy Black. The note said, "I need a survivor to scrutinize my website." She confided she was a parent who had discovered sibling sexual trauma within her own home. When she required guidance the most, information was almost nonexistent, so she created a site to assist others in similar situations. She was seeking a survivor's perspective before publishing information.

I agreed to review her material because no websites were explicitly devoted to sibling sexual trauma. As I delved into her content, its quality captivated me. This venture called for a team effort, and I knew just the individuals to enlist.

As part of a crew of moderators of a Facebook group of over seven thousand sexual abuse survivors, we often had to turn down parents wanting to join our group. Looking for a place to send them, I found a Facebook group for parents of sibling sexual trauma. I contacted the administrator, whom I'll call Hope Sittler, and requested to join her group to gain faith in referring parents to her and to offer my help. She politely told me no. Despite her response, I realized I had met someone who cared about sibling sexual abuse. So when Brandy reached out with her website, I tried Hope again. Hope was receptive this time and gave me her email address.

I also contacted Maria Socolof, a fellow sibling sexual trauma survivor and author who went public with her story. Maria eagerly joined our cause. A day later, I received another message from Fiona Ward, which read, "I want to be an advocate because this happened in my home. How can I help?"

Within a week, we connected via email, scheduled a Zoom meeting, and shared our stories, and 5WAVES.org, Worldwide Awareness, Voice, Education, and Support, was born, an international 501(c)3 advocacy group that offers information, support, and guidance about sibling sexual abuse and trauma. We all agreed to help Brandy publish siblingsexualtrauma.com. Hope helped familiarize us with Slack so we could collaborate with one another.

While immersed in writing my TEDx talk and working closely with Brian, the messages about website editing flew through email and Slack. I kept apologizing. "I can't look right now. My brain is full, and I must stay focused on the talk. I promise I will be more helpful when this is over."

To my reassurance, they assured me, saying, "No worries, Jane. You focus."

When the time came to share my talk with them, I understood this was not just my journey but our journey. I recorded the talk, and each listened to it at least once, providing valuable suggestions. Everyone participated in its development. We all had so much to say, which made the ten-minute limit imposed by the event organizers a challenge. We completed the talk, and I shifted my concentration back to rehearsing for the TEDx stage.

THE
UNTHINKABLE

As the Christmas season began, just a month before the TEDx talk, my two boys volunteered at the church to distribute gifts. I opted to wait in the car, dedicating that time to memorizing my talk. But fate had something different in store for me. Fran, a church office staff member, suggested I use the platform in the sanctuary while the kids worked on organizing the packages. I recognized it as a great chance to practice, as Brian recommended I find an audience to practice in front of. That was difficult because many venues were closed due to COVID.

Stepping onto the platform, something changed within me. My voice projected with a newfound confidence. An hour later, as I rounded up the boys and headed towards the exit, Fran made a generous offer. She proposed I return to the sanctuary and bring some friends along. Time was slipping away and the time had come to present my talk to a "live" audience, which wasn't composed of family members or stuffed animals, so her proposal was precisely what I needed, but I hesitated, not wanting to take advantage of her kindness.

In mid-January, Fran reminded me about her offer. I seized the opportunity and invited several of my mom friends to join me. We made plans for a dress rehearsal. The morning of the run-through, I tossed my blue blazer onto the back seat of my car, keeping it out of reach of Leo, who was always eager for a car ride. White hairs and a blue blazer would have been a catastrophe. As I drove to the church, messages from Suzanne, Krissy, and Meghan assured me they would be there. When I pulled up, seeing them ready and

waiting pleasantly surprised me. I quickly unloaded my ring light, my blazer, and the sheets of paper containing my speech, just in case.

Inside the lobby, my friends greeted me. They had fit me into their busy schedules, so I didn't want to unnecessarily take up their time. Together, we entered the auditorium. I addressed them and said, "Okay, I have written and memorized the talk. I can't change anything at this point. But let me know if I do something weird or annoying with my body or my face or if the wording doesn't make sense."

They nodded in agreement, happy to provide feedback.

I went to fetch Fran to find out if she wanted to join, and she accepted the invitation. With no warm-up and no prior preparation, it was show time. I pressed record on my phone and stepped onto the stage. My friends, all wearing masks, occupied the front row, and Fran sat further back, also masked.

"Is it okay if I remove my mask while speaking?"

Fran signaled in approval, and I spoke.

As I reached the part of my talk where I revealed personal experiences, I made eye contact with Fran, realizing she had no warning about the sensitive content. Thoughts raced through my mind: *Now, the church lady will know about my past.* I continued, sharing my story as honestly as I could.

Fran did not appear shocked or judgmental, and I found the strength to continue. As I concluded my talk with a message of support for survivors, I breathed a sigh of relief.

My friends offered their assessment, noting, "Wow, that was only ten minutes, but you packed a lot into ten minutes."

Their observations were positive. I thanked them and sent them on their way, mindful of my promise to keep our meeting brief. Fran remained in the sanctuary with me. We talked and prayed together, which brought me immense comfort.

Afterward, I spent an additional half-hour rehearsing. The practice of rehearsing in front of spectators had been invaluable. Time was running out

as the TEDx event approached. I only had a few hours before I had to pick up the kids and go to Michelle's house for another "live" run-through. Michelle had gathered a group of about nine runners willing to serve as my audience for one final rehearsal. We were departing for Florida on Thursday. The pressure was mounting, and the clock was ticking.

The appointed time for our gathering at Michelle's house was set for five in the afternoon. The chilly, windy afternoon gave me a shiver. With COVID still lurking, meeting indoors wasn't an option. Thankfully, I had my trusty blue blazer to ward off the cold. Standing there, ready to face a special assembly—my running friends, was surreal. Some of them had been on this journey with me for over a decade, while others had joined only in recent months. They took their seats on the outdoor patio, knowing I had promised not to take up too much of their precious time. As I stood on the back lawn, surveying my impromptu audience, I couldn't help but feel a strong urge to retreat into myself.

Among the faces in the crowd, I spotted several male runners who were already aware of parts of my story. However, this was different. This was being vulnerable in its purest form. Taking a deep breath, I commenced. But two minutes in, I stumbled, faltering over my words. I apologized, asking if I could start over. They were gracious enough to grant me a second chance. *Time, Jane,* I scolded myself internally. *You're using up their time.*

With renewed determination, I began again.

Around seven minutes into my talk, the unthinkable transpired. I froze, not because of the freezing wind whipping on every side of us, but because my brain refused to cooperate. I had hit a wall, a complete blackout, with no recollection of the next line. I stood, trapped in an extended pause, desperately searching for the missing words. And then, the forgotten line surfaced in my mind. I finished the talk, but the encounter had left its mark.

That momentary lapse had never happened to me before, and I couldn't help but berate myself for it. I was afraid to review the recording when I returned home, but my curiosity kicked in. I had to watch it. To my surprise, it wasn't as disastrous as I had feared, but it was a crucial learning experience that taught me several valuable lessons: It could happen to anyone. Instead of apologizing, I needed to keep my composure, smile, and breathe through such moments. I had over-rehearsed that day, causing me to lose track of what I had already spoken.

It was like navigating a maze, feeling disoriented. The "What if?" scenario haunted me.

The lingering "What if?" compelled me to take action when I boarded the plane the following Thursday. With my mask on and the plane's ambient noise as cover, I began practicing my speech. I reached a point where I took a break and read *Three New People*, a book Brian had written. In chapter ten, he discussed how taking notes and writing details after meeting someone may solidify those memories in your mind. That got me thinking—could the same concept apply to memorizing a speech?

Rummaging through my backpack, I realized while I carried a notebook everywhere I went, I had somehow forgotten to pack one for this trip. "Chase, Tate—did either of you bring a notebook?" I asked.

They shook their heads no.

"Crap. Guess I'll have to write it on the back of my speech."

As I began scribbling away, the tension in the cabin rose. Fear, excitement, the need to avoid making a single mistake—all swirled inside me, racing against my mind, a constant tug-of-war between wanting to rush ahead and staying focused on the task. My hands moved swiftly, tracing letters in a strange push-and-pull dance. Adrenaline coursed through my veins, and I reminded myself to breathe and smile. What an emotional ride.

As I reviewed my writing, I had made only a few minor errors, none of which would significantly alter the outcome or impact of the talk. With a

sense of accomplishment and readiness, we neared our destination. This was a good thing because our schedule in Florida was packed, and Brian had advised me to stop rehearsing twenty-four hours in advance. The TEDx event was drawing near, and anticipation was building.

THE
RED DOT

On that crisp January 29, 2022 evening, as we traveled to the venue, a chilly wind sliced through my navy blue blazer, cutting right to the bone, and a shiver ran down my spine.

As I went backstage, people were huddled together in the outdoor amphitheater, their breath visible in the cold air, hugging their coats tightly as they waited for the event to begin. Well, at least I wouldn't have to worry about sweat marks! Now my biggest concern was not to head onto the stage with chattering teeth. I worried that few people would brave the freezing cold.

I stood carefully in my almost four-inch high heels, aware a strong gust could knock me down. I hadn't worn heels in a long time. As a stay-at-home mom, my days were filled with the chaos of raising children, running errands, and keeping up with the never-ending laundry. Sneakers and leggings had become my go-to attire. But there was another reason I had abandoned those high heels. Foot injuries, the result of years of running away from my past, had taken their toll. I had been sprinting from my history, both figuratively and literally, trying to outrun the memories and the pain that lingered. Joey, my consummate stylist, had meticulously dressed me for this new role as a public speaker. The bow on my blouse represented the attention to detail I was now putting into my appearance. It was a sign of my determination to make this latest chapter of my life successful.

Being a first-time speaker was a leap into the unknown. I wanted to leave nothing to chance. These heels were more than footwear; they symbolized my transformation and reminded me that life could take unexpected turns. Reflecting on my journey, I realized how far I'd come. I had been on a passage

defined by change, growth, and the resilience to adapt to whatever life threw my way, even as I carried the physical scars of my past.

Matt, one of the sound crew, introduced himself. Lily, my makeup artist, fixed my tresses. Next, Joey raced over to position my necklace in the center of my chest. The metal felt cold against my skin. Their actions provided me with a sense of comfort and support.

I was ready.

My pillars of support, Joey and Lily, stood back, nodded approval, and snuck back into the shadows. As I waited backstage, preparing to give my talk, the memories flooded my mind, overwhelming me. Channell, the first speaker, was sharing her own experience with cancer, and her words transported me back in time.

She spoke of being treated with chemotherapy and the distress of losing her hair, and as I listened, it wasn't her cancer journey I was thinking about. I was reliving Mark's cancer battle, and the hardships came rushing back to me.

My heart ached, and I became wobbly on my heels, trying to hold back the tears that threatened to betray my composure. Channell's words had the power to stir up a deep well of grief. I had to find the strength to carry on. With Steve in the audience, I felt his love and support for my resilience, and I was totally ready to share my story about sibling sexual abuse. Life's complexities, with its ebbs and flows—mine and everyone else's—were on full display backstage, reminding me that even during times of chaos and sorrow there could be moments of peace and hope.

Matt, listening through headphones, said, "Say 'check, check' for me, please."

"Check, check, check."

Channell was holding her audience well. She was so inspiring, and the audience loved her. My talk was anything but uplifting. But I had something important to say. My mind wandered back to the previous forty-eight hours.

We had hosted lunch with my parents and five of my friends, who had all come in to hear the talk. After lunch, we headed to the event site to sneak a peek and take some pictures. A woman approached us and started asking questions. "What's happening here tonight?"

Steve answered her enthusiastically, "TEDxBocaRaton. My wife is a speaker."

"Really? That's amazing. What is your talk about?"

As I began discussing the topic, the tension grew thicker with every passing moment. She was not just anyone but a sex therapist, a psychiatrist, and a PhD. Her credentials added an extra level of intensity for me. She wasted no time in making her stance clear: "Well, I need to push back because you're going to create a panic, and parents are going to go overboard in the other direction, not letting their kids hug each other."

My initial reaction was to debate her and clarify my viewpoint. But Steve, ever the calming presence, placed his arm on my shoulder. His silent encouragement helped me to stay composed. I wanted so desperately to change her mind, to make her see the importance of what I was saying.

So I lied to Brian, my TEDx coach, when he asked how I was feeling later that afternoon while I was getting hair and makeup done for the Friday night VIP event. I told him about the therapist: "She is not my audience, and she gave me more motivation because she is part of the problem."

Brian responded, "You're right. She may not be intentionally trying to be a part of the problem, but you could say that about almost any major issue: 'Well if you speak about it, you will create panic, so let's not solve the problem; let's let people suffer in silence.' That's not a good solution. There is a tangible reason for you to do this talk, face to face."

What I needed to be told, as always. One of the makeup artists in the studio had overheard this conversation with Brian and asked questions. I shared with her my talk, the silent epidemic of sibling sexual abuse. Then she shared with me her own experience—her cousin had sexually abused her. The

weight of her revelation underscored the significance of the topic I was about to address, a reminder of the value of breaking the silence. Her story gave me more resolve to proceed with my talk.

As I stood backstage, a sense of calm came over me. Why was I so relaxed? Was this okay? Brian had assured me I was prepared, and my calmness indicated readiness, but nagging doubts persisted. The biting cold penetrated my bones, and my legs shook. I had been standing with my hands up, palms out, in a silent prayer of surrender, as if to say, "This is Your work. This is Your story. I trust You." But the chill in the air had left my fingers numb. I drew my arms around my body for heat.

Joey approached and stood close enough to block the wind. He took my cold hands in his, holding them tightly. I squeezed his hands, hoping to absorb some of the warmth and strength he offered. His touch was a physical manifestation of the encouragement I needed.

Lily joined in, stroking my arms and legs, helping me warm up. As the heat returned to my body, I felt a renewed awareness of purpose gradually replace the doubts that had plagued me earlier. I was doing the right thing by speaking out about sibling sexual abuse. I had support all around me to validate my cause.

Joey remained silent, and I loosened my grip and detected the breeze on my face, but my body was warm. I was at peace. The prayer team back in California was hard at work and their prayers were working. God is with me. I am supported. I sense Him.

Matt popped back over to ensure my mic was still working. "We need one more check."

"Check, check, check." He gave me a thumbs-up as he walked away. Again.

Someone approached me from the side, out of the darkness. They said, "Thank you for talking about this difficult subject. It happened to me, too."

Jane, don't cry, don't cry.

"Thank you for sharing with me."

"Please welcome Jane Epstein."

Joey made sure everything was in order. Lily pulled one curl forward to cover the tape on my cheek, and I was on my way to the red dot.

I took my time. After all, I was in high heels and didn't want to fall flat on my face. So much had transpired from the last time I took the stage in wobbly heels. The young twenty-year-old drunk girl who stepped onto the stripper stage, the one who carried that shy six-year-old girl who thought the abuse was her fault, had grown into the woman who was now walking toward the TEDx stage, hoping to help others. I strode purposefully onto the red dot.

The audience had grown over the last half hour, and more people were filing in. I noticed Tina, my friend who had come from California, smiling at me from the first row, sending me encouragement. Steve and our two boys were seated in the second row with my parents. I looked above their heads. This was too emotional to catch their eyes. I spotted Christy's winter hat to the left, sitting with Joanne, Julie, and Moselle, who had traveled to be with me from various states, all of whom I had met through running. I was supported.

The audience went quiet.

As I stood before the expectant faces, nervousness and excitement engulfed me. The amphitheater was so quiet you could make out sirens and traffic on the street. I took a moment to soak it all in. This was a talk I had prepared for, one that would be immortalized on YouTube, and I wanted to get it right.

I began my talk, trying to maintain a calm and composed demeanor. "My husband and I had been in marriage counseling for five long years. I'm pretty sure we put our marriage counselor's three kids through college." I forced a smile, reminding myself that humor was essential in breaking the ice. My heart raced as I continued, "You would think we had it figured out by then."

But then, it happened. Just as I was getting into the story, my voice unexpectedly squeaked, and I couldn't help but panic. I told myself to stay focused. Each word needed to emerge effortlessly, slowly, and deliberately to keep the crowd engaged.

As I proceeded with my narrative, I described a relatable scenario. "Have you ever been stuck in an awkward conversation at a party with someone, and you couldn't figure out how to get rid of them?" I observed the spectators nodding and connecting with my words.

I came to the first pause, where the audience would hold their breath. What is she going to say? My lines spilled out of me smoothly. "I'm a devoted advocate for survivors of sibling sexual abuse."

Applause.

What? Applause? I paused for a second, my eyes scanning the crowd in disbelief. That was not part of the script. *Who is applauding? Why? Take it in. Smile.*

The unexpected reaction stirred a mixture of emotions within me. First, there was surprise—why were they applauding at such a serious and sensitive topic? But then a sense of validation and gratitude washed over me.

I continued. And I remained calm. The words came, the pauses came, I didn't speak too quickly; I didn't forget to breathe.

"And if you're a survivor ... I hear you ... I believe you ... you are not alone."

Pause. A sense of relief. Then, applause.

And it was over, just like that. I turned and walked away from the magical red dot.

Matt came over to remove the mic. I perceived the sensation of joy. I felt heard. I hugged Joey and Lily and returned to the green room. I had nailed it. I would not change a thing. Okay, I may have hovered over the red dot for a few more seconds, but that's it. It was amazing.

"Jane, someone wants to see you outside—a woman."

I went to the exit and found a woman in tears. The expression of gratitude in her eyes was unmistakable. "Thank you for talking about this. My husband is here with me, and I almost left because I thought it might trigger me. I'm so glad I stayed. When does the hurt go away? When will I stop crying?"

I hugged her and asked her to contact me after the event and we said goodbye. I had reached a survivor, and that is why I had come to Florida. I headed towards my family to find them in line for hot chocolate.

A gentleman asked, "Jane? Are you Jane?"

"Yes."

"Thank you for your talk. It was powerful. The person next to me left right after you finished. They said they had to get home and tell their spouse that this had happened to them."

I told the gentleman how to contact me and to please tell this person to reach out. They did, by email the next day.

I continued to make my way to the hot chocolate line, where Steve and our friends were standing, when a husband and wife approached me. She said, "Thank you for sharing your talk. I feel so naïve and feel we are living in a society that does not know this is such a problem. You have enlightened us. You are very brave."

I finally made it to my family, Steve and the kids, and five friends who had traveled from four states to support me. Overwhelming emotions spilled over. Hugs were exchanged, tears flowed freely, and photographs captured the profound moment.

I heard a squeal and "There she is!" coming from my right. I glanced over and saw my mom running toward me with outstretched arms, and we hugged, symbolizing a lifetime of support and love.

People reaching out was the culmination of my journey, and each encounter supported my mission to raise awareness about a silent epidemic.

Looking back on my experience at TEDxBocaRaton, I am overwhelmed by its profound impact on me. I was filled with trepidation and self-doubt

when I started this undertaking. The idea of standing on that stage in front of strangers was terrifying. But I had a story, a story that needed to be shared.

As I prepared for my TEDx talk, I delved deep into my own experiences, reliving moments of joy and pain, episodes that had shaped me into the person I am today. It was an emotional rollercoaster in confronting my vulnerabilities and insecurities. Yet, I discovered a reservoir of strength within myself I never believed I could possess.

I hope my journey inspires others to do the same, face their fears, share their stories, and make a difference.

ACKNOWLEDGMENTS

There aren't enough words to express my gratitude toward those who have played a part in my healing journey. I wish I could have shared every story, but the space within these pages is limited. So instead, I've highlighted some small steps that led me toward advocacy and personal growth.

To Tabitha, my writing coach and publisher, thank you for pushing me to dig deeper and deeper. Yes, I cursed you often, but you helped me weave my story together with more layers.

To all my running friends, the incredible moms, nieces, extended family, and fellow survivors who stood by my side throughout this process, please know that your unwavering support has meant the world to me. Each of you has contributed to my healing in ways that words cannot adequately capture.

I've tried to share my story from my perspective, knowing we have unique viewpoints and experiences. Throughout this journey, I've strived to approach it with love, compassion, and unflinching honesty. As a result, many individuals have crossed my path and lent their helping hands along the way.

To my dear mom, I understand this hasn't been an easy road for you, but I want to express my deepest appreciation for your unwavering support. Your presence and love have been a constant source of strength.

To my incredible children, your boundless love and understanding have been my guiding light. Your belief in me and our love has fueled my determination to heal and become the best version of myself.

And to you, Steve, my rock and unwavering companion, I cannot find the words to express my gratitude. Your faithfulness, loyalty, and steadfast support in every endeavor have carried me through even the darkest moments.

Your love for me has remained firm, and I am eternally grateful. Thank you for never giving up on me.

To my found family, those individuals who may not be bound by blood but have become my pillars of strength and understanding, I am truly blessed to have you in my life. Your presence has brought warmth, comfort, and a deep sense of belonging that I cherish deeply.

Countless others have profoundly impacted my healing journey, and I wish I could name all of you. But please know that your presence, kindness, and support have touched my heart and propelled me forward.

With immense love and gratitude,

Jane

RESOURCES

TEDx talk: "Giving Voice To Sibling Sexual Abuse." Giving Voice to Sibling Sexual Abuse | Jane Epstein | TEDxBocaRaton

Siblingsexualtrauma.com

5WAVES.org

www.jane-epstein.com

https://www.incestaware.org/

http://stopitnow.org/

http://stopitnow.org/uk

https://siblingsexualabusesupport.org/s

ABOUT THE AUTHOR

Jane Epstein is a survivor of and advocate for survivors of sibling sexual abuse (SSA) and trauma. She is co-founder of IncestAWARE, an alliance of survivors, supporters, and organizations that offer services and solutions to end sexual abuse in families through prevention, intervention, recovery, and justice. She also co-founded 5WAVES, an international 501(c)(3) nonprofit dedicated to changing how sibling sexual trauma and abuse are understood and addressed. A TEDx speaker who has been featured in outlets including *People, Authority, The Sunday Times Magazine,* and FOX TV, Epstein educates and empowers parents on preventing SSA.

Visit www.jane-epstein.com to learn more about Jane.

Printed in the USA
CPSIA information can be obtained
at www.ICGtesting.com
LVHW010338300824
789651LV00001B/1